Pop Art

Pop Art

A Colourful History

ALASTAIR SOOKE

VIKING

an imprint of

PENGUIN BOOKS

VIKING

UK | USA | Canada | Ireland | Australia
India | New Zealand | South Africa

Viking is part of the Penguin Random House group of companies
whose addresses can be found at global.penguinrandomhouse.com.

First published 2015
001

Copyright © Alastair Sooke, 2015

The moral right of the copyright holders has been asserted

Set in 11/13 pt Bembo Book MT Std
Typeset by Jouve (UK), Milton Keynes
Printed in Great Britain by Clays Ltd, St Ives plc

A CIP catalogue record for this book is available from the British Library

ISBN: 978-0-241-97305-9

www.greenpenguin.co.uk

MIX
Paper from
responsible sources
FSC® C018179

Penguin Random House is committed to a
sustainable future for our business, our readers
and our planet. This book is made from Forest
Stewardship Council® certified paper.

For Tom and Ceridwen

Contents

Introduction: Whaam!

After it emerged in nineteenth-century Paris, modern art resolutely refused to pander to mainstream taste. If anything, provocation was its defining trait. Yet, by the beginning of the Sixties, the art world had witnessed so much scandal, outrage, capering and tomfoolery that it was tough to create anything that could jolt people out of indifference. Impressionism, Fauvism, Cubism, Futurism, Dada: all of these, and more, had made *le bourgeois* shockproof. The savagery of modern art's sacred monsters such as Picasso had been tamed. As an influential American curator of contemporary art put it in 1962: 'There no longer is any shock in art.' The following year, the American artist Roy Lichtenstein expanded on this theme: 'It was hard to get a painting that was despicable enough so that no one would hang it.' You could practically stick a dripping paint rag in the middle of a gallery, he said, and people would accept it as art. But then along came Pop Art, the most 'despicable' modern movement of the lot, and the shock factor that had gone AWOL from contemporary art suddenly returned: whaam!

'Art galleries are being invaded by the pin-headed and contemptible style of gum-chewers, bobby-soxers, and worse, delinquents,' the art critic Max Kozloff thundered in the journal *Art International* in 1962, soon after seeing Lichtenstein's first solo show of Pop paintings at the powerhouse Leo Castelli Gallery in New York. In American slang, a 'bobby-soxer' was a teenage girl who was wild about pop music and wore short 'bobby socks' reaching just above the ankle. In other words, bobby-soxers, like gum-chewers or delinquents, did not belong to the ranks of

upscale sophisticates who usually frequented Manhattan's galleries in the early Sixties. Kozloff concluded: 'If there is a general rule underlying the new iconography, it is that there is no rule, no selectiveness about it. Anything goes, just as anything goes on the street.'

Anything goes: in time, Pop's antic, street-smart approach would come to be seen as its greatest strength – the zesty X-factor that revitalized moribund modern art. When Pop Art first appeared, though, as Kozloff's remarks suggest, its irreverent energy didn't just irritate people: it made them furious. Take Lichtenstein, that purveyor of highly stylized paintings executed in the manner of cartoons and comic strips. Sometimes described as one of the 'architects' of Pop Art, he provides a useful case study. When he exhibited his Pop paintings at Castelli's in early '62, people couldn't stomach them. They certainly didn't try to understand what they were about. His work seemed so crass and vulgar, so frankly idiotic. If it was as straightforwardly dumb as it appeared, then it offered an abominable affront to taste and the time-honoured values of art. And if it wasn't, because it was somehow ironic or tongue-in-cheek, that was even worse, because it turned the people looking at it into the butt of a snide joke. According to Kozloff, it was 'a pretty slap in the face of both philistines and cognoscenti'. Towards the end of the decade, Kozloff – who was by then writing as a convert to Pop Art, which had come to be taken seriously by leading institutions and museums around the world – recalled the 'acid shock' of seeing Lichtenstein's canvases for the first time: 'To drink in those images was like glugging a quart of quinine water followed by a Listerine chaser. And there was, too, the fierce disbelief that anything so brazen as these commercial icons could have found their way on to prepared and stretched canvas. The very gallery seemed defiled by some quack churl who couldn't, or didn't, adhere to the idea of

painting as an easel art.' Writing in the immediate aftermath of Lichtenstein's debut Pop solo show, another critic was just as blunt: 'I am interested in Lichtenstein as I would be interested in a man who builds palaces with matchsticks, or makes scrapbooks of cigar wrappers. His "art" has the same folk originality, the same dog-gedness, the same uniformity.' (See how this writer protected herself from the stink of Lichtenstein's paintings by isolating the word 'art' within inverted commas.) The British art critic Herbert Read, who sat on the Tate Gallery's board of trustees during the Sixties, was even terser. Invited along with the rest of the board to consider whether the Tate should buy Lichtenstein's large diptych *Whaam!* (1963), he wrote to a fellow trustee, the sculptor Barbara Hepworth, to express his opinion that the painting was 'just non-sense'. When he was younger, Read had been one of the most prominent champions of modern art in Britain – but Pop left him narked and nonplussed: surely, he reasoned, it was a kind of anti-art. At the beginning, then, Pop Art caused pandemonium, scandalizing the tastemakers who believed they knew what art should be about.

*

To our ears, perhaps, such violent reactions may sound surprising. After all, part of the point of Pop was to bring back ordinary objects – the sort of stuff commonly encountered out on the street – into the lofty orbit of fine art. Over the ages this is some-thing that lots of artists have done. Place, say, a painting of a bunch of asparagus, an ice-cream soda and a packet of cigarettes by the American Pop artist Tom Wesselmann beside a seventeenth-century Dutch still life, and you will find essentially the same idea expressed in different ways: each offers an inventory of mundane consumables in order to provide a snapshot of – possibly a com-ment upon – a particular society at a given time. Moreover, modern

artists had been raiding the 'low' culture of commercial imagery
for generations. Monet and Cézanne found inspiration in fashion
engravings. Toulouse-Lautrec designed posters inspired by Paris's
nocturnal demi-monde. Picasso conjured witty wordplay by
incorporating real-life advertisements and newsprint into his
Cubist compositions. Bacon made paintings inspired by well-worn
scraps of photography culled from books, newspapers and maga-
zines. He was also interested in working with imagery from
films. Pop artists would have recognized all of these strategies and
techniques. Then there were the modern artists who seemed to be
creating something uncannily like Pop long before the movement
had begun. The American artist Stuart Davis painted commercial
products during the Twenties, including a packet of Lucky Strike
loose tobacco and a bottle of Odol mouthwash. In doing so, he
anticipated one of the central strategies of Pop Art: foregrounding
well-known brands. Almost two decades before Andy Warhol
decided to paint a Coke bottle for the first time, Salvador Dalí
placed a meticulously rendered Coca-Cola bottle centre-stage in
his oil painting *Poetry of America* (1943). Arguably, then, a Pop
impulse – if by 'Pop' we mean broadly an interest in commonplace
imagery and the popular arts – has always been a strong compo-
nent of modern art.

So why the big shock when Pop Art suddenly arrived? One
obvious explanation is that it looked so radically different from
the principal style of modern art then dominant in America:
abstraction. Thanks to an influx of important émigré European
artists during the Second World War, New York in the Forties
suddenly found itself superseding Paris as the capital of world art.
Inspired in part by French Surrealism, a new school of painters
emerged who came to be known as the Abstract Expressionists.
These artists included the likes of Jackson Pollock and Willem de
Kooning. They had a reputation as impassioned, heavy-drinking,

almost mythical bohemians, who took painting very seriously indeed. Abstract art, for this macho tribe, was about baring the chest and revealing the soul. It was a difficult journey inwards to articulate the *Sturm und Drang* of psychological or emotional turbulence. Abstract Expressionist paintings were hard-won and challenging, a tilt at the sublime. They didn't dillydally with frivolities, but unleashed volcanic energies on canvas in order to convey grand, essential truths about the human condition. As Mark Rothko, one of the major painters associated with the group, explained during an interview in 1957: 'I'm interested only in expressing basic human emotions – tragedy, ecstasy, doom.' By contrast, as Warhol once wrote, 'The Pop artists did images that anybody walking down Broadway could recognize in a split second – comics, picnic tables, men's trousers, celebrities, shower curtains, refrigerators, Coke bottles – all the great modern things that the Abstract Expressionists tried so hard not to notice at all.' Suddenly, the old order was under threat: the elitist, rarefied world of abstract art was confronted by the everyday culture of the street, as Kozloff had put it, evident in the new Pop paintings of cartoon characters and commercial products by Warhol, Lichtenstein, Wesselman and their peers. Art was becoming subversive once again.

Pop Art, then, was everything that Abstract Expressionism was not. Most fundamentally, of course, it was proud to be figurative rather than abstract. You wouldn't catch Pollock painting a tin of Campbell's tomato soup: rather, it looked like he'd thrown one across the canvas. (Interestingly, though, you would catch de Kooning cutting out the mouths of models from cigarette advertisements in magazines. Occasionally he attached these to his canvases while working on his series of aggressive and bulky *Women* during the early Fifties. Many Pop artists would later share his fascination with readily available, mechanically reproduced, cheap commercial imagery – as well as sexy lips.) In addition to the

obvious division between abstraction and figuration, there was also a profound generational schism in terms of the attitudes associated with each movement. Where Abstract Expressionism was lofty, serious, intellectual and 'heavy', Pop was light – nimble, deadpan, non-committal, witty. Rothko was striving for tragedy, ecstasy and doom; Warhol was after something much more trivial and arch. If we watch footage of interviews with Warhol shot during the Sixties, we see a curiously contrived, monosyllabic persona, walled up behind sunglasses and beneath a silvery toupee, responding to questions with little more than a 'Yes', a 'No', a 'Gee' or an 'I don't know'. It's impossible to imagine Warhol ever speaking about noble concepts such as tragedy, ecstasy and doom without cringing or unless he was being ironic. His ice-cold demeanour was capable of making everything seem risible – or, worse, boring. 'I've been quoted a lot as saying, "I like boring things,"' he once wrote. 'Well, I said it and I meant it.' Somehow his whole stance seemed engineered to make regular American citizens feel as though they were being mocked. And as for Lichtenstein: well, he was after what exactly? Obviously he was interested in painting simulacra of stock characters from comic strips, including all-action war heroes and lovelorn, Waspy blondes. But why would anyone want to do such a thing? In 1964, Lichtenstein was the focus of a substantial feature in America's *Life* magazine. In the accompanying photograph he sat calm and cross-legged, with a hint of a sphinx-like smile upon his lips, beside the headline: 'Is He the Worst Artist in the US?'

The truth, however, is that Pop Art was about something else besides simply rejecting Abstract Expressionism with impish, childlike gusto. By turning their backs on abstraction, the Pop artists found their own voice and forged a style – of course. They successfully blocked the oppressive, overbearing influence of these world-famous father figures and secured some room in which to

operate. But if this were all that Pop Art did, today it would be remembered chiefly as an academic movement, concerned with formal issues and knotty aesthetic conundrums. It wouldn't be anything like as popular as in reality it is. In addition to this assault upon abstraction, Pop Art illustrated a profound transformation that was occurring within Western society following the Great Depression and the Second World War. During these tumultuous decades, the West, led by America, vanquished the age of austerity and marched towards a future characterized by prosperity and abundance. Between 1941 and 1951, the disposable income of all Americans increased from almost $93 billion to more than $226 billion. By 1961, it exceeded $364 billion. A rapidly expanding mass media perpetually recycled capitalism's seductive slogans and promises: Sexy girls! Shiny cars! Domestic bliss! In those days newspapers and magazines still boasted vast readerships. Cinema, like now, was a potent force within popular culture. And the burgeoning new medium of television – 11 per cent of American households already owned a TV by 1950, while a decade later 86 per cent of American families owned at least one set – was beaming non-stop advertising into the living rooms of ordinary people. During the Cold War, capitalism became an essential part of America's self-identity, in opposition to Soviet Communism. And for many the American capitalist way of life was a form of Utopia. The mood at the outset of the Sixties was one of optimism – reflected in the charismatic smile of JFK. This upbeat atmosphere was also apparent across the Atlantic in Britain, where, in 1957, Prime Minister Harold Macmillan remarked in a speech, 'Most of our people have never had it so good.' It was boom time in the West, and Warhol was one of many artists who sensed it. He was excited by the vitality of the new popular culture. This is why, in 1962, he painted a monumental Coca-Cola bottle in black casein paint on cotton in a style that can only be described as cool,

mechanical and impersonal. Without sounding too corny about it, Coke for Warhol was a symbol of America. When his friend Emile de Antonio, the American documentary director whose judgement Warhol valued greatly, first saw the artist's painting of 'a stark, outlined Coke bottle in black and white', he told him that it was 'remarkable – it's our society, it's who we are, it's absolutely beautiful and naked'. 'What's great about this country is that America started the tradition where the richest consumers buy essentially the same things as the poorest,' Warhol wrote in 1975. 'You can be watching TV and see Coca-Cola, and you can know that the President drinks Coke, Liz Taylor drinks Coke, and just think, you can drink Coke, too. A Coke is a Coke and no amount of money can get you a better Coke than the one the bum on the corner is drinking. All the Cokes are the same and all the Cokes are good. Liz Taylor knows it, the President knows it, the bum knows it, and you know it.' Twelve years earlier, in 1963, Warhol had told an interviewer: 'I think everybody should like everybody.' 'Is that what Pop Art is all about?' the interviewer responded. 'Yes,' said Warhol, 'it's liking things.' Pop Art, in Warhol's vision, was about expressing a new attitude. It was about, in the words of another of his friends, 'not being selective, just letting everything in at once'. This was the central trait of Pop Art that Kozloff had already pinpointed as early as 1962: anything goes.

There is a brilliant anecdote that sums up the new mindset. The American artist Jasper Johns, whose work in the Fifties had an incalculable influence upon the development of Pop Art, once heard that de Kooning had been badmouthing Leo Castelli: 'That son-of-a-bitch,' de Kooning supposedly said about the dealer. 'You could give him two beer cans and he could sell them.' Tickled by this remark, Johns, who was already making casts of light bulbs, decided to do just that. He cast a couple of Ballantine Ale

cans in bronze – and, he said, 'Leo sold them.' Perhaps, like Kozloff, you find this sort of impudent gesture irritating. Or perhaps, as it seemed to Warhol and his friends, Johns's cheeky and brazen way of approaching art sounds liberating. Either way, the fuddy-duddy, European stiffness and seriousness that used to be associated with high culture had been chucked out for good.

*

This didn't mean that Pop Art was some sort of dead-behind-the-eyes cheerleader for the capitalist system. It wasn't. Although it often seemed to play dumb, in reality it could be ingenious and intelligent. There are plenty of examples of Pop Art questioning, even criticizing, the wider culture rather than simply adopting an unthinkingly celebratory tone. Warhol's well-known *Death and Disaster* paintings offer quite a few: here are silk-screens of electric chairs and grisly car crashes, of suicides jumping from buildings, and racist police brutality in the Deep South. There's nothing shiny or utopian about these images. Instead they present a punchy, confrontational, polemical vision – a side to America that campaigning presidents such as JFK would shy away from in a speech. Crucial to their effect is the way that Warhol often repeated a grainy photograph from a newspaper against a brightly coloured background. The jaunty hues – orange, pink – are at odds with the gruesome subject matter of twisted bodies and mangled automobiles, or the scary apparatus of the death penalty. The repetition, though, reminds us that we are looking at imagery which we encounter in the media every day. Warhol's 'serial imagery' makes us think of a roll of film flickering quickly through a projector. Or of hundreds of thousands of newspapers spinning off printing presses, all splashed with the same eye-catching, garish picture. The mass media can be a relentless, overwhelming phenomenon – and sometimes, after seeing similar

deaths and disasters broadcast endlessly on the nightly news, we can, if we're honest, become immune to their effect. Repetition engenders numbness – or, as Warhol would put it, 'boredom'. Warhol was trying to articulate something about the mass media's deadening impact.

He was not the only Pop artist obsessed with the mass media. In fact, one of the paramount characteristics of Pop Art is that it doesn't depict everyday reality so much as representations of reality in the media. Lichtenstein didn't paint people; he portrayed characters in comic strips. Like Warhol, he also depicted motifs from advertisements for cheap products that he found in newspapers and magazines. Warhol painted movie stars not from life but as they appeared in publicity photographs. Many other artists associated with the birth of Pop Art produced work that was directly related to the overlooked, shop-worn, clichéd world of the mass media and commercial imagery. The American James Rosenquist painted wild juxtapositions of fragments of photographs found in popular magazines on a vast scale as though they were billboard advertisements. Tom Wesselmann actually wrote to companies asking if they could send him life-sized copies of particular billboards that had caught his eye in the street. When they arrived, he incorporated them into his Pop paintings, including some of his famous *Great American Nudes*. The eyeless face of *Great American Nude No. 53* (1964), for instance, is dominated by a large set of white teeth and full red lips cut directly from the head of a model in a billboard advertisement for Royal Crown Cola. (This is a Pop elaboration of de Kooning's idea of pasting found photographs of mouths into paintings of women.) Wesselman's compatriot Robert Indiana was obsessed with the appearance of lettering and trademarks. Richard Hamilton, the progenitor of British Pop, also made collages and paintings inspired by glossy printed ads.

This, then, is what people mean when they say that Pop Art was about the 'mediated image': rather than paint objects as they could be observed in reality, just as artists had done for generations, Pop artists preferred instead to depict their appearance in, say, advertisements. Consciously or not, therefore, the Pop artists were anatomizing the visual codes commonly found in popular culture. They looked to the street for inspiration and found it saturated with a distinctive, raucous, energetic visual style that they could draw upon – and that everybody could understand, not just the chosen few who were in the know about contemporary art. Pop was about democracy, about bringing art to the masses. Accordingly, the processes, methods and techniques that the Pop artists adopted were deliberately designed to imitate the strategies of cinema, commercial design or even cheap, throwaway newspaper ads. As a result, a lot of Pop Art shares a distinctive appearance. A classic work of Pop Art appears glamorous, spectacular, graphic, tawdry, synthetic – or all of these at once.

In part this is why Pop Art often seems so 'impersonal' and 'mechanical'. Yes, Pop artists wanted to get away from the sort of visible and spontaneous painterly gestures that had characterized Abstract Expressionism. This was a primary motive behind Warhol's amusing *Do It Yourself* series of 1962, based upon commonly available paint-by-number kits, which had been a craze during the Fifties: the joke here was that you didn't have to be an Abstract Expressionist master to produce a respectable fine-art painting – anyone could do it. Of course, Warhol's flip attitude must have seemed outrageous, even sacrilegious, at the time – especially to abstract painters of the older generation who believed that things like intuition, touch and pictorial decision-making could never be replicated so glibly or automatically. But in addition to repudiating Abstract Expressionism, Pop artists also wanted to produce art that would capture frankly something of the modern,

media-saturated world. Think for a moment about Warhol's many portraits of Marilyn Monroe. He wasn't interested in making traditional portraits designed to impart nuanced revelations about her character. No: he was fascinated by the bewitching alchemy of the mass media that could turn her into a sort of goddess, or, in Warhol's coinage, a 'superstar', simply by disseminating her image ad infinitum. This is why Warhol's source for all his portraits of Monroe was a single black-and-white still from the actress's film *Niagara* (1953): he was more intrigued by publicity than by psychology. Monroe was one face in Warhol's wider investigation into the nature of celebrity – a defining phenomenon of the modern era. Warhol, like Pop Art in general, wanted to replicate the ceaseless neon churn of our cyclical mass media.

*

When I started planning this book, it occurred to me that there would be little point in writing another textbook about Pop Art: enough of those exist already. Instead, as a starting point, I asked myself what sort of writing about art I most enjoyed reading. The answer was criticism with a biographical component. I like profiles of artists – perhaps because they foreground what artists actually have to say about their work. (This may also have something to do with my training as a journalist: sometimes a stylish and nimble snapshot can be more revealing than a long or theoretical overview.) One of my favourite books about art is *Life with Picasso* (1964), written by the artist's lover Françoise Gilot in collaboration with the critic Carlton Lake. Yes, at times it reads like a racy, scandalous, even lightweight and gossipy exposé – but it also remains an important source for Picasso's thinking about art. Like the best Pop Art, it communicates complex ideas in a straightforward but never simplistic manner. *POPism* (1980), Warhol's 'personal view of the Pop phenomenon in New York in the 1960s',

does something similar – with one important, and characteristic, difference: unlike *Life with Picasso*, *POPism* mostly keeps Warhol's thoughts about fine art to a minimum. Very little of the book is actually about the old-fashioned art of painting, while page after page is devoted to describing fashion trends and nightclubs in exhaustive detail. In true Pop style, Warhol hated the idea of getting 'heavy' or intellectual about art. With this in mind, I set out to write something immediate, not academic.

Moreover, while some of the chief practitioners of Pop are no longer alive – Warhol died in 1987, while Lichtenstein passed away a decade later – many of the artists who were central to the movement are still working. This, to me, seemed like reason enough to invite them to bear witness to the 'Pop phenomenon' more than half a century after its inception. These artists will not be with us forever, so if anyone wanted to record their thoughts about Pop Art in retrospect, they would have to do it now, before it became too late. Accordingly, I decided to focus upon the work of four different Pop artists, in the hope that, by studying the stories of their individual careers, the larger narrative of Pop Art would also become apparent. Instead of aiming to write something panoptic, I wanted to present a sort of alternative, fractured micro-history of Pop Art, via a succession of encounters and personal stories. With any luck, if the four smaller portraits in this book have some clarity, the bigger picture about Pop Art will come into focus too.

I selected my four artists so that each would represent a different facet of Pop Art. In the first chapter I meet the British artist Peter Blake, who, perhaps to his chagrin, remains best known to the public as the co-designer of the cover artwork for The Beatles' album *Sgt Pepper's Lonely Hearts Club Band* (1967). Long before he accepted this commission, though, Blake was one of a number of artists who had pioneered a form of Pop Art in London ahead of

Lichtenstein and Warhol on the other side of the Atlantic. In the
second chapter I switch the attention from London to New York,
which is often thought of as the cradle of Pop Art. In this section
I write about my encounter with James Rosenquist, the former
billboard-painter turned Pop artist who arrived in the city in 1955,
a few years after Warhol. Along with Jim Dine and Claes Olden-
burg, as well as Lichtenstein, Warhol and Wesselmann, Rosenquist
is considered one of the hardcore, 'big six' original artists associ-
ated with American 'High Pop'. He was linked with the movement
from the very beginning, participating in several crucial exhibi-
tions at the start of the Sixties. In those earliest days, the movement
still didn't even have a proper name, but was referred to by various
labels such as 'New Realism' and 'Neo-Dada'. By the time the
'Pop Art' tag had stuck, Rosenquist had already painted some of
its most iconic artworks.

Of course, London and New York were not the only centres of
Pop Art: Los Angeles also boasted an important Pop scene. This
was the city where Warhol had his first solo exhibition as a Pop art-
ist in the summer of 1962. That show was far from the only
landmark Pop exhibition in LA: towards the end of 1962, for
instance, the heiress and philanthropist Virginia Dwan staged an
important group exhibition in her gallery that featured the work
of Lichtenstein, Oldenburg, Rosenquist, Warhol and Wesselmann,
among others. The following year, the recently established Los
Angeles County Museum of Art hosted a major travelling exhibi-
tion called *Six Painters and the Object*. The six artists were Dine,
Lichtenstein, Rosenquist and Warhol, as well as Robert Rauschen-
berg and Johns, whose work during the Fifties had heralded the
advent of Pop. Concerned, though, that the exhibition was skewed
disproportionately towards New York, LACMA decided to stage
an additional section called *Six More*. This included artists such as
Billy Al Bengston, Mel Ramos, and the slightly older Wayne

Thiebaud, who was born in 1920 and raised in Long Beach, California. Thiebaud had trained as a commercial artist before painting what he called the 'tattletale signs' of American prosperity, including cakes, hot dogs and other ephemera that he saw displayed in the windows of diners and dime stores. Like all of the artists in the *Six More* section at LACMA, he was a key member of what would become known as West Coast Pop Art. Another of the West Coast 'six' was a young Pop artist with movie-star looks called Ed Ruscha, who would make his name by painting gas stations and monosyllabic words floating mysteriously against flat, monochrome backgrounds. Since the Sixties, Ruscha's reputation has grown to such an extent that while I was writing this book, one prominent art critic referred to him in a review as 'after Warhol, perhaps the most influential American artist of the past half century'. The third chapter of this book records the afternoon that I spent with Ruscha in his studio in Culver City on the outskirts of LA. Today he is considered not only a standard-bearer for the West Coast scene but also one of Pop Art's most stylish and profound practitioners, period.

In the fourth chapter I move away from the mainstream story of Pop Art to focus on artists who are less well known. Over the past decade or so, several art historians have challenged the orthodox narrative of Pop in the hope that in the future it will no longer focus so relentlessly upon the white American men who remain its biggest stars. One way that they have done this is by rehabilitating the reputations of a handful of women Pop artists. Often these artists enjoyed considerable success during the Sixties. For instance, the Paris-born Venezuelan sculptor Marisol Escobar, who found fame in New York for her roughly carved and painted wooden assemblages, once attracted as much publicity as Warhol: already by 1962, she had appeared in *Life* magazine's list 'A Red-Hot Hundred', alongside John Updike and Jim Dine. In part

Marisol won so much attention because she was catnip to the media: known as the 'Latin Garbo', she was beautiful, glamorous and enigmatically silent. 'On the New York art scene, the Marisol legend is nourished by her chic, bones-and-hollows face (elegantly Spanish with a dash of gypsy) framed by glossy black hair, her mysterious reserve and faraway, whispery voice, toneless as a sleepwalker's,' wrote the American journalist Grace Glueck in a big feature about Marisol that appeared in the *New York Times Magazine* in 1965. Note that 'faraway, whispery voice': to a degree, Warhol derived his infamously detached, idiot-savant-like persona from studying the way that Marisol presented herself in public. At the same time, though, Marisol was a celebrity because of the quality of her work: this, after all, is why three thousand people queued to see her solo exhibition at the Sidney Janis Gallery in New York on a single Saturday in the spring of 1966. Yet, over the ensuing decades, like many other women Pop artists, Marisol slipped slowly out of the picture – thanks, perhaps, to the intrinsically chauvinistic nature of the art-world system. The Bronx-born Pop artist Rosalyn Drexler, who is the focus of the second half of Chapter 4, suffered a similar fate. During the Sixties, Drexler, who in 1951 had pursued a brief career as a professional wrestler, touring America under the stage name 'Rosa Carlo, the Mexican Spitfire', participated in group exhibitions of Pop Art. At the start of 1964, for instance, she showed a number of paintings alongside work by Lichtenstein and Wesselmann in the *First International Girlie Exhibit* at New York's Pace Gallery. In the context of this book, then, Drexler represents the many early adherents of Pop Art who, for whatever reason, faced subsequent relegation to the sidelines. As an artist, she deserves much greater recognition.

With all four encounters, I have tried to communicate something of the experience of meeting the individual artists. Blake,

for instance, was down to earth and chatty – a friendly, open guide to a movement that was about inclusiveness and accessibility. Rosenquist, meanwhile, could be gruff: it would be a lie to say that I ever relaxed in his spiky company. Perhaps this was a product of age, but his attitude also seemed to me to encapsulate the pumped-up swagger of Pop Art, which can clobber you unexpectedly with surprisingly forceful imagery. Ruscha, by contrast, was so easy-going that it was tempting to forget about the riddling philosophical implications of his art. As for Drexler, she was a curious but beguiling mixture of defensiveness and dogmatic self-assertion. She was also delightful – animated by the unforgettable personality of a strong and original artist.

In each case, my primary concern was inviting the artists to talk about their breakthroughs into Pop, in the hope that they would reveal things that weren't known or said in their own words before. In doing so I believe that they help to illuminate how Pop Art emerged when and where it did – and why it took its distinctive shape. Warhol's influential friend Henry Geldzahler, a curator of twentieth-century art at the Metropolitan Museum of Art in New York, once described the origins of Pop like this: 'It was like a science fiction movie – you Pop artists in different parts of the city, unknown to each other, rising up out of the muck and staggering forward with your paintings in front of you.' Geldzahler was referring to New York, but the Big Apple wasn't the only place where Pop flourished. By making the contrasting stories of several different international artists emblematic of the movement as a whole, this book explores the fertile elements at work within the 'muck' of Western society that caused this generation of bold, sometimes brash and often rabble-rousing Pop painters and sculptors not only to emerge but also to change modern art for good.

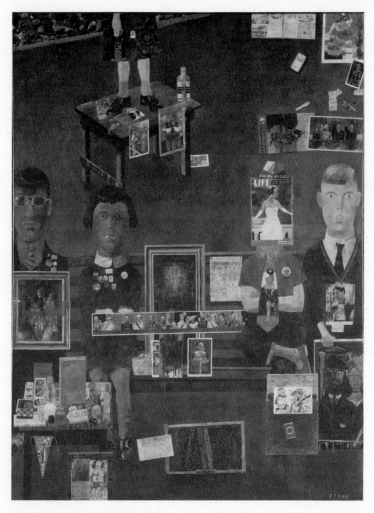

Peter Blake, *On the Balcony*, 1955–7

New Art for an Old World

Pop Art is often thought of as a quintessentially American phenomenon – and with good reason. After all, the imagery we most readily associate with it evokes American celebrities and products: Elvis Presley, Marilyn Monroe, and prominent members of the Kennedy political dynasty; hamburgers and hot dogs, cans of Campbell's soup, Ford automobiles. As a school of art, it is full of chutzpah, bound up with the boom in American affluence and self-confidence that followed the Second World War. This was the era when the country's rampant economic and political power grew unchecked, and the Machiavellian executives on Madison Avenue convinced the American population that success equalled a well-stocked refrigerator in a shiny modern kitchen, along with a gleaming new television set in the living room, and a Chevy in the driveway. Between 1947 and 1970, the real income of Americans rose by almost 80 per cent.

Moreover, if you had to point to a single image that captured the impetuous new impulse of Pop, you could do worse than select Lichtenstein's diptych *Whaam!* (1963), which, despite Herbert Read's protests, did end up in the collection of the Tate. A large painting more than 13ft wide, it depicts an aerial dogfight in the style of a comic strip. From the left, a heroic fighter jet screams into view, unleashing a rocket that thunders into an enemy aircraft, hits the bull's-eye, and causes an eye-catching, red-and-yellow explosion. The extended, onomatopoeic word of the

painting's title – not just 'WHAM' but 'WHAAM!' with its double 'A' and an excessive exclamation mark emblazoned in gigantic yellow type at the top of the canvas – could be the war cry for Pop Art generally, as the artists behind it, who were initially dismissed as 'vulgarians', stormed the citadels of high culture with the same unruly, take-no-prisoners vigour as the Visigoths who had sacked ancient Rome.

Lichtenstein, of course, was American, as were Warhol and Rosenquist, Wesselmann and Dine – in other words, all of the canonical trailblazers of Pop Art from the early Sixties, who were exhibited together as the core of the movement from the very beginning. Even Oldenburg, the son of a Swedish diplomat, who is often mentioned in the same breath as Lichtenstein, Warhol and the others, grew up in Chicago before settling in in New York, where he still has a studio. Pop Art, then, crackles with much of that cute, wisecracking, smartass, tough-guy attitude which was such an essential part of America's self-image in the twentieth century.

So for many people it comes as a surprise to learn that, if we want to get technical and pedantic about it, Pop Art was invented not in America but in Britain. That's right: Britain – the drizzle-drenched kingdom of politeness and understatement from the Old World, not the New. In the wake of the Second World War, Britain was still a bleak, benighted realm of austerity, rationing and ruined buildings destroyed by bombs. It didn't seem like the sort of fertile ground where the sapling spirit of Pop – sprouting movie stars, pin-up girls and neon lights – would necessarily take hold. And yet that is exactly what happened.

There are lots of stories about how and when the term 'Pop Art' came into being – competing creation myths, if you like, for the movement as a whole. But the artist Peter Blake, who was born in 1932 and is often described as 'the godfather of British Pop Art',

relates a pithy version that is compelling because he was an eye-witness. It was the late Fifties and Blake, a recent graduate from the Royal College of Art in London, had been invited to a dinner party thrown by the older British art critic and curator Lawrence Alloway. At this point, Alloway, who would later pursue a career in America, was still acting like a mentor towards young British artists such as Blake. Their dinner companions that night, for instance, included two of Blake's contemporaries from the Royal College: Robyn Denny and Richard, aka 'Dick', Smith. In those days, Blake, who was (and remains) a big vinyl aficionado, was a fan of American popular music, including jazz and the even newer sounds of rock and roll then being pioneered by, among others, Chuck Berry and Bo Diddley, whom he would later paint. During dinner, he started explaining to Alloway the effect that he was hoping to achieve in his own art by referring to this new music. 'I told him I was trying to make an art that works on the same level as music,' Blake recalls. 'So that if somebody listened to an Elvis Presley record, they could look at a picture by me of Elvis on the same level.'

Around this time, Blake did indeed start making pictures of Elvis. In *El* (1961), for example, he collaged a picture of the rock star, which he had found embellished with the lipstick imprint of a kiss in a fan's scrapbook, on to a panel of wood painted with the letters 'EL' above graphic diagonal stripes. *Got a Girl* (1960–61) contains two publicity photographs of Elvis alongside other pop stars such as Frankie Avalon and Ricky Nelson in a band of collaged elements at the top of the painting. Beneath them, in loud enamel paint, Blake fashioned a chevron pattern in red, white and blue. And in the top-left corner he stuck an actual record of the track 'Got a Girl' by American pop quartet The Four Preps. In the song, a frustrated boy sings about his sweetheart, who wears a locket containing pictures not of him but of her true crushes – the

pop stars who appear in Blake's painting. In a playfully self-conscious way, then, the imagery of the painting acts out the lyrics of the song on the record it contains: we could even think of the whole composition as a rudimentary precursor to the music video.

Of course, at the dinner party, Alloway had not seen any of these works of what would become known as British Pop Art, since Blake had yet to make them. But he was intrigued by what Blake was telling him all the same. 'You see, maybe the young teenage girl who loved Elvis would also love my picture,' Blake remembers saying. At which point, Alloway turned to Blake and said: 'What, you're trying to make a kind of "pop art"?' 'And my theory is that was the first manifestation of the phrase "Pop Art",' Blake says. 'Honestly, that's what he said – though no one else remembers. I mean, Dick isn't sure. Robyn kind of denied it. But I maintain that the phrase was invented to describe what I was trying to do.' Maybe, then, we should think of Blake not as the 'godfather' of Pop Art but as its paterfamilias? 'Yeah,' he smiles. 'The originator. One of the things I was trying to invent was the phenomenon of art becoming like popular culture.'

*

More than half a century on, it is impossible to verify Blake's story – though there's no question that it has a pleasing ring. Actually, Blake was not the first artist to incorporate imagery of Elvis Presley into his work: on the other side of the Atlantic, a little-known, mercurial and eccentric artist called Ray Johnson – who deserves much greater credit as one of the instigators of Pop Art – had already done so in a number of collages that date from the mid Fifties. In another collage from the same period, created in 1957, Johnson enhanced a photograph of the film actor James Dean by adding two examples of the Lucky Strike logo cut from real-life cigarette packets. These emerge from the sides of Dean's

head like the circular ears of the Disney character Mickey Mouse. In other words, this far-sighted image contained what would become the Holy Trinity of Pop Art imagery: a movie star, a consumer product and a reference to a cartoon. Still, it is significant that the other principal character in Blake's *Just So* story about Pop Art, aside from himself, is Alloway – since Alloway is often credited with coining the phrase 'Pop Art'. Certainly, Alloway pushed the idea that he had done so – referring to an article he had written for the journal *Architectural Design* in February 1958, which, he claimed, contained the first recorded use of the phrase 'mass popular art'. At the risk of confusing matters, it is worth pointing out that in this piece Alloway never actually used the term 'Pop Art'. Still, there is no question that Alloway was one of the 'originators', to borrow Blake's word, of the movement in Britain – thanks to his close involvement with a group of artists, architects and intellectuals from a slightly older generation than Blake's who began calling themselves the 'Independent Group' in the early Fifties. And it is with the obsessions and output of the Independent Group that the story of Pop Art – for all its competing origins and false starts – truly begins.

The Independent Group, or IG, was a small band of like-minded thinkers and forward-looking creative types who were excited by the novelties of modern popular culture. As well as Alloway and the architectural historian Reyner Banham, their ranks included the artists Richard Hamilton and Eduardo Paolozzi, the Constructivist painter Victor Pasmore, the sculptor William Turnbull, the architects Alison and Peter Smithson, the photographer Nigel Henderson and the collagist John McHale. Beginning in 1952, they met as a kind of informal cultural think-tank at the Institute of Contemporary Arts on Dover Street in London's Mayfair in order to discuss and share their passion for, in Alloway's words, 'mass popular art'. These gatherings, discussion groups and

lectures continued regularly, often on a monthly basis, until spring 1955. The sort of thing they talked about at the ICA encompassed a wide range of topics, from the aesthetics of aircraft and car design and the notion of proportion, to science fiction, Hollywood cinema, fashion magazines and the 'magical' strategies of advertising. The cerebral British artist Richard Hamilton, for instance, gave an address on American domestic appliances: 'I was fascinated by "white goods" as they were called,' he later said, 'washing machines and dishwashers and refrigerators – not simply as objects in themselves as designed objects, but also in the ways in which they were presented to the audience.' IG members began to tear advertisements out of magazines and tack them to the walls of their studios and homes. Americana was the order of the day.

Perhaps the best-known presentation, though, occurred early in the IG's history, in April 1952. Ever since he was a child, Paolozzi, who was born in Edinburgh to Italian immigrants, had collected pictures from popular magazines. In the late Forties, when he spent two years in Paris and became influenced by the Surrealists, he started pasting some of these images together to create energetic compositions full of incongruous juxtapositions. At this point, he didn't consider these collages finished works of art. Yet he kept them in scrapbooks for reference because he felt that they might provide him with inspiration in the future. Soon after the IG began meeting at the ICA, Paolozzi decided to show some of these scrapbook collages as a sequence, viewed quickly one after another, using an opaque projector. His presentation marked an important moment in the prehistory of Pop Art.

The imagery in the collages came from a wide variety of sources, including comics and trashy covers for sci-fi and pulp-fiction novels, as well as lowbrow magazines. Later, in the

early Seventies, Paolozzi reproduced some of the collages in an edition of forty-seven silk-screen prints and lithographs called *Bunk*. The title of the collection came from a particular collage in the original series, *Bunk! Evadne in Green Dimension*, in which the slogan 'BUNK!' is visible beside the bodybuilder Charles Atlas wearing leopard-print trunks. Both slogan and bodybuilder were culled from a black-and-white advertisement from 1936 in which Atlas, with glistening, slicked-back hair and a six-pack, promises: 'Nobody is just "naturally" skinny! Give me 15 minutes a day and I'll give YOU a new body.' In the pell-mell fantasy world of Paolozzi's collage, Atlas, like a version of King Kong terrorizing tiny citizens, holds aloft a small American saloon car containing a spick-and-span, regular family. Meanwhile, beneath the body-builder, we see vivid pictures – torn perhaps from a recipe book or some sort of lifestyle magazine supplement – of strawberries atop pastry and a big wodge of blueberry pie. To the left of Atlas, against a background wash of yellow, there is a linear diagram of the cross-section of an erect penis and testicles. At the base of the penis, in an oval, sac-like shape that is apparently part of the original diagram, Paolozzi wittily pasted a small black-and-white photograph of a pin-up posing in a slip – the cause, of course, of the erection. In other collages produced by Paolozzi around this time, we find similar ideas and motifs jumbled together like a kaleidoscopic reflection of the modern world: a tin of White Star 'fancy' tuna; a logo for the Dr Pepper soft drink; the cartoon character Minnie Mouse; a gleaming integrated oven-and-hob kitchen appliance from an advertisement; a photographic portrait of the Hollywood B-movie star Lucille Ball; and, generally, lots more cars, heaped plates of plentiful, mouth-watering food that look like garish still lifes, and sexy, glamorous women, often seen in skimpy underwear.

In part, Paolozzi was inspired by the émigré German artist

Kurt Schwitters, who arrived in London as a refugee during the war and made collages drawing upon American magazines and comic strips, as well as everyday detritus such as ticket stubs. Paolozzi's collages, though, are much sexier and more contemporary in feel and tone than Schwitters's compositions, which hark back to an earlier tradition of avant-garde twentieth-century art, with which he had been involved. Indeed, it is uncanny how prescient of cardinal Pop concerns Paolozzi's *Bunk* collages still seem today. Here is a checklist of just a few of them. The interest in commonplace commercial imagery. The awareness of the nexus in the mass media between commerce and sex. The obsession with all this shiny *stuff* promised by the siren song of advertising. The fascination with brand names, movie stars and cartoon characters. The use of frantic, almost aggressive collage and repetition as a means of replicating the bewildering experience of living in the modern world, which bombards us with throwaway imagery every day. And, arguably most important of all, the awakening of a new, vernacular, democratic and excitable spirit – typified by that slogan 'Bunk!' It is likely that Paolozzi was drawn to that word in particular because he was aware of something uttered by Henry Ford during an interview with the *Chicago Tribune* in 1916: 'History is more or less bunk. It's tradition. We don't want tradition. We want to live in the present.' It was a famous quote – and Paolozzi sensed that the attitude behind it was equally applicable to the sphere of fine art. In the aftermath of the atrocities and depredation of the Second World War, which had unleashed the spectre of mechanized genocide on a mass scale, it would no longer do for society – or, indeed, art – to cling to the old beliefs of history and tradition. It was time for a fresh start, for something new: an opportunity for art to live in the present. And since, as used by Paolozzi, this monosyllabic slogan referred as much to the contents of his collages as it did to the sense of history evoked by

Ford, that meant acknowledging the lurid, vulgar, often nonsensi-
cal flotsam and jetsam – the cornucopia of visual 'bunk' – that
now pervaded popular culture. A few years later, artists in both
Europe and America would start to cobble together sculptures out
of urban debris and discarded odds and ends. In doing so, they
were building upon the originality of the French Modernist Mar-
cel Duchamp, who earlier in the century had provocatively offered
up commonplace, mass-produced objects, including a bicycle
wheel, a bottle rack, a snow shovel and a porcelain urinal, as
'ready-made' sculptures – at a stroke transforming perceptions of
what art could be. As we shall see in the next chapter, the new
'assemblage' style of the Fifties, developed by artists such as Jean
Dubuffet, who coined the term, Joseph Cornell, Rauschenberg
and Schwitters, was an important precursor of Pop Art: its influ-
ence upon major Pop artists, including Rosenquist, cannot be
underestimated. For now, though, it is sufficient to point out that
the former IG member Alloway gave this innovative tendency a
name: 'Junk Art'. (He had a flair for providing art movements
with catchy identities.) And, of course, it is striking how similar
the word 'bunk' is to its cognate 'junk'. As Paolozzi, who was
himself an exponent of Junk Art, intuited, art in the Fifties that
wanted to seem fresh or contemporary had to draw upon aspects
of the everyday world that previous generations of artists had dis-
missed. Suddenly 'junk'/'bunk' was fashionable.

Paolozzi wasn't the only artist from the Independent Group to
make work that heralded Pop. In the late summer of 1956, a year
after the IG stopped meeting at the ICA, an exhibition called *This
is Tomorrow* opened at the Whitechapel Art Gallery in London's
East End. The original idea behind the exhibition had been to
encourage collaboration between painters, sculptors and archi-
tects – and, after months of wrangling and planning, the show
eventually consisted of twelve installations and displays, each

organized by a different interdisciplinary group. Today the exhi-
bition is principally remembered for the show-stealing, proto-Pop
installation of Group Two, dreamed up by the artists, and IG
members, Richard Hamilton and John McHale, and the architect
John Voelcker. Their section, which was designed so that entering
it would feel like stepping into a funhouse, offered a number of
elements from popular culture, including a working jukebox
playing hit records. There was also a large inflatable model of a
Guinness beer bottle – presented in a fine-art context eight years
before Warhol exhibited his sculptures imitating the cardboard
packaging of products commonly found in supermarkets, includ-
ing Brillo soap pads and Heinz tomato ketchup, in a gallery in
New York. Visible nearby in the Whitechapel was a life-sized
photographic reproduction of the notorious moment from Billy
Wilder's film *The Seven Year Itch*, released the previous year, when
Marilyn Monroe appeared with her skirts flying up. Monroe, of
course, would go on to become Pop Art's pre-eminent muse,
depicted most famously by Warhol in various guises and incarna-
tions – sometimes, even, as nothing but a repetitive grid of her
distinctive pouting lips floating in mid-air. Behind her, on the
same wall at the Whitechapel, was a 16ft-high section from a
gigantic poster for the sci-fi thriller *Forbidden Planet* (1956), bor-
rowed from the London Pavilion cinema at Piccadilly Circus, in
which the film's hero, Robby the Robot, could be seen clutching
a woman with large breasts and shapely legs wearing very little.
The sexy, effervescent atmosphere of the Group Two installation
felt like a carnival or a fairground.

Even more startling, though, in terms of its prophetic qualities,
was the small collage that Hamilton produced as a poster for the
exhibition. To make it, he used material from illustrated maga-
zines and other American ephemera mostly supplied by McHale,
who had spent time at the Yale School of Fine Art in New Haven

between 1955 and 1956. Titled *Just what is it that makes today's homes so different, so appealing?*, this collage was also reproduced in black and white in the catalogue – and it is now considered a landmark in twentieth-century British art. It is remarkable because, despite its early date, it looks like a sort of index or compendium of Pop Art's chief characteristics and motifs – featuring pin-up girls, advertisements, comic books, and so on. At the time, though, in 1956, it would be several years before the phenomenon of 'Pop Art' was recognized as a new, cohesive international movement. Admittedly, the phrase 'pop art' was already circulating informally in conversation among affiliates of the Independent Group. A year after making the collage, in a letter dated 16 January 1957, Hamilton would provide an early (if not the earliest) recorded written definition of 'Pop Art' to former IG members Alison and Peter Smithson, by compiling a list that contained the following descriptive terms: 'popular', 'transient', 'mass produced', 'witty', 'sexy', 'gimmicky', 'glamorous' and 'big business'. Hamilton's list remains an eloquent working definition of Pop Art today, even if he was using the phrase to refer to popular culture generally, rather than to a specific style of art. Somehow, Hamilton sensed the direction in which contemporary art was moving – and his collage was full of imagery that functioned like signs pointing the way.

He designed the collage as a parody of American advertising during the so-called 'Age of Boom' – the exploding, post-war consumer culture of the Fifties. Indeed, the title was supplied by the first line of copy in an ad that appeared on the inside cover of an American magazine called the *Ladies' Home Journal* in June 1955. The actual image of the ad, showcasing a new linoleum product for a company based in Pennsylvania called Armstrong Floors, provided the principal source for the setting of Hamilton's collage: a modern living room to die for, with swish designer furniture.

Into this space Hamilton inserted various figures and objects, including a covetable, large-screen television set. To the left, a woman (a maid?) wearing a red dress cleans a staircase using a vacuum cleaner with a surprisingly long hose – something that a black arrow containing the words 'ordinary cleaners reach only this far' draws our attention to, as it did in the print ad that formed the basis for this part of the collage. In the main area of the room, an attractive, semi-naked couple anticipate a pleasurable evening together of domestic leisure. The most prominent figure is the man – another champion bodybuilder, like the one in Paolozzi's collage *BUNK!* – nude this time apart from a pair of tight white trunks. In his right hand, in place of a dumbbell, he holds an enormous lollipop wrapped in red cellophane with the brand name picked out in yellow: 'Tootsie POP'. Because the lollipop, like a kind of magic wand, seems to bestow a name upon the entire movement, Hamilton's collage is often described as the first 'Pop' work of Pop Art, perhaps even its manifesto – despite the fact that a few years earlier, in a collage of 1947 called *I was a Rich Man's Plaything*, Paolozzi had included a disembodied hand pulling the trigger of a pistol to produce a puff of smoke containing the word 'POP!' As a smutty innuendo, in the manner of traditional British saucy seaside postcards, the bodybuilder in Hamilton's image holds his lollipop so that it appears to emerge from his crotch like an oversized red phallus pointing in the direction of his desire: his naked, big-bosomed squeeze sitting on the sofa to the right, wearing nipple tassels, glitzy earrings and a lampshade on her head. With her left hand she softly caresses the underside of one breast. If this is the first genuine 'Pop' artwork, then the couple are the movement's burlesque Adam and Eve, frolicking in a consumerist paradise of instant gratification. (And if they are Adam and Eve, the snaking hose of the vacuum cleaner must be the serpent.) In addition to the mod cons of television and vacuum cleaner, various items

representing the modern consumer economy surround them: a large tin of ham (a playful reference to Hamilton's own surname, like a sort of abbreviated signature), the impressive crest of the Ford Motor Company like a medieval coat of arms, a wind-up tape recorder, a black-and-white rug. On the wall an old-fashioned Victorian portrait hangs next to a larger picture of the front cover of a comic book called *Young Romance*: a detail that anticipates by several years Lichtenstein's earliest use of comic-book imagery in his Pop paintings. (The patrician ancestor in the portrait has a pronounced sneer on his face as he peers down upon the tawdry ephemera before him.) In a surreal coup, what at first appears to be the room's ceiling turns out on closer inspection to be an upside-down photograph of the Earth's curving surface, swirling with clouds, seemingly shot from outer space – a nod to the Cold War Space Race between the Soviet Union and the United States, but also a reminder of just how vain and pointless the concerns of human specks on Planet Earth can seem when viewed from afar.

Inevitably, there is satire here: all this materialistic, transatlantic clutter bemused Hamilton, and he offered up his preening paramours like modern-day incarnations of the protagonists in the eighteenth-century artist William Hogarth's satirical series *Marriage A-la-Mode*. But there is also a certain level of infatuation. Even though it would have been straightforward enough to find a home decked out in such luxurious fashion on the other side of the Atlantic, coming across one at this moment in austere Fifties Britain would have been much more difficult. As a result, the collage articulates a wider cultural fascination with the fantasy of the perfect American lifestyle. In this sense, it represents the 'have-nots' (the Brits) gazing with a curious mixture of adoration as well as scepticism at the 'haves' (the Americans). Reyner Banham summed up this attitude when he later described the excitement that post-war American magazines initially held for British readers. He and his

IG contemporaries were transported by their sumptuous printing methods and sensuous use of colour: 'Remember we had spent our teenage years surviving the horrors and deprivations of a six-year war. For us, the fruits of peace had to be tangible, preferably edible.' For many Britons during the late Forties and drab Fifties, the grass was greener on the other side of the Pond. And if the bountiful plates of colourful, glistening food in Paolozzi's *Bunk* collages are anything to go by, the oranges were juicier too.

*

One such covetous Brit was the young painter Peter Blake, who was also infatuated with American popular culture following the ravages of the war: in one of his most famous paintings, *Self-Portrait with Badges*, he appears dressed in American denim and sneakers. By the time he painted it, in 1961, he had been wearing denim for around a decade, ever since he'd noticed one of his teachers at the Gravesend School of Art, which he attended before studying at the postgraduate institution of the Royal College, wearing jeans after returning from a trip to America. To begin with, though, Blake had to improvise his own makeshift denim. 'We'd never seen jeans before,' he says, 'and you couldn't buy them. So I bought a carpenter's bib and brace – work overalls but with a top that went over your shoulder. And I cut the top off to make a pair of jeans. It wasn't quite denim but it was a similar kind of cotton material.' *Self-Portrait with Badges*, he says, 'was about the unusualness of wearing jeans and trainers – people only wore trainers then for sport. And the idea of an adult covered with lots of badges didn't exist. People would have thought I was mad.' Even as late as 1961, then, it still felt sufficiently different and exciting for a young artist to want to present himself in a painting as an acolyte of everyday American culture.

At the time of *This is Tomorrow* at the Whitechapel, Blake was

finishing up at the Royal College, where he had been studying painting since 1953, following a two-year stint in the RAF on National Service. Influenced by American Symbolic Realist painters such as Bernard Perlin and Ben Shahn, as well as by 'Outsider Art' (including a picture of the *Queen Mary* ocean liner by an anonymous Sunday painter that he had picked up in a junkshop near the railway station in Gravesend), Blake had already produced a number of distinctive, autobiographical pictures featuring children and their hobbies. These included *Children Reading Comics* (1954), in which a boy with a zit on his forehead and a blonde girl wearing an eye-patch sit on a bench holding up comics. (The painting offers an early, possibly unprecedented instance of comic strips intruding as subject matter upon fine art.) Meanwhile, in *ABC Minors* (1955), two schoolboys stand facing the viewer with ruffled hair and their hands in the pockets of their shorts, while wearing a number of badges that announce their membership of various clubs. One of these was the Saturday morning cinema club of the same name as the painting's title, of which Blake was a member during the war. Even *Self-Portrait with Badges* has a childlike quality: 'In a way I was sort of dressing up and becoming a child again, yes,' he agrees.

By 1956, Blake had also painted the bulk of his famous canvas *On the Balcony* (1955–7), his diploma composition at the Royal College that is now in the collection of the Tate, in which more children wearing badges sit on another bench surrounded by a welter of diverse imagery. There are covers of illustrated magazines such as *Life*, black-and-white 'photographs' of the royal family on the balcony of Buckingham Palace, a small version of Manet's 1868–9 oil painting *The Balcony*, which continues the title's theme, and the packaging of everyday products including a block of Red Seal margarine, a box of Kellogg's corn flakes and a packet of Lucky Strikes, which Blake painted shortly before Ray

Johnson also plundered the brand's logo. In a puzzling but bravura device that plays tricks with perspective, some of these images exist within the fictional logic of the painting – the framed replica of the Manet, for instance, is held by the schoolboy wearing sunglasses and badges pinned to his lapel sitting on the left. But others float illogically against the green patch of grass in the background, parallel to the surface of the picture, like tear sheets tacked to a noticeboard's baize. This so-called 'pin-board aesthetic' would become a hallmark of Pop Art. The painting – which, unlike Hamilton's *Just what is it . . .*, isn't actually a collage, but still borrows the scrambling effects of one – represents an important moment in the development of Pop Art in Britain: not least because it encapsulates a new, youthful spirit and rat-a-tat approach towards high and low culture, indiscriminately melding them so that Manet and margarine can coexist in a single space. Along with his other childhood pictures, such as *Children Reading Comics* and *ABC Minors*, this painting was something of a watershed for Blake. 'That was my initial contribution to Pop Art,' he says. Its message for younger painters was liberating, since it suggested that pretty much anything was now fair game as subject matter for a picture.

Blake's feelings about popular culture, however, differed significantly from those of the IG – something that was evident in their respective attitudes towards *Playboy*, the American adult magazine founded by Hugh Hefner in 1953. For Hamilton and his circle, publications such as *Playboy* were fascinating social documents to be analysed, interpreted and deconstructed. In 1961, Hamilton remarked: 'It is the *Playboy* "Playmate of the Month" pullout pin-up which provides us with the closest contemporary equivalent of the odalisque in painting.' Hamilton even anatomized this phenomenon in a painting from the same year titled *Pin-up*, in which a faceless, kneeling sex kitten wearing sheer

stockings and high heels removes her bra (actually a photograph collaged to the supporting panel) to reveal a pair of prominent breasts with a notable tan line, modelled in three-dimensional relief. The painting isn't meant to be titillating, necessarily, but a commentary on the objectifying effects of the sex industry or, worse, the social conditioning of housewives to conform to the sexualized stereotypes of advertising. It also alludes to the art-historical tradition of the female nude by presenting a voluptuous odalisque – a descendant of those sensual denizens of oriental harems painted by French masters such as Ingres – in a thoroughly up-to-the-minute manner, performing a striptease beside a telephone.

Like Hamilton, Blake was also aware of *Playboy* in the mid Fifties, but he consumed the magazine as a regular reader without self-consciousness or any intellectual agenda. 'I was never standing back,' he says. 'Someone from the Independent Group would go to America and bring back a bundle of *Playboys* and then they'd all look at the car advertisements or the refrigerators. Whereas if I were looking at *Playboy*, I'd be looking at the pretty girl in the centrefold, you know. So they were analysing and I was a customer for it.' When, during the Sixties, Blake painted his own series of buxom, bare-chested pin-ups, they appeared much more straightforwardly salacious than Hamilton's version – so much so, in fact, that over the years these pictures have often provoked feminists. Why did he paint them? 'Maybe it was for sexual gratification – and to do that in the art world was pretty unforgiveable,' says Blake, who once revealed that he did not lose his virginity until he was twenty-nine. (In an interview published in 2003, Blake explained that he remained a virgin for such a long time 'because of being scarred, and feeling I was ugly' – referring to a terrible bike accident that he suffered in the summer of 1949, when he lost three front teeth and required thirty-seven stitches.)

At the same time, Blake sees his paintings of pin-up girls as a development from the art produced by the IG: 'I suppose the change in attitude was to admit that it was a pin-up girl and not a comment on a pin-up girl.' Providing another example of this contrasting approach, he continues: 'In those days, my genuine interests were boxing, wrestling and speedway – but something that Richard [Hamilton] introduced me to was stockcar racing. Again, though, he probably saw something quite different in stockcar racing to me. He would have been outside it, looking at it and commenting on it – whereas I was enjoying cars crashing. So it was the difference between commenting on something and being in the middle of it. We were just different people.'

Blake recalls attending some of the Independent Group's seminars at the ICA. He even remembers giving a lecture there himself: 'It was a slideshow that was synchronized to music, so the story was told with slides and then you had a soundtrack of music that related to it directly – there was an image of the Queen, I think, and somebody singing "Her Royal Majesty". It was very primitive.' Blake may have misremembered the details of his involvement with the IG – the Italian-American performer James Darren's hit single 'Her Royal Majesty' wasn't released until 1962. Moreover, he was just as capable as Hamilton of engaging with art history – the various references and allusions in *On the Balcony* are evidence of this. Indeed, part of the charge of *On the Balcony* derives from the fact that its cast of ingenuous kids are much more knowing than they initially appear. This is why the schoolboy wearing sunglasses at the far left has a surprisingly adult face, while the girl sitting beside him smokes a cigarette: these kids are budding hipsters, conscious of the adult world in which they are growing up. Yet the general point still stands: the members of the IG were intellectuals and aficionados, enthusing about popular culture and even incorporating it into their work, but usually

inspecting it from a distance, like a scientist manipulating toxic material in the laboratory with a pair of tongs. Blake, meanwhile, had a much more instinctive relationship with popular culture. Put simply, he was a fan – and his autobiographical paintings of the Fifties and early Sixties record his passions and enthusiasms frankly.

*

To understand how this came about, it is worth investigating his past – something of particular interest, given that so many of his early paintings are about childhood. In addition, in several ways Blake's personal story is also representative of the wider narrative about colourful British Pop Art erupting from monochrome wartime hardship and austerity. The eldest of three children, Blake was born on the edges of Greater London in Dartford in Kent in 1932. His family was lower middle class: his father worked as an electrician, while his mother was a nurse. The most formative event of his childhood was the outbreak of the Second World War at the start of September 1939, little more than two months after he had turned seven. 'Everyone just panicked,' Blake recalls. 'On the street where I lived there was one Anderson shelter, so all the children were put into it – people just expected that the Germans would attack that afternoon. Although fleets of German aircraft didn't arrive that day, my mother, who was about to give birth to my brother Terry, organized for my sister, Shirley, and me to be evacuated privately – literally the next day.'

Peter and Shirley, who had never left Dartford before, ended up in the Essex farming village of Helions Bumpstead, where they were looked after by a homely woman called Mrs Lofts, an acquaintance of the Blake family whose husband was a steward in the navy, stationed at Greenwich. Mrs Lofts had two children: a son with a substantial collection of comics and a daughter with a withered hand. 'That was unusual to be living with somehow,'

Blake recalls. 'There was also a farm labourer and an old man who stayed in his room all the time. During the Boer War, he'd had his leg amputated on the field of battle, and he'd gone to this little village to hide himself away. So it was weird. Being in the country was very strange.' Looking back now, Blake doesn't remember his time with Mrs Lofts with much fondness. Sundays were especially painful. Mrs Lofts was a devout Christian, and she forced the children, dressed in their Sunday best, to attend church not once but three times every Sabbath. 'It was horrific,' Blake says. 'She didn't beat us, or anything like that, and we weren't abused. She fed us and was kindly. But I do remember one day that was pretty rough. Every day we were allowed to spend a penny in the sweet shop next door, and to earn it we had to go and collect molehills, since the soil from molehills was very good and could be spread on the garden. And one day, as my sister and I were sent off with two buckets to gather this molehill soil, I thought, "This is awful – I'm going to commit suicide." And I tried to strangle myself – which, of course, as a seven-year-old kid, you can't.' Slowly, though, he adjusted to his new life. 'There was an upside,' he says. 'In a way it was also a kind of paradise, because it was the countryside. I worked on the farm, I rode big shire horses, towards the end of my time there I drove a tractor – I must have been ten or something like that. I learned about the joys of the countryside: bird-nesting and making dams in streams. So it left me with a certain nostalgia – a damaged nostalgia.'

This period of Blake's life would have a significant impact upon his later paintings. Much of his art is characterized by a sense of nostalgia – for the evaporated innocence of childhood, but also for a bygone, pre-war age. 'For me, Pop Art is often rooted in nostalgia: the nostalgia of old, popular things,' he said in 1963. 'And although I'm continually trying to establish a *new* Pop Art, one which stems directly from our own time, I'm always looking back

at the sources of the idiom and trying to find the technical forms that will best recapture the authentic feel of folk pop.' Nostalgia is also an important aspect of Pop Art more generally. Take Warhol, who famously painted thirty-two *Campbell's Soup Cans* in 1962. By then, the red-and-white packaging of this brand of tinned soup had remained unchanged for decades. In interviews, Warhol frequently drew a connection between his *Campbell's Soup Cans* and the fact that his mother had often served Campbell's soup to him when he was a boy. For an American audience in the early Sixties, then, cans of Campbell's soup already had associations of nostalgia – which is partly what made them so appealing to Warhol as a subject. Even Warhol's portraits of film stars such as Marilyn Monroe and Elizabeth Taylor can be seen through the prism of nostalgia. Warhol was a sickly child, and in 1936, when he was eight, he was confined to bed for two months after he was diagnosed with a disorder known as St Vitus's Dance. This caused involuntary spasms and jerking movements for which he had been bullied at school. When he recovered, he started spending almost every Saturday morning at the cinema (like Blake). That year, after watching *Poor Little Rich Girl*, Warhol became obsessed with Shirley Temple. He wrote letters to her requesting photos and autographs. In reply he received at least one autographed picture, which has survived. The inscription on it reads: 'To Andrew Warhola from Shirley Temple.' ('Warhola' was the artist's original family name until he later dropped the final 'a'.) 'Actually, we were both in the Shirley Temple fan club,' Blake tells me. 'My mum joined me – though, unlike Andy, I never had a signed picture.' Warhol's boyhood passion for Hollywood never left him, even when he was a famous Pop artist. For all his veneer of deadpan apathy and sang-froid, Warhol – just like Blake – remained a fan of popular culture until his death in 1987.

Blake's wartime experiences shaped his art in other ways too.

Meeting the little girl with a withered hand and the amputee veteran of the Boer War in Helions Bumpstead sparked his lifelong fascination with people with unusual physical conditions. In the Fifties and Sixties, sideshow performers and mashed-up wrestlers with made-up names such as Baron Adolf Kaiser and Doktor K. Tortur became common characters in his paintings. For instance, in 1955, while he was still at the Royal College, Blake invented the eponymous character of his painting *Loelia, World's Most Tattooed Lady*, a squat figure in stockings and bejewelled panties with billowing locks of golden hair and stacks of blue designs inked on to her torso. Blake rendered her using oil paint and collage on a panel in the naive style of a weather-beaten board by a fairground painter advertising what used to be known as a 'freak show'. Loelia stands at the start of a long sequence of similar characters from both the circus and the wrestling ring in Blake's art. 'I still watch TNA wrestling on Tuesday evenings,' he tells me. 'It's a piece of drama. I absolutely love it.'

In addition, Blake's interest in collecting can be traced back to his time as an evacuee during the war. In 1943, he returned to Dartford before being evacuated again, this time to Worcester, where he stayed with his paternal grandmother – an eccentric woman who amassed a curious collection of around twenty aluminium meat grinders. 'If she saw one, she'd buy it,' Blake says. 'She also collected caravans. And cocktail cabinets – I mean very elaborate cocktail cabinets shaped like the prow of a yacht that would have lit up when opened, although they wouldn't have been plugged in.' Blake's own whimsical tendency to collect trinkets and bric-à-brac was inspired – if not consciously then at least genetically – by the example of his grandmother. Today, his expansive, two-storey studio in a converted Georgian stable in west London houses an enormous collection of folk art, Victoriana, and sundry curiosities from yesteryear that Blake

has compiled over many decades. The first item that he bought was the picture of the *Queen Mary* that he had come across in a junkshop while he was studying in Gravesend: 'It has a primitive quality that I liked at the time,' he explains. Since then, over the years, anything and everything has caught his eye: striking bits of driftwood, carved horses from old fairground carousels, stacks of vintage vinyl, which he plays on an old Pioneer turntable while he is working. His studio is now a sort of museum to the overlooked and the forgotten, housing his 'collection of nostalgia', as he calls it, boasting countless examples of the folksy objects that he has celebrated so frequently in his paintings. 'When I moved in, it was never meant to be a museum. But the collection evolved, and by the time I started grouping things together, it did become a kind of museum, yes. The main thing that unifies it is that everything in it I collected personally. In a sense, it is like a big self-portrait.'

When the war ended, Blake soon arrived back in Dartford. Aged thirteen, and starved of fun for much of the Forties, he plunged with gusto into the alluring world of popular entertainment. Encouraged by his mother, Blake rediscovered his old passion for the cinema. He started going to weekly wrestling matches at Bexleyheath Drill Hall. He watched motorcycle speedway racing in West Ham, and supported Charlton Athletic football club. He was also interested in popular music: 'My dad loved swing music and I liked modern jazz. So one of the things I would do just after the war, along with wrestling and speedway and everything else, was go to the local jazz club, which was called the Dartford Rhythm Club.' Unusually shy, Blake was a solitary teenager, so he pursued all these interests either with his mother or by himself – which perhaps explains why they seared themselves with such force upon his imagination. All of the pastimes that he enjoyed during these early years helped to fashion his sensibility.

They would also become essential elements in his art. And Blake's experience was not unique. During the Fifties many other fledgling artists who would later be linked with Pop Art were consuming popular culture with similar voracity. As one of them – a young painter from Birmingham called Peter Phillips, who would arrive at the Royal College of Art six years after Blake – put it in 1964: 'My awareness of machines, advertising, and mass communication is not probably in the same sense as an older generation that's been without these factors; I've been conditioned by them and grew up with it all and use it without a second thought . . . I've lived with them ever since I can remember and so it's natural to use them without thinking.' Just like Blake, Phillips was differentiating his own attitude towards 'machines, advertising, and mass communication' from that of the Independent Group.

At this point, it had never occurred to Blake that he might become an artist – though it was dawning on him that he was a gifted draughtsman. After failing to get into the local grammar school, he was accepted by the Junior Art School of Gravesend Technical College, where, as well as life drawing, he studied silversmithing, typography and graphic design. Typography is an important part of many of Blake's paintings, which ape the handmade quality of lettering found on circus and fairground hoardings and signs. 'The fact that I was a half-formed graphic designer who knew about lettering informed what I became,' Blake tells me. More broadly, it is also significant that he gained experience as a commercial artist. (Commissions such as designing illustrations for the *Sunday Times Magazine* as well as book covers, including this one, have been an important source of income for Blake throughout his career.) The same was true of lots of artists associated with Pop – not least Warhol. Throughout the Fifties, before he found any success as a fine artist, Warhol achieved considerable

acclaim working as a commercial artist in New York, having arrived there by train from Pittsburgh at the old Penn Station in the summer of 1949, when he was just twenty-one years old. His delicate pen-and-ink drawings for advertisements in newspapers and magazines won him several awards and blue-chip clients such as Tiffany & Co., as well as financial security: his income skyrocketed, and by 1960 he could afford a four-storey brownstone townhouse on Lexington Avenue. It used to be the case that Warhol's metamorphosis into a Pop artist in 1960 was considered a clean break with his past. More recently, though, art historians have stressed the continuity between Warhol's commercial work and his Pop output. In particular, as a budding commercial artist, Warhol perfected his trademark 'blotted-line' technique – a basic form of printmaking that involved transferring the inked lines of a drawing rendered on a water-resistant surface such as tracing paper on to a sheet of more absorbent paper by 'blotting' this second sheet on top of the first one. The printed look of the final image pleased Warhol – long before he turned to screen-printing as a way of revolutionizing traditional painting as a Pop artist. During the Fifties, Blake even kept an eye out for Warhol's commercial work. 'I watched out for his drawings in American fashion magazines and then I'd cut them out,' he says.

In 1950, Blake – who now aspired to become a painter but was under pressure from his tutors at Gravesend to pursue a more sensible career as a graphic designer – applied to study graphics at the Royal College of Art. In support of his application, he sent in a small oil-on-cardboard portrait of his sister, Shirley. To his surprise, the College, spotting its promise, offered him a place on the painting course. Before he could start, though, he was called up for National Service. 'Very few artists did it,' Blake tells me. 'A lot pretended they were gay, which was illegal then, so they weren't allowed to do it because of that. A lot more pretended they were

mad, and they took some kind of substance, which meant they were erratic. One or two shot a toe off, which I wasn't prepared to do. And eventually I thought, well, it's only two years – and I've got my place at the Royal College when I come out. It was too much bother not to do it.' For the next couple of years, Blake served as a teleprinter operator in the RAF, stationed mostly in camps dotted around the West Country. He also spent time in Northern Ireland – 'It wasn't a war zone then,' he says – and Lincolnshire. One benefit of National Service was that his diffidence disappeared: 'The RAF was no place to be shy.' During this period, Blake also began a self-portrait wearing his regulation blue RAF jacket over harlequin trousers. In the painting he stands against a wall that has been pasted from top to bottom with posters advertising circus acts. It was a moment of self-revelation, announcing the private passions that would surface in his art. At the same time, this seemingly unaffected image of a kid who happens to be a fan of the circus also contains sophisticated allusions to modern art – especially the example of Picasso, who was also fascinated by the circus, and painted himself in the guise of a harlequin. Blake often asserts that he did nothing but paint the things he knew about – but we shouldn't forget that he was as familiar with the exotic tumblers and artistes of the big top in Picasso's Rose Period paintings as he was with the circus in reality.

At the Royal College, Blake began his series of paintings about childhood. It was a heady, energizing period in his life, and Blake attributes some of this to the social changes that occurred after the war. 'Now the war was over, it was a new start,' he says. 'And there were people like myself going to art school who wouldn't have had the opportunity before the war. Suddenly, working-class people were taking photographs too – like David Bailey and Terence Donovan. And you had [working-class] actors invading a world that they wouldn't have been allowed to be part of before

the war. There were grants available – so I was financially able to go. So suddenly things were different. New kinds of people were coming into the art world, bringing their own information.' These days it is a cliché that working-class talent can invigorate insipid high culture by adding much-needed energy. But, in the case of the emergence of Pop Art in Britain during the Fifties, this was an important element in the story. And Blake was one of the most prominent examples of the 'new kinds of people' coming into the British art world – bringing 'information' about his own life, such as his enthusiasm for the circus. In 1957, the year after he graduated from the Royal College, Blake produced an audacious picture called *Knife Thrower's Board* that is often grouped together with his earlier circus pictures such as *Loelia, World's Most Tattooed Lady*. Really, though, it should be considered among his first 'proper' works of Pop Art – since it marked an important depart-ure. The focus of the painting is a life-sized pin-up of the screen siren Brigitte Bardot wearing a scandalously short corset with a tutu-like fringe. This pullout pin-up was published in several sheets by a popular weekly tabloid magazine called *Reveille*. Blake pasted the various sections on to hardboard before covering the visible parts of her flesh with (now faded) pink tissue paper and touching up her face and hair by hand with paint. In the finished picture, Bardot is surrounded from head to (almost) toe by floating images of ornate, nineteenth-century cutlery – representing the 'knives' hurtling towards the glamorous assistant in the circus act implied by the title. Blake sourced all this tableware from the cut-lery section of the catalogue for the Great Exhibition of 1851 – and the presence of forks as well as knives provides a visual joke: Bar-dot is delicious enough to eat. If the effect of this image had overtones of nostalgia – thanks to the Victorian silverware, and the allusion to a time-honoured circus act – then the approach was strikingly modern. As well as providing a likeness of the French

actress, the pin-up of Bardot is meant to be 'understood' as an actual object from the real world, a bit like one of Duchamp's ready-mades: in the context of the picture, just as in reality, the pin-up is a pin-up, and nothing else. In the years to come, as Blake's work became more and more purely Pop, this would be one of his chief modi operandi: incorporating ephemera such as photographs and postcards into his collaged constructions, and deliberately avoiding any semblance of that exquisite painterly touch of which he had already proved himself capable. The top of *The Fine Art Bit* (1959), for instance, features a band of postcards depicting famous works of art. Blake collected most of these images while travelling through Holland, Belgium, France, Italy and Spain in 1956–7, having won a Leverhulme Research Award to study popular art. Beneath the postcards, occupying the majority of the picture, are several colourful horizontal stripes painted in bold enamel paint, referencing the appearance of flags or street signs: bright and brash, they are a playful rejection of the sort of considered brushwork often found in traditional works of art like those reproduced in the postcards above. *Kim Novak Wall*, from the same year, also combines collage – this time enlarged photographs from a publicity still of the American film star – with expanses of enamel paint on hardboard. *Girlie Door*, again from 1959, was perhaps Blake's most 'Pop' work to date, featuring more collages of pin-ups and contemporary film stars – including Novak (once more) and Marilyn Monroe in Billy Wilder's *Some Like It Hot*, released the same year as the picture's creation – pasted to a *trompe-l'œil* red door. In *Locker* (1959), Blake used yet more pin-ups, this time stuck to an actual military locker that he had chanced upon in a junkshop on Chiswick High Road in west London and that reminded him of his time in the RAF. Unlike some modern art – such as, say, the refined yet hard-to-fathom compositions of early Cubism, which mostly appealed only to a small and

exclusive audience of clued-in connoisseurs – there was nothing overtly intellectual, detached or 'difficult' about work like this: *Locker* served itself up without artfulness or guile, transporting the viewer with memorable immediacy into the bedroom (and private fantasies) of male adolescents and young adults. It had the snap, attitude and inclusive, democratic spirit we now associate with Pop: it was art, in other words, for 'new kinds of people'. Blake's pictures inspired by teenage fans who enjoyed rock and roll – *El*, *Got a Girl*, *Bo Diddley* (1963), and so on – were within touching distance.

*

Today, Blake occasionally worries that some people may dismiss his work, which often happens to be humorous, as whimsical and lightweight. At the same time, if this is the case, he suspects that by consistently accepting so many commercial commissions over the decades he is probably in part to blame: 'I've got this history of being a rogue graphic designer,' he says, 'and I've always been outside the painting world in a curious way. On one level I haven't been taken seriously because of this – but it's the bed I've chosen to lie in. I mean, you can't do record covers and expect to be on the same level as someone like Frank Auerbach or Lucian [Freud] or Leon [Kossoff].' (It is easy to forget that Blake overlapped at the Royal College with the highly regarded School of London painters Auerbach and Kossoff.) Still, during our conversation, Blake is also keen to emphasize that on several occasions in the Fifties and early Sixties he did come up with devices or ideas that pre-empted the advances of other Pop artists by several years. The prominence of comics, anticipating Lichtenstein, in *Children Reading Comics* is one example of this. 'I also did a straight watercolour of the front of a comic book before Lichtenstein,' Blake tells me, 'but sadly it went missing.' Another (surviving) example is a sculpture that he worked on in 1961. *Captain Webb Matchbox* is a swollen wooden

simulacrum of a real-life Bryant & May matchbox, printed with a
red design celebrating the athletic prowess of one Captain Webb,
who was the first man to swim the English Channel, achieving the
feat in less than twenty-two hours in 1875. In one sense, this work
is typical of the nostalgia that marks much of Blake's output. After
all, Bryant & May had sold Captain Webb matchboxes for dec-
ades, and Captain Webb himself was a popular figure from a
different age – just look at his archaic, full-length swimwear as he
stands stiffly, posing like a classic Victorian hero, with the white
cliffs of Dover and the waves of the Channel visible behind him.
Moreover, the execution of the design on Blake's sculpture is
deliberately loose and painterly – a style that purveyors of 'pure'
Pop in America would downplay in the coming years, as they
sought to rid their work of any evidence of the artist's hand. In
another sense, though, Blake's *Matchbox* was surprisingly
forward-looking. Three years after Blake conceived it, Warhol
unveiled his famous *Brillo Boxes* – enlarged imitations of the pack-
aging that encased a cheap brand of soap pads commonly available
in supermarkets. The painted logos on Warhol's boxes are much
crisper and more mechanical than the one in Blake's design. In a
sense, therefore, they are also that bit more courageous, since
nothing about the *Brillo Boxes* tries to remind the viewer that they
are works of art, which is the function of the loose brushwork in
Blake's *Matchbox*. Still, the concept behind both works is surpris-
ingly similar. And, as the words 'British Made' visible at the
bottom of the label on Blake's *Captain Webb Matchbox* suggest, the
Brits got there first.

By the start of the Sixties, Blake had fashioned and fine-tuned
his mature Pop style. As he approached thirty, the 'godfather' of
British Pop was now old enough to have influenced a number of
'godchildren'. A younger generation of painters was emerging,
and, once again, the seedbed for British Pop was the Royal College.

In 1959, the institution welcomed a blazingly talented intake that included Derek Boshier, Allen Jones, R. B. Kitaj, Peter Phillips, and a witty, charismatic, working-class kid from Bradford, born five years after Blake, called David Hockney. Like Phillips, who also came from England's industrialized North, Hockney was a prime example of what Blake describes as 'the new kinds of people' coming into the art world after the war. Writing in a wonderful, effervescent book called *Private View*, which was first published in 1965 with photography by Lord Snowdon documenting, in the words of its subtitle, the 'lively world' of Britain's burgeoning art scene, Bryan Robertson, then the director of the Whitechapel Art Gallery, explained the impact of fresh blood like Phillips and Hockney: 'These young artists from the provinces bring to London a built-in, edgy, sceptical intelligence and a particular awareness of fashion and "what's in the air" which give at once an extra drive to their work and a marked irreverence towards prevailing standards and aesthetic issues.' Where once British art had felt stuffy, insular and decorous, now, thanks to people like Hockney, it was becoming insouciant and up to date, even rebellious. In 1960, Patrick Caulfield joined Hockney and his peers at the Royal College – and already by 1961 they had all shown together (alongside Blake) at the annual *Young Contemporaries* exhibition, where it was apparent that an important new artistic movement had arrived. As a group, they were jaunty, exuberant and irreverent – and excited by the popular culture of America. Their ringleader was Kitaj, a slightly older American, born the same year as Blake, who had served in the US Army and under the terms of the GI Bill had studied at the Ruskin School of Art in Oxford before fetching up at the Royal College. In their idiosyncratic ways, all of these fresh-faced artists were exploring artistic territory recently charted by Blake, who, along with Hamilton, was arguably the first to unfurl the Pop Art banner. Boshier

painted cheap everyday products, including tubes of toothpaste, airmail envelopes and boxes of Kellogg's cereal (something that Blake had included a few years earlier in *On the Balcony*). Jones created a series of paintings inspired by London's distinctive red double-decker buses. He also painted freely about feeling attracted to the opposite sex in *Thinking about Women* (1961), in which fantastical enchantresses cavort above a man's head like the contents of a thought bubble in a comic strip, and *Bikini Baby* (1962). With its prominent red door in the background, the latter owes a debt to Blake's *Girlie Door*. Phillips, too, depicted pin-ups: *Forces Sweetheart – Synchronised* (1962), for instance, contains four of them, presented within blue stars in a band that runs through a composition dominated by strong, graphic stripes in various colours, recalling Blake's enamel paintings in a similar vein. Meanwhile, the protagonists of Phillips's *For Men Only – Starring MM and BB* (1961) are Marilyn Monroe and Brigitte Bardot. 'I wouldn't analyse these images in a way that an artist of an older generation might,' Phillips wrote in 1964, presumably alluding to the intellectual attitudes of the Independent Group.

These days, Blake is keen to emphasize the differences between his work and that of his British Pop contemporaries: 'For instance, Derek [Boshier],' he says, 'was very interested in the Space Race at the time, and I couldn't have been less interested in that – I've never done anything about it. In some sense, art is always autobiographical, and as well as the Space Race, Derek was interested in international politics. So his early, '61 pictures are about what was happening in Russia and going to the moon. I'd say that we all did different things. Some artists' intentions are to be political. Others are to reminisce. Others are to be angry. I mean all painters have a different reason to paint. Mine is to make magic.' At the same time, he concedes, 'Their contribution was enormous.'

One of the biggest contributions, at least in terms of the public's

awareness of his work, came ironically enough from the artist who most rapidly distanced himself from Pop: Hockney. A preternaturally gifted draughtsman, who would soon start bleaching his hair with peroxide and wearing a gold lamé jacket, Hockney early on produced a few works that most people now consider Pop. One of these is *Tea Painting in an Illusionistic Style* (1961), the last in a series of three paintings of Typhoo Tea packets that Hockney made while he was still a student at the Royal College, following a spell experimenting with abstraction. To create the picture, Hockney started by preparing an unusually shaped canvas that was not a traditional rectangle, so that, when painted, it would resemble a box of Typhoo Tea with its lid flipped open. He then reproduced the design printed on the sides of a nondescript packet of tea in a deliberately indistinct, painterly and, despite the title, not especially 'illusionistic' manner – comparable to the style on the side of Blake's *Captain Webb Matchbox* from the same year. In fact, Hockney seemed to be at pains to emphasize the artist as the intermediary between a real-life Typhoo Tea packet and the finished painting – so much so that, as well as favouring a loose painting style, he also included a misspelling of the word 'tea' as 'tae', and introduced a ghostly, naked figure that threatened to obscure the brand's central logo altogether. 'This is as close to Pop Art as I ever came,' Hockney later said, acknowledging that by choosing a mundane brand of tea as a motif, he was performing a classic Pop manoeuvre. (Around this time, he also painted a wall calendar and boxes of Alka-Seltzer.) Moreover, it is worth pointing out that, according to Hockney, Typhoo Tea was his 'mother's favourite', so in some respects this was a work of nostalgic Pop akin to Blake's affectionate and tender childhood paintings or Warhol's *Campbell's Soup Cans*. At the same time, like Hamilton attempting to fashion a classic odalisque out of a pullout pin-up, Hockney understood that he could use ordinary packets of tea,

which he encountered every morning alongside tins and tubes of paint in the Royal College, to construct a traditional still-life painting with a very contemporary feel. This doublethink would prove characteristic of a lot of Pop Art both in Britain and in America.

★

By 1962, Pop Art was recognized as a fully fledged and controversial phenomenon on both sides of the Atlantic. From the off, it attracted a great deal of press interest. In Britain, the first issue of the new, full-colour *Sunday Times Magazine* contained an article featuring Blake's work. That same year, Blake was one of four young artists to appear in *Pop Goes the Easel*, Ken Russell's, impressionistic documentary about Pop Art for the BBC's *Monitor* strand. (The other artists were Boshier, Phillips and a young woman, also a graduate of the Royal College, called Pauline Boty, whom we shall meet properly in a later chapter.) In 1963, Blake married the American artist Jann Haworth, who, like Boty, also steered the course of Pop Art in Britain. Throughout the Sixties, Blake and Haworth continued to make Pop Art, exhibiting at the fashionable London gallery run by the hedonistic Old Etonian Robert Fraser, aka 'Groovy Bob', who was friends with pop stars, including The Beatles and The Rolling Stones. In fact, it was Fraser who won Blake and Haworth the commission to design the cover for The Beatles' *Sgt Pepper's Lonely Hearts Club Band* – a collaboration that remains Blake's (and Haworth's) most famous work of art. 'In a way I'm enormously proud of it, but in a way it's an albatross,' says Blake, who usually refrains from talking about it. 'You know, every article about me mentions *Sgt Pepper*. There was a point when it came up and my mouth just went to sawdust and I couldn't speak about it again.' Why does he hate talking about it so much? 'We are talking about it now, aren't we?' he

shoots back, suddenly shrewd and guarded. Then he relaxes again. 'There are many reasons. Financially we were paid very little – actually, we were paid less than the people who came in to arrange the flowers. And I signed a contract that signed away any royalties as well as copyright – until quite recently I've never been able to use it in any other way. So it was a raw deal. It doesn't matter any more – I mean, it's coming up to fifty years ago – but for a long time I felt that some knight in shining armour would come along and say, "Oh, Pete, you had a raw deal there. Let's give you a bonus." But no one ever did.'

Jaded by the cut-and-thrust of London's art world, and receptive to the idea of an alternative way of life following the birth in 1968 of their first child, Juliette Liberty, Blake and Haworth decided to leave the capital altogether. 'The main years of Pop Art were '59 to '64,' Blake tells me. 'I think then it should have stopped. You know, everyone should have got on with their lives.' At the end of 1969, Blake moved with his family into a converted railway station in the West Country, where they would live for most of the Seventies. He stopped making Pop Art and started painting fairies. He also made a beautiful suite of illustrations to Lewis Carroll's *Through the Looking-Glass*. Blake wasn't the first artist to renounce Pop Art. Several years earlier, when the movement was still in its pomp, Hockney, who had never warmed to Pop Art as a concept, left London and visited California for the first time. He became so besotted with the place that he ended up living there permanently for much of the Sixties, painting, in the words of one art historian, 'poolside idylls' that were arguably yet another permutation of the Pop movement. And, like Hockney, it is to America that we must turn next.

James Rosenquist, *Zone*, 1960–61

The New Vulgarians of New York

If London witnessed the invention of Pop Art, New York was the city where the movement really bloomed. To begin with, in '60 and '61, Pop's tentative buds and shoots were seen in Manhattan by only a handful of the artists' closest friends, including the confidantes to whom Warhol showed his earliest paintings of comic-book super-heroes such as Superman and Popeye. These hand-painted works, which in retrospect look somewhat hesitant compared with his later silk-screens, included the five pictures that Warhol displayed in the window of the chic Bonwit Teller department store near the intersection of Fifth Avenue and East 57th Street for a single week in April 1961. Most of the thousands of passers-by glancing in at the arrangement would have registered little besides the mannequins in the foreground wearing high-end women's clothes. The gaze of a few might have lingered momentarily upon the imagery at the back. But only the tiniest minority would have looked at these paintings and sensed a seasonal change in the way that art was being made. Anyone who did was like a keen-eyed walker spotting the earliest flowers of spring following the big chill of the Fifties, when figurative representation had been frozen out by abstraction. *Nancy* (1961), a painting by Warhol of a chubby, eight-year-old cartoon girl who was the eponymous character in a comic strip, makes clear that at the outset of the Sixties, in America at least, what would become known as Pop Art could still expect a frosty reception. In the picture, which functions as a sly self-portrait thanks to

the slang double meaning of the character's name that flags up the artist's homosexuality, Nancy has just stepped out of her house on to a patch of snow. 'Brr,' she says in a speech bubble above her head, as she folds her arms against her body to stave off a shiver. 'My snow suit isn't warm enough . . . I'll put on a sweater too.'

A few months later, shortly before his thirty-eighth birthday, Lichtenstein also decided to brave the elements and take his first Pop paintings of cartoons and commercial imagery out of the warm sanctuary of his studio. Early in that autumn of 1961, he secured five of them to the roof of his station wagon and drove from New Jersey, where he taught art at Douglass College, which was part of Rutgers University, to New York. His friend Allan Kaprow, a charismatic colleague who also taught at Rutgers, had brokered a meeting between Lichtenstein and a director at the Leo Castelli Gallery called Ivan Karp. Kaprow was an avant-garde performance artist and theorist in his own right: his activities during the Fifties played a decisive role in preparing America for the wild novelties of Pop. In an influential essay called 'The Legacy of Jackson Pollock', published two years after the Abstract Expressionist was killed in a car crash in 1956, Kaprow called for a new sort of art inspired by 'the space and objects of our everyday life': 'paint, chairs, food, electric and neon lights, smoke, water, old socks, a dog, movies'. With hindsight, it reads like a manifesto for the nascent Pop Art movement.

When Lichtenstein arrived at Castelli's gallery, which was situated four flights up a townhouse off Fifth Avenue on East 77th Street, he spotted Karp through the doorway talking to a group of students. Tongue-tied and wary of showing his work to so many people, he loitered outside until Karp joined him in the foyer. Usually Karp was confident and self-possessed. But when he saw Lichtenstein's 'peculiar and aggressive' paintings, as he later described them, he was dumbfounded. After a while he told Lichtenstein: 'You really can't do this, you know.' Karp recalled:

'It was just too shocking for words that somebody should celebrate the cartoon and the commercial image like that. And they [Lichtenstein's paintings] were cold and blank and bold and overwhelming. So I said, "Well, look, I'd like Castelli to see these. They're pretty unsettling." We kept four of them.'

Karp's language is revealing: towards the end of 1961, Lichtenstein's paintings appeared 'peculiar', 'aggressive', 'shocking', 'cold', 'blank' and 'overwhelming'. And if all this came from the mouth of one of Pop's foremost champions, just imagine what enemies of the movement had to say. One of them, as we have seen, was the critic Max Kozloff, who attacked the new style in 1962: 'Art galleries are being invaded by the pin-headed and contemptible style of gum-chewers, bobby-soxers, and worse, delinquents.' Yet, as Kozloff's remark implies, this 'pin-headed and contemptible style' had gone from nought to sixty in New York with remarkable acceleration. In 1961, Lichtenstein was still an unknown. By the following year, after his first solo exhibition at the Leo Castelli Gallery had opened in February, art like his could be seen right across the city.

Towards the end of 1962, for instance, Lichtenstein and Warhol were both included in the landmark *International Exhibition of the New Realists* at the blue-chip Sidney Janis Gallery. This show was noteworthy for a couple of reasons. Firstly, with fifty-four works of art, it was big – so large, in fact, that it colonized a, temporarily rented space nearby. The twenty-nine selected artists came from all over the world and included Peter Blake and Peter Phillips (the reviews for the Brits were so bad that Blake refused to show in New York again for decades, until 2002), as well as a group of French and European artists who were collectively known as the Nouveaux réalistes. These artists, including Arman, Martial Raysse and Jean Tinguely, had signed a manifesto drawn up in 1960 by the French critic Pierre Restany, and their work is often

broadly described as a European equivalent of Anglo-American
Pop Art. In other words, the Sidney Janis show was the first exhib-
ition to recognize the new Pop tendency in contemporary art as
an international movement – even if this movement was still
known by a different name. What had seemed 'peculiar' to Karp a
year earlier was already becoming canonized.

Secondly, and perhaps more importantly, the *New Realists* exhib-
ition was significant because of where it took place. During the
Fifties, Janis had been one of the most high-powered dealers of
Abstract Expressionism. He represented the pre-eminent names
associated with the movement, including, as well as Pollock, Franz
Kline, Willem de Kooning, Robert Motherwell and Mark Rothko.
Yet now here Janis was, aligning himself with the upstart 'New
Vulgarians', as Kozloff had described them, who defined themselves
specifically in opposition to the Abstract Expressionist old guard:
'Pop is everything art hasn't been for the last two decades,' one of
them, Robert Indiana, would say tartly during an interview in
1963. By kowtowing to the 'Popsicles', as Rothko supposedly called
the younger generation of artists in a putdown as exquisitely acidic
as a Popsicle is sweet, Janis was a traitor to the serious cause of
abstraction. Wounded and upset, Rothko, Motherwell and several
other Abstract Expressionist painters left the gallery in protest. From
the perspective of the 'New Realists', though, Janis's shift repre-
sented a welcome sea change in taste. These Pop-artists-in-waiting
were stars almost overnight. The Pop putsch had prevailed.

Immediately after the exhibition's opening, one of its vulgar
Popsicles, a 28-year-old former billboard painter called James
Rosenquist – who was riding high following his sell-out solo
show at New York's recently formed Green Gallery at the start of
the year – was invited over to an upscale Park Avenue apartment
that belonged to the courageous twentieth-century art collectors
Burton and Emily Tremaine. Rosenquist had already visited their

apartment after the Tremaines had paid $350 for his small painting *Hey! Let's Go for a Ride* (1961), which features a claustrophobically cropped close-up of a good-looking girl's face, juxtaposed with the top of a green soda bottle, a bead of moisture dripping down its neck. It's a hard, aggressive image, fraught with sexual tension: 'You're in the picture,' Rosenquist once said. 'It's coming at you as if you're a couple of inches from the girl holding the soda bottle. You almost have to back off.' On that occasion, he hand-delivered *Hey! Let's Go for a Ride* and watched as the Tremaines removed a painting by the Swiss painter Paul Klee in the hallway so that his work could occupy the same spot. 'Although my painting was replacing a classic piece of Modernism, I thought, This looks pretty good! This fits!' Rosenquist later wrote.

This time, though, Rosenquist walked into a cocktail party where maids wearing little white hats were serving drinks. He looked around and noticed that the guests included Lichtenstein and Warhol, as well as two other important artists associated with the new Pop mode: Indiana and Wesselmann. Another scan of the room revealed that *Hey! Let's Go for a Ride* was now hanging near Warhol's *Marilyn Diptych*, his magnificent acrylic silk-screen painting made shortly after Monroe's death from an overdose of sleeping pills in August 1962. In this meditative tearjerker about the death of a celebrity, Warhol divided up his composition across two canvases, each containing twenty-five images of Monroe's head arranged in five rows. This diptych is a quintessential example of the artist's fascination with serial imagery and repetition, which Warhol used so skilfully as a device to mimic the scatter-shot relentlessness of the mass media, indiscriminately carpet-bombing us with images of superstars, news footage, ads – and all the rest. The left-hand panel is in colour, while the one on the right is black and white. People often quote Warhol's well-known line, 'I want to be a machine' – yet look closely at this

painting and you will notice that, actually, it is much less mechanical than it otherwise might appear. The black-and-white faces, in particular, are full of wonky variation, with smudges, streaks and blotchy squeegee marks all left deliberately visible, reminding us of the artist's hand – and, perhaps, the media's inaccuracy. Moreover, the images towards the right become ever-more faint and shadowy, as though imitating the movie star's slow fade to oblivion. The transition from her garish, overly made-up face on the left – where she appears exaggerated and unnatural, as if viewed on a television screen with the colour amped up to maximum – to the spectral death's heads on the right is audaciously simple. Indeed, the contrast is so simple that it seems obvious. But perhaps this is a sign of the painting's brilliance: like great masterpieces in any discipline, Warhol's *Marilyn Diptych*, which the Tate Gallery bought from the Tremaines in 1980, has the aura of inevitability. It just works.

We do not know whether any thoughts like these passed through Rosenquist's mind while he was contemplating Warhol's diptych and his own painting in the Tremaines' apartment that autumn evening in 1962. He is on record, though, noticing the flattering company that their artworks now kept: the Tremaines had hung *Hey! Let's Go for a Ride* and *Marilyn Diptych* on the same wall as some 'fantastic' paintings by Picasso and de Kooning. It was a good night to be a young Pop artist in New York: following the opening of the show at the Sidney Janis Gallery, they, and not the Abstract Expressionists, were the hottest things in town. And if there were any lingering doubts about this, they were vanquished by the awkward incident that occurred next, while the party was in full swing. Suddenly, de Kooning himself arrived through the door of the apartment accompanied by another painter called Larry Rivers, whose hard-to-categorize style was once described by Warhol as 'unique – it wasn't Abstract

Expressionist and it wasn't Pop, it fell into the period in between'. (Rivers had a big influence upon Hockney while the younger artist was still at the Royal College of Art in London.) Rosenquist recalled: 'Burton Tremaine stopped them in their tracks and said, "Oh, so nice to see you. But please, at any other time." I was very surprised and so was de Kooning. He and the others with him soon left . . . At that moment I thought, something in the art world has definitely changed.' Perhaps Tremaine simply didn't want any trouble: after all, the hard-drinking Abstract Expressionists were known as an aggressive bunch, forever getting into fistfights over aesthetic matters. 'I mean, how corny,' Warhol wrote in his memoir *POPism*. 'I was glad those slug-it-out routines had been retired – they weren't my style, let alone my capability.' At the same time, it is tempting to think of Tremaine snubbing de Kooning in such a public fashion as an emblematic moment, representing the blitzkrieg triumph over Abstract Expressionism of Pop.

<p style="text-align:center">*</p>

Today, there aren't many survivors from that original cadre of New York Pop artists. Of the guests at the Tremaines' party, Warhol, Lichtenstein and Wesselmann are all dead. Indiana is alive but frail, confined due to ill health to his house in Maine in New England. Rosenquist, though, who is considered a founding father of Pop (after all, his one-man debut at the Green Gallery opened in January 1962, predating Lichtenstein's at Castelli's by a month), is still going strong. These days he divides his time between a five-storey building on Chambers Street in Lower Manhattan, which he has occupied since 1977, and a property in Aripeka, Florida, on the Gulf of Mexico, where his principal studio benefits from copious natural light. Feisty and funny, he has a brusque demeanour that embodies Pop's punchier side – and his testimony about life as

an up-and-coming artist in the cockpit of mid-century New York illuminates the East Coast scene. In fact, his account offers in microcosm the macro trajectory of Pop Art in the city.

Now aged eighty-one, Rosenquist speaks with volatile, sparring energy, like someone who had to make his way without help in New York more than half a century ago. This, during the Fifties, is exactly what he did. Tough and terse, he is a product of the school of hard knocks, scattering his conversation with deadpan rejoinders and one-liners. I should have sensed what was coming as soon as we shook hands, when I asked if I could call him Jim. 'Call me Abraham Lincoln,' came the rapid-fire reply. 'Whatever you like.' Indeed, talking to Rosenquist is like conversing with a character from a screwball comedy. Standing in his old ground-floor studio on Chambers Street, beneath a tattered glitter ball offering a reminder of the parties he used to throw here in the days when he still made art in New York, we were surrounded by scores of vast canvases wrapped in cellophane facing the walls. I asked him how he felt to walk past so much work stretching all the way back to the Sixties. 'I feel old!' he hollered back, as a mournful police siren faded away outside. This wisecrack, I soon discovered, would be typical of our interaction. Hard of hearing and abrupt, Rosenquist can come across as crotchety, pugnacious, even irascible – but he is also quick-witted, in that jabbing, show-no-weakness way that certain streetwise New Yorkers have.

Part of his shtick is that he likes to be contrary. (I sense that interviews aren't his bag.) Looking around at all of the wooden frames supporting enormous, unseen paintings, I reminded him of something he once said: that he put the steroids into Pop Art. I was half remembering a line from his 2009 memoir, *Painting Below Zero*. Following a passage reflecting on the large scale of a lot of Pop Art, such as Warhol's monumental *Elvis* portraits, Lichtenstein's blown-up cartoons or the giant *Floor Burger* of Oldenburg, he wrote: 'I started

that . . . I'm the one who gave steroids to Pop Art.' 'I didn't say that,' he snapped back. I paused, recalling another line from his memoir in which Rosenquist compared the effect of his Pop paintings to 'smashing images in your face'. Biff! But before I could protest, it was too late: like an ageing boxer who hadn't forgotten how to turn defence into attack, he had already followed up this initial blow with a sucker punch. 'Pop Art,' he said, 'is a misnomer. The art critic that named it [Lawrence Alloway] said that all those artists were just enthralled by popular culture. Bull-*shit*. Not true. That's why I want to tell you about it upstairs where it's more comfortable, so you get the whole picture.' Sure, but before we went up, I wanted to ask: do you even consider yourself a Pop artist? 'No.' Why not? 'I consider myself an art-*something*, I guess. I don't even know if I'm an artist. People call me an artist.' They call you a Pop artist. 'Yeah, but so what? Like a gravedigger digs graves.' With that, Rosenquist walked towards an ancient-looking elevator, which, he said, dated from 1908 but had been totally revamped: 'It's all new. Re-welded, new cables, new motor.' My eye was drawn to a handwritten sign on an orange background: 'In case of New York City power failure remove screws and climb out to next floor.' 'See, you could be here, this elevator could be perfect, and then the power in New York could just blink and go off,' Rosenquist says. Has that ever happened while he has been inside? 'Once.' I'm not sure I'd like to be stuck inside a powerless elevator with him for long. Rosenquist adjusted a lever, which looked like a makeshift piece of machinery raided from a Second World War submarine, and up we went. Luckily, on this occasion, New York's electrical system kept on humming.

Rosenquist's forceful disposition surely owes much to his upbringing. Born in 1933 in a hospital that would later become a Chinese restaurant, he was brought up as an only child in America's Midwest. He spent his early years living in half a dozen different places, including the flatlands of North Dakota as well as

Ohio and his grandparents' farm, with 500 acres and twenty dairy cows, in Minnesota. (Rosenquist often refers to himself as a 'farm boy' who happened to become an artist.) During the Thirties, the Midwest was still convulsed by the aftermath of the Great Depression, and the family never had much money: 'A dollar was as rare as frog hair,' he once said. For a time, his father ran a Mobil gas station off the highway – when, Rosenquist recalls, 'the big treat for me was being able to drink the bottom half of my father's five-cent Coca-Cola.' Later, when Rosenquist was seven, his dad opened a motel in northern Minnesota, before working in a munitions factory and then servicing B-24 bombers during the war. His mother found employment as an accountant. All of these jobs were modestly paid – and by 1945, by which time the family had settled in Minneapolis in a newly built house resembling a cottage on Cape Cod, Rosenquist felt embarrassed that he had to take on odd jobs such as selling ice cream in order to help make ends meet. He wasn't the only Pop artist who came from a humble or down-right poor background: when Warhol was growing up in a Pittsburgh slum, his immigrant parents were so strapped for cash that his mother went from door to door peddling metal flowers that she had created by cutting up tin cans.

By now, Rosenquist had started to draw elaborate battle scenes on the white side of rolls of discarded wallpaper, which his mother, herself an amateur painter and pianist, had sourced because it was cheaper than proper paper. It is tempting to make a link between these long, bustling compositions and the wide paintings, bursting with visual activity, of his maturity – especially, of course, his most famous painting, *F-111* (1964–5), which is constructed around a colossal depiction of an advanced fighter-bomber plane of the same name. As a boy, Rosenquist also enjoyed making model airplanes. A black-and-white photograph taken in 1946, when he was thirteen, shows him standing on a snowbound street

squinting at the camera while holding a fine example that he had built. With his left hand slung in a trouser pocket, and his cap worn at a raffish angle so that it slopes up from the back of his head, he has an air of devil-may-care cheekiness – presaging his octogenarian self.

A year after posing for that picture, Rosenquist made a watercolour of a sunset and won a scholarship to study art for four Saturdays at the Minneapolis School of Art: 'I knew I was involved in serious business here, because they gave us erasers that cost 25 cents and paper that cost 35 cents a sheet,' he wrote in *Painting Below Zero*. It was the first formal recognition of his gift for drawing. It was also the first time he heard properly about modern European art, as well as what post-war American artists such as Pollock were up to.

After graduating from high school, he enrolled at the University of Minnesota at the insistence of his mother, who was not keen on his vague plans of skipping higher education in order to surf and work as a cattle rancher in California. At university, he studied art and found a mentor in Cameron Booth, an Abstract Expressionist who had trained in Munich under the important German-born painter, teacher and theorist Hans Hofmann, who settled in New York during the Thirties and had a profound influence upon American artists of Pollock's generation. With Booth, Rosenquist visited the Art Institute of Chicago, where he was 'overwhelmed' by the paintings and sculptures that he encountered.

Around this time, in parallel with his introduction to 'high' culture, Rosenquist did something that would be arguably much more important for his development as an artist: aged seventeen, he answered an advertisement in a local newspaper in Minneapolis looking for an 'artist/sign painter'. The contractor, a dour man called W. G. Fischer, was offering $1.60 an hour to anyone willing to paint Phillips 66 insignia on gas tanks and refinery machinery. Rosenquist was hired.

In *Painting Below Zero*, Rosenquist talks with flinty romanticism about his gritty experiences as a budding sign painter. His co-workers were a drunken rabble, including a few former jailbirds, and they travelled across the Midwest spending nights in cheap hotels or sometimes sleeping rough on tarpaulins in fields. On one occasion they awoke to discover that a circus had pitched up in the field next to them. 'I got my first taste of the wild side,' Rosenquist recalled. 'It was like an *On the Road*-type of adventure.' By 1954, when he graduated from the University of Minnesota, Rosenquist already had valuable experience as a sign painter – and so, at the suggestion of Booth, he found work as a billboard painter for General Outdoor Advertising in Minneapolis. He was so proud of his first big billboard job that he took his mother to see it.

A colour photograph preserves this moment, when Rosenquist couldn't resist pointing out that he was now making more money than his dad. A young, blond Rosenquist stands on the sidewalk to the right of his mother, who is wearing a gingham summery frock. The pair lean back their heads in order to stare upwards at a mighty billboard advertising Coca-Cola beneath a colossal neon sign of the logo. Rosenquist painted the company's white emblem against red on the left, while the main body of the painting is to the right. Against a blue sky adorned with picture-perfect fluffy white clouds, an elegant young woman wearing earrings, a necklace and white gloves raises one hand to shield her eyes as she stares with a smile into the distance. To the right, a green sign with the word 'REFRESH' in yellow block capitals points in the direction of a glass of Coke that floats amid the clouds like a divinity surrounded by a halo of bright white light.

In some ways this billboard resembles a work of Pop Art *avant la lettre*, because it anticipates Rosenquist's later output as an artist. The enormous scale, the bright, bold colours, the figurative imagery, the subject matter incorporating consumer products, the

unexpected juxtapositions evoking a hinterland of Surrealism (the device of singling out objects against a blue sky is indebted to the paintings of the Belgian Surrealist René Magritte) – all of these elements would become hallmarks of the Pop Art that Rosenquist pioneered, just six or seven years later, in New York. There is something absurd about this vision of a gigantic glass of Coke playing the role of saviour to an attractive, yearning ingénue – and a keen sense of the absurd would inform Rosenquist's mature work too. At this moment, though, very few people – and almost certainly nobody in Minneapolis – would have thought that this billboard had anything to do with fine art. In Fifties America, modern art was still supposed to look refined: it definitely wasn't meant to evoke the imagery of the street. Yet Pop Art would change all that – closing the gap between modern art and the masses for good.

*

A few months after completing his Coca-Cola billboard in Minneapolis, Rosenquist arrived in New York City after winning a scholarship to the Art Students League, an independent school for artists where he would be taught by, among others, the German painter and caustic caricaturist George Grosz. Although the scholarship didn't cover his living costs, Rosenquist was urged to go by his teacher Booth. In September 1955, having taken the night flight from Minneapolis, Rosenquist turned up in New York with less than $300 in his pocket. He headed straight for the YMCA on West 34th Street, before eventually finding a room on West 57th for eight bucks a week. 'New York was different then,' he says. 'Cheap. And there was hardly any traffic. All the GIs had moved out of Manhattan to New Jersey. That was nice.'

At this point Rosenquist was still under the influence of Booth, who advocated abstraction. 'Cameron told me that I should try to make an interesting picture plane,' Rosenquist says. 'He spoke

about everything after Cubism and how to make a dynamic pic-
ture, whatever you painted, so that's what I was thinking about.'
In concentrating on this, Booth was not alone: the default style of
most artists with pretensions to be taken seriously in the mid Fif-
ties was abstraction. Everybody was still in awe of 'Jack the
Dripper', aka Jackson Pollock, and other colossuses of Abstract
Expressionism such as de Kooning. Even Rosenquist, soon after
his arrival in New York, sought out the notorious Cedar Tavern
on University Place and East 8th Street, where Pollock, de Koon-
ing and like-minded artists, including Franz Kline used to hang
out. 'I was curious about their energy,' he explains. 'Bill de Koon-
ing was tremendously energetic, painting constantly – Bill was a
good friend of mine. The rage at that time among real artists was
what they called Abstract Expressionism. And that meant people
would throw anything at a canvas and then try to eke out an idea
from the *schmears* and the big blobs on the canvas and the totally
abstract splashes. So the art teachers in New York all encouraged
people to throw paint on the canvas and try to get an idea from
that.' Rosenquist's tone makes *schmear* sound derogatory – like so
many other Yiddish words beginning with 'sch' – implying that
artists were slapping paint on to canvas with as much care as some-
one spreading cream cheese across a bagel.

Still, to begin with as an artist, Rosenquist was 'schmearing' along
with the rest of them. In 1958, he was pursuing this abstract idiom in
compositions consisting of lots of crowded squiggles painted on top
of deliberately dull, earthen and dun-coloured backgrounds. These
paintings look like renditions of thick body hair seen in close-up
against patches of mottled skin. Rosenquist called them his 'excava-
tions', since they were inspired by little-noticed textures that he had
spotted in neglected nooks and corners of the city.

But just as his introduction to modern art had coincided with
jobs as a sign painter in Minneapolis, so now, in New York,

Rosenquist continued to seek out work as a commercial artist while doing his own abstract thing whenever he found a moment. He would later say that during these years he led a double life: sign painter by day, fine artist by night. After a brief spell upon leaving the Art Students League in 1956 working as a chauffeur and bartender for an upper-crust family in Irvington, New York, Rosenquist was back in the city painting billboards. Talented, strong and quick, he was soon in demand, overcoming the resistance that he had initially encountered among the grizzly old-timers on the board of New York's sign painters' union. According to Rosenquist, it was a cut-throat business: 'New York was such a wild place, so capitalistic. I would get laid off on Friday [by General Outdoor Advertising in Brooklyn], because they didn't have any more work. Then the next morning they'd call me: "Jimmy, come back to work!" They had another big job for me to do.' But Rosenquist thrived. He rapidly became a dab hand at reproducing objects on the sides of buildings in Brooklyn: 'It could be anything: a bottle of whisky, hair curlers – anything. All you had to do was paint it *large*. I just thought I was lucky to be able to do it and that it had come off so I'd keep my job – that's all. Because if you weren't any good, you were fired instantly – or quicker than that.'

When the work in Brooklyn eventually dried up, he returned to Minnesota and freelanced painting signs. That summer of 1957 he painted an eye-catching Cadillac Convertible hurtling in mid-air towards the viewer on the side of an auto shop in Minneapolis. Inevitably, in retrospect, this image puts one in mind of the many cars that appear in well-known works of Pop Art, from the seductive, curvaceous automobile body panels that form such an essential part of Hamilton's paintings *Hommage à Chrysler Corp.* (1957) and *Hers is a Lush Situation* (1958), to Warhol's macabre *Car Crash* silk-screens and the sinister, shadowy Ferraris and Alfa Romeos that the Dresden-born artist Gerhard Richter painted in the mid

Sixties when he was an adherent of so-called Capitalist Realism, Germany's answer to Pop. Car parts also populate many of Rosenquist's later Pop paintings – including, famously, the chrome grille and headlights of a 1950 Ford, seen flat-on and severely cropped, at the top of *I Love You with My Ford* (1961), above images of embracing lovers and a jumble of spaghetti. This painting was one of three works of art that Rosenquist contributed to the *New Realists* exhibition at the Sidney Janis Gallery in 1962.

For a while, Rosenquist rattled between low-paid jobs like this, establishing his credentials, working his way up the ladder, until later in 1957 he landed a steady job painting billboards for the Artkraft Strauss Sign Corporation. In the world of billboards, he'd hit the *really* big time: soon he was painting vast signs in Times Square for the Astor Victoria and Morosco theatres, which were both located at Broadway and West 45th Street. The Astor Victoria sign was 58ft high and 395ft wide – and Rosenquist painted it seven times. By 1959, when he was still only twenty-five, Rosenquist had become the corporation's head sign painter. The following year, he was featured in a United Press International article headlined 'Broadway's Biggest Painter'. He was also designing displays and backdrops for windows in fashionable shops such as Tiffany & Co. and Bonwit Teller – something undertaken by several other artists associated with the Pop movement, including Johns, Rauschenberg and, of course, Warhol. Even Lichtenstein decorated window displays for a department store for a while in the early Fifties.

In many ways, painting billboards had more influence upon Rosenquist's growth as a fine artist than his time at the Art Students League. He describes its impact simply: 'It [billboard painting] was art school for me – tough, tough, tough art school.' What in particular did his time as a sign painter teach him? 'The ability to paint,' he deadpans. Then he continues: 'Yeah, you had to paint huge things quickly – large areas. It was always hard

work. You'd be handed a little sketch of anything and everything, and you'd take this little image, square it off in pencil, and then you'd square off the sign and say these little squares are each now two feet wide. And you'd draw accordingly from this little sketch into these big squares and it had to be perfect. And you had to interpret, in a painterly way, how the sketch would look [from a distance] so that it would sell.' As a Pop artist, Rosenquist would use exactly the same technique: gridding up the small collages that he made, sometimes over several months, in order to plan out his large paintings, before transferring the imagery to canvas.

The longer he was living and working in New York, the more Rosenquist realized that he was starting to understand painting as a craft – something that he felt was lacking in the abstract work of many of his contemporaries who were also trying to position themselves as fine artists. 'They didn't know how to paint,' he says. 'They didn't know how to draw either, whereas I'd get up on this huge wall with just a piece of charcoal and start drawing these huge things. It would take me about a week to draw [one design] and then I'd paint it in a few days. I went through many, many, many different images. Sometimes there were many different images on one big sign and I had to put them in the right place. That helped me make paintings later. I was constantly painting and mixing all the colours. And it had to be perfect. You know, they liked me. They kept me.' At the end of each working day, Rosenquist would gather up any paint that he had mixed but which, for whatever reason, he had ended up discarding, and take it home to the privacy of his own studio. This was a way of sourcing potentially costly materials for free.

Rosenquist's bosses may have liked him, but he was falling out of love with his profession. For one thing, the working conditions were 'dangerous', though 'that didn't mean anything to our management, who were very cruel'. In 1960, Rosenquist witnessed

two fellow sign painters tumble to their deaths: 'Yeah, they fell. Fell off a wall. Whoa, splat!' In the wake of that incident, he quit. Even before that, though, he had been finding the work mind-numbing and repetitive. Forever on autopilot, he was bored by churning out gigantic whisky bottles and other everyday objects – something that, by the end of his time as a sign painter, he could practically do in his sleep. Everything about the exercise now seemed hollow. Even the satisfaction of painting on such a scale had withered: 'There I was, painting these huge, blown-up, empty images that had no meaning. The imagery I was painting was like a big, empty cardboard box – it was nothing. So what? I didn't care about any of that imagery at all.' The curious thing, though, as we shall see, is that in his later Pop paintings, Rosenquist would often strive for a similar sense of nothingness. Blankness would be a crucial part of their effect.

<div align="center">*</div>

The year that Rosenquist quit the Artkraft Strauss Sign Corporation would prove to be the fulcrum on which the rest of his life turned. That summer, in a traditional ceremony at the Forest Hills Tennis Club, he married a textile designer called Mary Lou Adams, whom he had courted while painting a billboard outside her office in Times Square. (After getting hitched they rented a flat with no hot water for $35 a month on the Upper East Side.) He also decided to pursue a career in fine art full time. He moved into the former studio of the abstract painter Agnes Martin on the third floor of 3–5 Coenties Slip, a couple of blocks of artists' lofts in a shady neighbourhood near the waterfront in Lower Manhattan, where the artists Robert Indiana, Ellsworth Kelly and Jack Youngerman also worked. From the off, he kept it 'messy', because he felt that such an environment would help to stimulate 'more ideas'. (The notion of a pristine, whitewashed space, by contrast,

seemed oppressive and deadening.) The strategy worked. His loft at Coenties Slip functioned as a sort of chrysalis in which Rosenquist underwent his metamorphosis from jobbing sign painter to iridescent Pop artist.

Elsewhere in the city, Warhol was already at work on the first pictures in his series of hand-painted comic-strip characters that would include Dick Tracy and Batman as well as Superman and Popeye. He was also painting black-and-white motifs raided from cheap newspaper advertisements for self-improving surgery: *Before and After* (1961), for instance, dramatizes the effect of a nose job on a woman seen in profile. By the time some of these paintings appeared in the window of Bonwit Teller, Lichtenstein was planning his breakthrough canvas, *Look Mickey* (1961), featuring the Disney cartoon characters Mickey Mouse and Donald Duck. This was one of the paintings that Lichtenstein took to his meeting with Ivan Karp. In other words, Pop Art was starting to crystallize – fast.

As yet, Rosenquist was oblivious of Warhol and Lichtenstein: one of the curiosities of Pop's stirrings is that artists unknown to one another were developing similar subject matter and themes at the same time. The galvanizing force, though, was a pair of important, slightly older artists who were instrumental in the evolution of Pop: Jasper Johns and Robert Rauschenberg. Rosenquist – who met them by chance in 1956 when he was hunting for a loft on Fulton Street in the Financial District and was directed by the owner of a restaurant to meet a couple of young artists who were living above his establishment – was mindful of them both.

At the start of 1958, Leo Castelli had given Johns – a shy young man who had grown up in South Carolina – his first one-man exhibition. The previous spring, Castelli had seen Johns's painting *Green Target* (1955) in a group show at New York's Jewish Museum and fallen in love: it provoked, he later recalled, 'the sensation you

feel when you see a beautiful girl for the first time and after five minutes you want to marry her'. For his solo show at Castelli's, as well as *Green Target*, Johns presented other similarly impersonal and arbitrary-looking paintings that he had also produced during the preceding three years: images of the American flag; more colourful targets in red, yellow and blue, beneath plaster casts of anonymous faces and body parts; hypnotic, commanding pictures of numbers and letters. Many of these were rendered using an unusual, archaic technique known as encaustic, in which pigment is bound with molten wax. The success of the show is now art-world lore. Invited to see the exhibition before it was even finished, the editor of *ARTnews* was so impressed that he reproduced *Target with Four Faces* at once on the cover of the magazine's January issue. A few days later, Alfred H. Barr, the founding director of New York's Museum of Modern Art, visited the exhibition and bought four works for the institution on the spot, including *Green Target* and *Target with Four Faces*.

For much of the Fifties, when he was making this groundbreaking work, Johns had been intensely involved, both romantically and intellectually, with his lover Rauschenberg – the outgoing, gregarious yang to his introspective yin. Where Johns made art that was considered and enigmatic, Rauschenberg produced work animated by a madcap, footloose energy that seemingly wanted to encompass the entire world. In 1953, Rauschenberg – who, like Johns, also grew up in the Deep South – had been so poor that he was surviving in New York on a food budget of just 15 cents a day. Unable to afford traditional materials – but prodigiously resourceful and inventive – he turned his poverty to his advantage and started combing the streets for junk that he then transformed into spellbinding art evoking overlooked, throwaway aspects of the city. In opposition to the Abstract Expressionists, Rauschenberg felt that art shouldn't be divorced from everyday reality. 'I don't

want a picture to look like something it isn't,' he once said. 'I want it to look like something it is.' In a sense, this was the fundamental shift in attitude that triggered the Pop Art movement. If Abstract Expressionism was art that said, 'Keep out!' – in other words, if it was a highbrow type of art enjoyed by a coterie of initiated connoisseurs, but was otherwise considered pretentious and out of touch by the general public – then Pop Art was a mode that shouted, 'Come in!' Accordingly, Pop's snappy, recognizable imagery proved a big hit with the public from the beginning – while some of those guardians of high culture who had previously tended the flame of abstraction were appalled by it.

In 1954, Rauschenberg started work on his famous *Combines* – strange, hybrid, seemingly chaotic works of art that assembled all sorts of bits and pieces from everyday life into something in between sculpture and painting. *Canyon* (1959), now in the collection of the Museum of Modern Art, is a representative example of the more than sixty *Combines* that Rauschenberg produced in those intervening five years. A stuffed eagle swoops outwards from a canvas embellished with various items, including buttons, a shirtsleeve, scraps of newspaper, a squeezed paint tube and part of a flattened metal drum.

At first, *Canyon* looks like a total mess – casual, even slapdash. But Rauschenberg's genius was to make disparate junk cohere. The eagle provides a sense of uplift, possibly even spiritual ascent – something mirrored in the photograph of Rauschenberg's own son with an outstretched arm (an image of naive optimism), as well as a nearby picture of the Statue of Liberty, which, like the eagle, is also an emblem of America. So there's method to the madness. And the eagle extends the painting out into our world – it's outrageous, really, but arresting – so that the whole thing soars with originality and freedom. 'I really feel sorry for people who think things like soap dishes or mirrors or Coke bottles are ugly,' Rauschenberg

once said, 'because they're surrounded by things like that all day long, and it must make them miserable.' That attitude would prove inspirational for younger artists such as Rosenquist – and it wasn't long before Rauschenberg was being described as the 'Old Master' of the new Pop style. 'Bob was very inventive – and generous too,' Rosenquist says. 'Jasper was really quiet. He was a singular person who seemed alone a lot – but I like him [while Rauschenberg died in 2008, Johns is still alive, and now based in Connecticut]. They were totally different personalities.' When Rosenquist encountered their work for the first time, he recalls, 'It felt like the news – some fresh wind.' Why was that? 'Because you'd never seen it before,' he roars. 'That's why it felt new!' Ka-POW!

Later, during a more reflective moment, he returned to the impact that their work had on him. 'At first, Jasper only showed targets and flags, American flags and targets. To me, it was very . . . questionable. Everything was like a giant question for you to figure out.' Rauschenberg's work, by contrast, was 'very loose and looked very fresh. Jasper's was sort of tight and constricted – it was a statement, but you couldn't figure out what the hell the statement was. His images are very strong. They make you go: "What?" And Bob's always seemed sort of ephemeral.' How did their work inspire Rosenquist as an artist? He raps out a single word three times as though offering an incantation: 'Free . . . free . . . freedom. Jasper said almost anything could be a painting. Got to be the right painting. Bob was always amazing. He'd say, when you're having an accident, that's when you have your inspiration – if things don't go well. He was so – so bright. I was with him on his deathbed. He said, "I don't mind death. I just don't like the infinity part of it." He wanted to have another party – seriously. Once I was invited to his birthday party in Florida – I was living in Florida. I decided to bring him a case of Jack Daniel's [whiskey]. Then I thought, no, he doesn't need

another case of Jack Daniel's. So I brought him a roll of material that you could see through and – holy cow. He made a whole series of works called *Hoarfrost* from it. Sold them for a lot of money.' Rauschenberg could make art out of almost anything.

<p style="text-align: center;">★</p>

In late 1960, inspired by Rauschenberg and Johns, Rosenquist decided to change tack as an artist. He veered away from abstraction, which he felt had become entirely exhausted as a way of painting. 'Abstract painting is like jazz – it's going *be-bitty-bop, woo-ba-dado*,' he wrote in his memoir. 'The melody is great, but what is the statement? Great tunes, but not connected to the real world where roses are red and the sky is blue, Tide is orange, and 7-Up is green.' This sentiment chimes with something that the American figurative painter Alex Katz – who became very fashionable during the late Fifties and, like Larry Rivers, is often considered part of that bridging generation between Abstract Expressionism and Pop – told me: 'The older guys were painting these, I don't know, metaphysical things – a lot of internal stuff and French philosophy. But it just wasn't in my life, so I didn't take any of it seriously. I was playing basketball and dancing.' Like Rauschenberg, like Rosenquist, and like many other artists linked with the sudden emergence of Pop, including Blake, Katz considered abstraction moribund because it was too high-flown and detached from the reality of being young and alive. It had nothing to say about the vigorous everyday world of soap dishes and mirrors, Coke and 7-Up, basketball and dancing.

Staring for hours at a time out of the window of his rented studio at Coenties Slip, Rosenquist considered the people swarming about their business in the street beneath him, and puzzled over how to free his art from the shackles of abstraction. On a whim, he started flicking through some old copies of *Life* that had

belonged to his mother-in-law. At the time, *Life*, a weekly news magazine celebrated for its photojournalism, was one of America's most widely read publications, with enormous reach. As he turned the pages of this stash of old copies in his studio, Rosenquist realized that he wasn't particularly interested in stories about current affairs, but that perhaps he could make something out of the anonymous imagery of the advertising that was printed in the magazine. More specifically, he found himself compelled by advertisements that had appeared in *Life* in the decade roughly between 1945 and 1955. Intuitively, he understood that these pictures formed a curiously shadowy, hard-to-define category of imagery: photographs from yesteryear that were neither so old that they would spark nostalgia, nor so recent that they would still feel contemporary. Instead they had a sort of un-dead blankness, devoid of vivid associations, as if they were lost in limbo – which he liked: 'Imagery that's very old is classic or nostalgic,' he says. 'Something brand new is just brand new. But if you take things that are, say, five to seven years old, then that's like a never-never land of memory. It's hard to explain but they're very peculiar.' Perhaps this also accounts for why Warhol was drawn to a publicity photograph of Marilyn Monroe taken in 1953 as the source for his portraits of the star. Either way, the image bank of Rosenquist's imagination was slowly filling up – before it would be unleashed in the months and years to come.

This was the context for Rosenquist's breakthrough: a large painting called *Zone*, which is usually dated to 1960–61, and which the artist once called 'the beginning of my thinking'. It was inspired by a full-page advertisement for Pond's 'all-new Angel Skin' hand lotion, which appeared near the start of an issue of *Life* published in January 1961. (This would make it more contemporary than the retro advertisements that would inspire Rosenquist's paintings to come; it would also suggest that *Zone* should possibly

be dated to 1961 alone.) As was customary at the time, the ad contained a large panel of sales-pitch copy promising that the lotion would guarantee women 'young hands' on account of a secret ingredient called 'Penetressence': 'an exclusive concentrate of age-defying moisturizers, softeners, secret oils and essences that go *deep down where aging begins!*' Jaded by his years painting billboards, so that he was more cynical about the tactics of advertising than most, Rosenquist understood at once that 'Penetressence' was actually an 'exclusive concentrate' of ad-speak guff. Something, though, intrigued him about the accompanying photograph of a pretty young woman placing both her hands, with immaculately painted fingernails, upon her windswept hair. He ripped out the page and used it as the basis for a sketch of his new painting.

At first this sketch outlined a busy composition, dominated by the upper part of the woman's face, focusing on her eyes and a few of her front teeth, juxtaposed against a saltshaker gushing out grains that somehow became the white-on-blue stars of America's national flag. In the lower half of the sketch, a man's torso could be seen wearing a tie and a shirt. Blood seeping from gunshot wounds metamorphosed into the flag's red stripes, while the nose and jaws of another face, possibly a baby's, was visible with an open mouth apparently chewing at the incisors of the woman from the ad above. At the top, in a surreal flourish, Rosenquist included a band containing the heads of three cows floundering through water, accompanied by a note: '3 swimming cows only noses showing'.

In the end, the finished painting was much less busy and much more – well, much more brutal. Retaining the black-and-white palette of the original photograph that was his source, Rosenquist started turning the sketch into a large painting measuring just under 8ft × 8ft. As he went about his task, though, he became frustrated by all of its chaotic, heterogeneous imagery, so he began painting

everything out. The swimming cows disappeared. So did the salt-
shaker and the man's shirt. Soon the baby's face and the Stars and
Stripes had gone too. Finally, Rosenquist was left with two princi-
pal elements: the face of the woman from the Pond's ad, cropped as
he had originally envisaged it in the sketch, and an ambiguous
expanse of grey, adorned with a few ovoid and spherical shapes that
seemed to catch the light like pearls. There were also some darker,
curling, leaf-like forms that offered a visual echo of the twists and
arabesques of the model's hair. You wouldn't necessarily recognize
it immediately, but this part of the painting depicted a black tomato
seen in close-up. The pearl-like spheres, which have a similar shape
and sheen to the woman's lustrous canine teeth and shiny finger-
nails, are actually water droplets visible on the tomato's skin. The
leafy shapes belong to the fruit's stalk.

I call this painting brutal because the more you look at it, the
more you realize that it is dead-eyed cold. By opting for a gri-
saille, or grey monochrome, palette – something that he would
repeat in several subsequent early Pop paintings, including *Push-
button* and *Flower Garden* (both 1961) – Rosenquist subverted the
promise of the original advert at a stroke. Here is a woman offered
by Pond's as an icon of glowing, vital, youthful health – yet in
Rosenquist's vision she appears veiled in a shadowy colour scheme
more redolent of death. Moreover, by cropping the original
photograph, Rosenquist homes in like a predator hunting prey
upon two of its most bizarre aspects: the woman's eyes and teeth.
In the painting, as in the photograph, the eyes are hidden by
shadows so deep that the sockets appear black – two ghoulish cav-
ities, whose contents have been plucked out. Rosenquist also
spotted that the prominent teeth, which were supposed to be
alluring in the photograph, actually appear strangely forced and
fierce – the model's smile is more of a rictus than a spontaneous
grin. Certainly, the three teeth visible in the final painting,

explicitly suggesting the skull beneath the skin, only enhance the atmosphere of menace – after all, primates usually bare their teeth as a display of aggression. There is something of a visual joke as the woman's teeth bite down upon the flesh of the tomato – but it's a joke with a dark punchline, since the tomato is getting its revenge: in the upper third, the tip of a pointy, beak-like wedge of tomato is positioned perilously close to her left eye, as though it's about to start pecking at the soft jelly. Even the woman's disembodied fingers are disconcerting and ambiguous, since they could belong to someone else, clawing at her head with violence, not tenderness. The title of the painting is *Zone* – and the zigzagging line that divides the two 'zones' of the image into woman and tomato creates a distinct Z-shape in the middle of the composition. This functions like the famous mark of Zorro, scarring the woman's face as though the artist has slashed at the canvas with a sword instead of a paintbrush, adding to the air of violence and disfigurement. The water droplets on the tomato could be tears or maybe even plump beads of this nervous woman's sweat as she comes under attack. One of Rauschenberg's early *Combines*, *Bed* (1955), which included his own pillow and patterned blanket slathered with agitated splashes of oil paint, was considered so shocking at first that some critics called it the scene of an axe murder. To borrow the metaphor and apply it to *Zone*, if you had to compile a profile of the 'killer' responsible for Rosenquist's first Pop painting, you wouldn't opt for a crazy, blood-bespattered axe murderer, but rather a psychopath with ice in his veins. Like I said: as an image, it's cold.

<p style="text-align:center">*</p>

Historically one of the big debates about Pop Art has been whether it was celebrating or castigating the popular culture that it depicted. With many Pop artists, such as Warhol, this will probably

always remain moot. But in the case of Rosenquist's early Pop paintings, I'm fairly sure that it's the latter. *Zone* ushered in an assault upon the visual world of television commercials and printed advertising that would be sustained for several years to come.

The strange thing is that this isn't necessarily how Rosenquist sees it. Does he consider *Zone* a watershed in his career? 'Right in there,' he says. 'The Ford and spaghetti painting [*I Love You with My Ford*] is another one, now in Stockholm [in the Moderna Museet].' What was he doing differently in *Zone* that he hadn't done before? 'Going to the bathroom,' he shoots back, sounding crabby. 'I don't know what you mean.' Well, what was new about *Zone* in terms of his approach to making a picture? At this point, Rosenquist answers by articulating an idea that he has often expressed before: 'Making paintings with huge fragmented realistic things where I was consciously putting imagery back. I thought these paintings were non-objective because the imagery in them didn't mean anything to me. I didn't like it, I didn't care about it, it was just stuff to put in a space.' He sums up his achievement like this: 'I want people to know the truth of my energy: I'm responsible for introducing imagery back into contemporary non-objective painting.'

What he means will possibly sound surprising. Rosenquist is saying that at the time his early Pop works were part of a vogue for non-objective – i.e., non-figurative, abstract – painting, in particular so-called 'hard-edge' painting, which was being practised by American artists such as Kenneth Noland and Ellsworth Kelly, who had originally tipped him off about the studio at Coenties Slip. This school of painting, which was in its own way reacting against Abstract Expressionism by banishing drips, splashes and any other evidence of spontaneity from the canvas, was characterized by geometric forms and broad expanses of unmodulated colour – bound, crucially, by crisp, sharp, 'hard'

edges. If we wish, we can find some of these characteristics in *Zone*: the geometric forms of the water droplets, the sharp edge of the harsh, Z-shaped line that divides the canvas in two. According to Rosenquist, though, the most refreshing quality of the picture is the way that it treats representational, figurative images (a woman's face, the surface of a tomato) as though they were nothing but abstract elements in a 'non-objective' painting. He has taken imagery commonly found in popular culture and drained it of context and meaning by aggressively cropping it and enlarging it so that it seems to smash up against the surface of the painting like a bug squashed and deformed by a fast-moving windscreen: splat! As a result, Rosenquist suggests, for a short while we don't even register the woman's face or the tomato. Instead, we consider the interplay of formal qualities across the composition: the way that shapes bounce off or echo one another, or the manner in which the tone subtly shifts and alters for the sake of pleasing variety, while still ensuring that the whole picture coheres. Rosenquist, in this reading, is responsible for a subtle – and novel – paradox: constructing an abstract painting out of non-abstract imagery recognizable from real life. And scale – something that he learned about during his time painting billboards – was an essential tool in this endeavour. This is because, he says, 'It makes things oblivious. They get so big you can't see them any more.' This is the blankness to which I was referring earlier.

It sounds remarkably clever. Or, rather, it *is* remarkably clever – since I don't doubt for a second that this was an important part of what Rosenquist was up to in those first Pop paintings. Take *I Love You with My Ford*, which is divided into its three distinct bands of car grille, embracing lovers and spaghetti. Rosenquist's rendition of a plate of cheap, regular Franco-American Spaghetti – a particular brand that was produced, incidentally, by the same Campbell Soup Company whose packaging Warhol would

famously paint the following year – is a tour de force. (Rosenquist would paint spaghetti several times during the Sixties; it became one of his signature tropes.) All those garish squiggles of pasta, squirming about in their glinting, red tomato sauce, offer a visual joke: they parody the writhing, impassioned marks and gestures that had characterized the work of the Abstract Expressionists. In other words, we may not initially register that we are looking at spaghetti at all: unconsciously we 'read' this section of the work to begin with as a piece of abstract painting. Lichtenstein was another master of this effect. So many of his classic Sixties works, which are considered as purely 'Pop' as Pop Art gets, are in dialogue – surprisingly – with contemporary abstract painting. In his celebrated comic-strip painting *Drowning Girl* (1963), for instance, a tearful young cartoon woman with blue hair is about to be sucked beneath a vortex of swirling water, while a thought bubble emanating from her right temple reads: 'I don't care! I'd rather sink – than call Brad for help!' By manipulating, enlarging and so transforming his source, Lichtenstein turned the woman – particularly her hair – and (especially) the water into a series of quasi-abstract marks and shapes, which, in the process, burlesques abstract American painting of the Forties and Fifties. It's sophisticated and ingenious – despite the ostensibly dumb subject matter of a panel from a throwaway comic strip. Indeed, that Lichtenstein could do something so clever with such an unpromising, lowbrow source only enhanced the painting's sophistication.

With Rosenquist's Pop paintings, I'm not sure that their imagery is ever, quite, 'just stuff to put in a space', as he puts it. Yes, we take a minute or two to register the tomato in *Zone* – but understanding that the woman's face is a woman's face is crucial to the picture's impact. Without sensing the violence that the artist has inflicted upon the sort of stock photographic imagery that unconsciously we recognize as belonging to the world of

advertising, the picture loses its bite: Rosenquist's frustration with what he calls the 'ridiculous' strategies of Madison Avenue is wiped out. More generally, the picture also loses its relationship with the real world – something that artists including Rauschenberg, Katz and also Rosenquist himself felt had already happened to abstraction, to its detriment.

In short, here is a case where I believe that the artist is telling us part of the story but not the whole tale. The imagery of Rosenquist's early Pop paintings *is* important as upfront imagery in its own right – even if it has been presented in a confusing, distorted and unsettling manner. Yes, Rosenquist was interested in fragments – in part because he felt that collage could help to capture the experience of modern life: 'If, for example, you take a walk through midtown Manhattan,' he once wrote, 'you might in quick succession see a street vendor, the back of a girl's legs, and then out of the corner of your eye catch a glimpse of a taxi as it comes close to hitting you. You see parts of things – the vendor, the legs, the cab – and you rationalize them into a scenario.' Likewise, the strange, brilliant poetry of the surreal juxtapositions of fragmentary imagery in his paintings invites us to rationalize them into a scenario for ourselves.

It doesn't take long before we start doing this with *I Love You with My Ford*. The 1950 Ford in the top third of the painting has an anthropomorphic quality – the headlights could be eyes, the circular shape in the centre could be a nose, and so on. Thus the car becomes a stand-in for the obscured face of the male lover in the clinch in the middle third of the painting. This car looks macho and confident and unyielding: hell-bent on continuing in its particular direction – a proxy, then, for a man experiencing sexual desire who will not be deflected from gratification. The spaghetti in the bottom third, though, is associated by its position with the female lover, who closes her eyes and parts her lips as she

sensuously succumbs to the man's attentions. Is the spaghetti, then, an analogue for swirling female sexual desire? Or, perhaps more darkly, a symptom of fluttering, stomach-churning nerves? Is she even acquiescent in this embrace? Certainly, the spaghetti has a visceral, bowel-like quality – soft and squelchy like body tissue, in opposition to the hard external carapace and unflinching chrome fittings of the car above. So the painting is structured around contrasts between men and women, man and machine, and, of course, colour and black-and-white. If we elaborate this thought process one stage further, we might start to think about the way that advertising imposes itself upon us in an off-putting, almost sinister manner: in the vision of *I Love You with My Ford*, all those ads that imply 'Buy this car, and you'll get the girl!' may be doing unpleasant things to our vulnerable insides.

My point is that Rosenquist's imagery isn't just random: often he has some sort of agenda. This is certainly the case with one of his most famous paintings, *President Elect*, which was completed in 1964. Here, like *I Love You with My Ford*, the composition is divided into three areas, though this time the divisions occur vertically, not horizontally. On the left is a likeness of John F. Kennedy, replicating a promotional photograph used on a presidential campaign poster in 1960. In the middle a woman's hands break apart a slice of cake. And on the right is another fragment of a car – this time an old-fashioned Chevrolet's wheel with a shiny hubcap and part of the green panel running along the vehicle's side also visible above. Both car and cake were taken from advertisements that appeared in *Life* in, respectively, 1949 and 1954; the artist was intrigued by how Kennedy could 'advertise' himself in a similar fashion. To Rosenquist, the relationship between this trinity of imagery is self-evident: 'What did Kennedy offer you, as a candidate? A Chevrolet and a piece of cake.' End of story – except that it's worth pointing out how Rosenquist altered his

sources. In the campaign poster, Kennedy appeared in black and white – but in the painting, he blooms into bright, Technicolor life. The chocolate cake, meanwhile, which had appeared in the original advertisement in colour, has been painted in grisaille in the finished picture, along with the woman's fingernails, which were once red. In making this tweak, Rosenquist was surely concocting a cynical statement about the value of the guarantees of politicians: they may promise us cake today, the painting suggests, but come tomorrow either it will taste like ashes or it will have disappeared altogether, like the insubstantial spectre of a cake we see before us. See what I mean? This is editorializing – rebuking the culture, not celebrating it – in a subtle, allusive fashion. As Rosenquist also told me, the 'other' novelty about his early Pop paintings was 'questioning the capitalistic system. You know, advertising is what seems to keep television alive now – and I hate it. It's bombarding you to buy a new car or some other product every two seconds.' The point, I suppose, is that Rosenquist was not led simply by his visual instinct as an artist but also, importantly, by the specific thought behind each painting that governed its particular collisions and juxtapositions.

<center>*</center>

Nowhere is this more evident than in Rosenquist's masterpiece, *F-111* (1964–5). This is a painting so extraordinarily big – 86ft wide and 10ft high – that these days it is rarely shown in its entirety, since it makes such a land grab within crowded museums, where wall space is at a premium. A few years ago, it was exhibited as it was first shown, wrapped around the walls of the Leo Castelli Gallery in 1965, at the Museum of Modern Art in New York, where it is part of the permanent collection. 'Recently I was in a magazine [feature] about the ten best paintings to look at in New York City,' Rosenquist told me, apropos of a brief discussion

about Warhol's saying that in the future everyone would be world-famous for fifteen minutes. (The painting chosen by the magazine, of course, was *F-111*.) 'I'm mentioned next to Velázquez and Picasso. Not too bad.' Does he think that *F-111* is his greatest work? 'No – but that's what people think.'

Rosenquist once said that painting billboards was like 'training for the Olympics'. If so, then *F-111* is the feat that won him gold – according to the consensus view, at least, if not his own. Even by his standards, it is a vast, cacophonous, all-encompassing work of art painted in twenty-three sections, like a gigantic puzzle. The main structuring device, which unites its many disparate components, is the horizontal thrust of the fuselage of an F-III fighter-bomber attack aircraft emblazoned with the words 'U.S. AIR FORCE'. (This particular F-III is also identified by the number 39766 stamped upon its tail-fin.) Rosenquist first saw a photograph of the experimental new supersonic F-III aircraft in late 1964. An enthusiast of model airplanes as a boy, he was enthralled at once. Although at this point the aircraft, one of the most technologically advanced weapons of its time, was still top secret, he managed to get hold of some pictures and plans of it, which he then used to help design the painting. His idea was to create something really epic and memorable for his first exhibition at the Leo Castelli Gallery the following spring. He even measured the small room in the gallery where his work was going to be shown to ensure that his painting would fill it entirely.

In the final composition, images of all sorts of consumer products are superimposed on the aircraft's fuselage. Picking out the most prominent objects, we see, going from left to right: a hurdle; a massive black Firestone tyre with a chunky tread above an angel sponge cake; a broken yellow light bulb as fragile as an eggshell in between two intact bulbs, one powder pink, the other baby blue;

a smiling, blonde, doll-faced girl sitting beneath a bomb-shaped hairdryer against grass coloured a radioactive green; a beach umbrella in the foreground with an atomic mushroom cloud visible behind it in the distance; and a diver wearing an aqualung, gasping for air. At the far right, the aircraft's nose cone lances through a surreal cloud of Rosenquist's favourite brand of Franco-American spaghetti in tomato sauce, touched up with Day-Glo paint to give it a toxic glow: a stand-in, the artist later explained, for flak – 'the flak of consumer society'. In lesser hands, this welter of chaotic, fragmentary imagery would threaten to splinter apart, if not disintegrate altogether. Rosenquist, though, manages to corral it – and he does so via two principal means. First, he ensures that the dominant colour scheme of the composition is a simple triad, with differing shades of primary reds, yellows and blues accompanied by passages and accents of orange and green. And second, he introduces several visual rhymes – so that discrete objects and motifs appear to be in sync. Thus, the spume of bubbles created by the gasping diver echoes the shape of the mushroom cloud to its left. The metallic hairdryer is an upright version of the F-111's nose cone. (Somehow, the little girl with the helmet-like metal form above her head seems like a portrait of the pilot of this deranged contraption laden with cake and light bulbs rather than bombs.) The tyre finds an analogue in the round angel cake with a hollow centre. The zigzags on the tyre's tread resemble the points of the star insignia stencilled on the aircraft's fuselage. And so on. At either end of the composition, flanking it like a frame, are several panels of reflective aluminium – implying that the entire thing has been painted on a suitably militaristic, metal support. Actually, most of it was rendered in oils on canvas.

So what was this cornucopia of collaged imagery supposed to be about? 'It sounds esoteric,' Rosenquist says, 'but really it was

the idea of paying income taxes to make war weapons. And you
have an example right here in Manhattan. We have an aircraft car-
rier called *Intrepid* with trillions of dollars of war weapons sitting
on the deck just rusting away.' He is referring to the USS *Intrepid*
aircraft carrier, which was built for the US Navy during the
Second World War and decommissioned in the Seventies, before
ending up as a museum ship docked in New York City. 'They
[the war weapons] were used, probably, to prevent war – we hope,'
he continues. 'But I think a lot of it is just money for the military-
industrial complex.' In other words, *F-111* wasn't a piece of satire
so much as a great, sock-it-to-them protest painting. 'I remember
thinking: how terrible that taxpayers' money is being spent on
this war weapon that is going to rain death down on some inno-
cent population halfway around the world for some purpose we
don't even understand,' Rosenquist wrote in his memoir, 'while at
the same time this war-plane is providing a lucrative lifestyle for
aircraft workers in Texas and on Long Island.'

I ask him why he felt it was so important to juxtapose a paint-
ing of this lethal fighter-bomber with more innocent imagery
such as the beach umbrella or the smiling little girl. By this point,
Rosenquist is beginning to look tired – and murderous. 'Our –
our whole economy is built on selling war weapons,' he says
gruffly. 'I think it's wrong.' You sound angry about it even now, I
say. 'Yeah, why not?' Why not, indeed? So is that what motivated
the painting at the time – anger? 'Yeah,' he replies, before repeat-
ing himself for emphasis: 'Yeah, yeah.' Perhaps, then, we should
understand other well-known examples of his Pop Art as an attack
on aspects of America that he also felt were wrong? 'I don't know,'
he says, sounding weary. 'I live in it. I don't know how I can attack
it, because I'm in the middle of it.'

Then, suddenly, I get it. That sense of blankness which Rosen-
quist was striving for in his paintings: well, maybe it expresses the

emptiness of existence generally, rather than simply assaulting the supposed hollowness of the American Dream. 'Indeed,' Rosenquist agrees. Then he points out that in his formative years as a fine artist, he was influenced a great deal by the philosophy of existentialism. 'Zen Buddhism, too. And, according to Zen, everything is [empty] – not just America, not just capitalism.' In this, he was not alone. Back in the Forties, the avant-garde American composer and philosopher John Cage had also studied Zen Buddhism, before developing a new mode of composition based upon chance. His radical ideas influenced younger visual artists, including his friend Rauschenberg, with whom he collaborated at the experimental Black Mountain College in North Carolina in the early Fifties. Characteristic work dating from this period included Rauschenberg's series of proto-Minimalist *White Paintings*, which were exhibited in 1953 and in turn partially inspired Cage's infamous *4'33"*, a three-movement composition lasting for the duration of the title in which the performers were instructed not to play their instruments. Along with Johns, who was also a friend of Cage, Rauschenberg, of course, would lay the foundations for Pop. So you could argue that, paradoxically for an art form so concerned with images and discrete *things*, a philosophical sense of the dynamic emptiness and impermanence of existence was built into all Pop Art, and not just into Rosenquist's work, from the very start. 'I got a phrase for you,' says Rosenquist, who has been staring silently into space. 'All things are devoid of intrinsic existence. Think about that a while – it blows you away.' And, as I do, my mind turns to another Zen master of blank Pop Art: the brilliant Ed Ruscha.

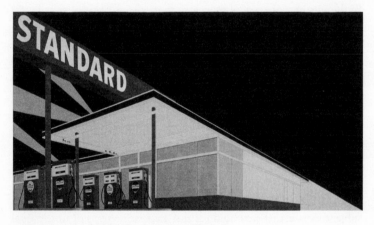

Ed Ruscha, *Standard Station, Amarillo, Texas,* 1963
(© Ed Ruscha. Courtesy of the artist and Gagosian Gallery)

The Laureate of Los Angeles

In the summer of 1962, after years of struggling to achieve any sort of recognition as a fine artist, Andy Warhol was finally looking forward to his first one-man exhibition of Pop Art. Sure, it would have been swell if a gallery in New York, where he had lived for more than a decade, had agreed to present his work. But he had offered his paintings of comic-book superheroes such as Superman and Popeye – the same pictures that he had shown in the window of Bonwit Teller in the spring of 1961 – to the Leo Castelli Gallery, and they hadn't played ball. Too similar to the cartoon paintings of Lichtenstein, Warhol was told – and Lichtenstein was already on Castelli's books. In a sense, though, this rejection was the making of Warhol. He left cartoons behind and began casting around for fresh subject matter that he could call his own. To this end, in the final weeks of 1961, he polled his friends for ideas. One of them, the American gallery owner Muriel Latow, told him: 'You should paint something that everybody sees every day, that everybody recognizes . . . like a can of soup.' So he did. And not just one can of soup, but thirty-two of them – documenting every single flavour in the manufacturer's catalogue of the Campbell Soup Company.

Soon after he began the series, Warhol received a visit from a suave individual called Irving Blum, who ran a gallery in Los Angeles. Blum had called upon Warhol five months earlier, when the artist's comic-book pictures had left him bemused: 'When he saw my Superman, he'd laughed,' the artist later wrote. In the

intervening period, though, Blum had found himself thinking about Warhol a lot – and now, presented with the first six canvases in the *Campbell's Soup Cans* series, he felt a crescendo of excitement. On the spot, he offered Warhol an exhibition at his gallery that summer. Warhol gleefully accepted. And so one of the most important exhibitions in the history of Pop Art occurred not in New York, where we might expect it to have taken place, but on the other side of North America altogether, on the West Coast. This was Warhol's big break.

In truth, not everyone realized it at the time. Even though the Ferus Gallery, which had been established in 1957 by the curator Walter Hopps and the artist Ed Kienholz, had showcased advanced contemporary art in the city for five years by the time of Warhol's exhibition, the *Campbell's Soup Cans* caused controversy. According to Blum, who was also a partner in the gallery and installed Warhol's paintings like commodities in a supermarket, running along a shelf attached to the wall, several LA-based artists were 'tortured' by them. A cartoon appeared in the *Los Angeles Times* featuring a couple of beatniks considering paintings of soup cans in the 'Farout Art Gallery'. 'Frankly,' its caption read, 'the cream of asparagus does nothing for me, but the terrifying intensity of the chicken noodle gives me a real Zen feeling.' Down the street from Ferus, a dealer in Pre-Columbian art lampooned the exhibition by displaying a pyramid of fifty shop-bought tins of Campbell's soup in his own gallery window, accompanied by the following sign: 'Get the real thing for only 29 cents a can.'

Still, Blum was adamant that Warhol's new art was important. Indeed, he was so certain about this that he telephoned the five collectors, including the actor Dennis Hopper, who had already committed to buying individual soup-can canvases for $100 each, and persuaded them to forgo the pictures. (Supposedly, Hopper was the trickiest to talk around.) On a mission to keep the

paintings together as a group, Blum then called up Warhol and struck a deal – agreeing a discounted price of $1,000, paid in ten monthly instalments, for the whole lot of them. Today Warhol's *Campbell's Soup Cans* rank among the most prized masterpieces in the permanent collection of New York's Museum of Modern Art.

The following year, Blum invited Warhol to exhibit at Ferus again. And this time, despite the gallery's location thousands of miles from his home in Manhattan, Warhol – that pale, withdrawn enigma who so craved recognition and success – decided that since his first exhibition at Ferus had caused such a stir, he wouldn't miss the opening of the new show for the world. Ahead of it, he sent Blum an enormous roll of canvas featuring screen-printed paintings of a life-sized, gun-slinging Elvis Presley, seen against a silver background. Sometimes Elvis appeared singly, at other times he was doubled up, and occasionally images of him were superimposed one on top of the other in multi-figure groups. Warhol also provided a box of wooden stretcher bars of different sizes. He then instructed Blum to cut up the roll of canvas however he wished, before assembling the various parts into paintings using the bars, and hanging them 'edge to edge, densely' around the gallery. By delegating all of this to Blum, Warhol – who famously said, 'I want to be a machine' – was replicating the kind of imitation mechanical production line that he had been developing with his assistants in his New York studio, which became known as the 'Factory'.

Confident that Blum would not let him down, Warhol then arranged to visit California in time for the opening of the exhibition. Towards the end of September 1963, accompanied by his assistant, Gerard Malanga, a young poet from Brooklyn, as well as the underground film actor Taylor Mead and the painter Wynn Chamberlain, Warhol packed a mattress into a station wagon and set off on a three-day road trip across America to LA. Hurtling along the highway, listening on the radio to songs by Lesley Gore

('It's My Party') and the Ronettes, Warhol and his companions experienced a kind of epiphany. All around them, marking the landscape, were huge and garish commercial signs. And suddenly, to their eyes, every one resembled a gigantic, ready-made work of Pop Art. Later, in his memoir *POPism*, Warhol wrote about their adventure. 'The farther west we drove, the more Pop everything looked on the highways,' he recalled. 'Once you "got" Pop, you could never see a sign the same way again. And once you thought Pop, you could never see America the same way again . . . We were seeing the future and we knew it for sure.'

Even though Pop Art ended up becoming indissolubly associated with New York, since this was where so many of the movement's biggest names lived and worked, Warhol sensed what any first-time visitor to Los Angeles could tell you today: it is hard to conceive of a city more in sync with Pop's spirit. When Warhol arrived there in the early Sixties, LA was already growing into the sprawling, jumbled, hedonistic megalopolis it is now: a hundred suburbs in search of a city, as someone wittily once put it, basking beneath palm trees and eternal sunshine, and dreaming (like Warhol) of the big time. And just as Pop Art would be obsessed with the surface of things, so LA was already a city of artifice and superficial appearance: a consumerist wonderland full of commercial signage, whimsical and fantastical buildings that looked like façades on a film set – and, of course, Hollywood itself, the epicentre of the glamorous movie industry. As the American photographer and painter Man Ray once joked: 'There was more Surrealism rampant in Hollywood than all the Surrealists could invent in a lifetime.' Even the sprinkler-fed grass by the sidewalk in LA appears eerily lush, hyper-green – and fake. For rising Pop stars like Warhol, then, Los Angeles – which has been called 'the Mecca of popular culture' – was a kind of paradise. Upon his arrival, Warhol bagged himself a suite at the Beverly Hills Hotel and attended a party thrown in his honour by Dennis

Hopper and his wife Brooke Hayward: 'This party was the most exciting thing that had ever happened to me,' he later said. He even found time during his stay in the city to shoot an experimental 'home movie' called *Tarzan and Jane Regained . . . Sort Of*, which was released the following year.

A few weeks after the opening of Warhol's exhibition of *Elvis* paintings at the Ferus Gallery, Peter Blake also arrived in LA for the first time. Blake had been invited by the *Sunday Times Magazine* to pick a place towards which he felt 'an affinity' and then to travel there to record his responses to it. He chose LA in part because he had always wanted to go, but also because he had recently married Jann Haworth, who had been brought up in Hollywood, where her father worked in the movie business as an Oscar-winning art director. They turned up in the city in November 1963. 'I remember arriving in Los Angeles very clearly,' Blake says, 'because Jann's father, Ted, who had art-directed *Some Like It Hot*, met us at the station in a gold Corvette Stingray Convertible. He lent it to us, and so for the rest of the trip we drove around LA listening to very early Beach Boys on the radio. That was arriving.'

As he knew he would do, Blake quickly became besotted with Los Angeles. Inspired by its bizarre and outlandish character, he made drawings everywhere he went. He sketched the octogenarian lion tamer Mabel Stark, whom he met in the LA neighbourhood of Tarzana, as well as the funfair in Pacific Ocean Park. On the day that President Kennedy was assassinated, on 22 November, he was sitting on a daybed in a back lot of a film studio, drawing props that had been used in *Cleopatra* (1963), starring Richard Burton and Elizabeth Taylor. (In 1963, Warhol painted *Blue Liz as Cleopatra*, a silk-screen of Taylor, wearing an Egyptian headdress, set against an azure background.) Driving through the city, Blake was bowled over by a gigantic doughnut sign that he suddenly

spotted above an outlet in a chain of bakeries then known as the Big Do-Nut Drive-In, so he stopped and drew it while still sitting in the passenger seat of the Stingray. This extraordinary sign, which dwarfs the building beneath it, and looks as alien as a colossal rock in the middle of a flat desert, is still visible on top of a restaurant now called Randy's Donuts. It is exactly the sort of thing that seemed 'Pop' to Warhol during his road trip of '63 – and it is no surprise that Blake, who had also been working as a Pop artist for several years, was smitten by it too.

During their time in Los Angeles, Warhol and Blake both fraternized with many of the city's younger artists, including Larry Bell, who made abstract compositions incorporating shards of glass and household mirrors; Bruce Conner, an underground film-maker and sculptor who worked in the 'assemblage' style; and Billy Al Bengston, an athletic, flamboyant figure from Kansas who made art strongly influenced by southern California's motorbike and customized car culture. At the same time, in northern California, Mel Ramos, who, like Warhol and Lichtenstein, had already painted comic-book superheroes by 1961, was beginning his tongue-in-cheek (or plain tasteless?) series of voluptuous pin-up girls. These naked nymphomaniacs sit seductively in martini cocktail glasses, caress phallic bottles of Coca-Cola, and emerge from chocolate-bar wrappers. Along with other artists such as Vija Celmins and Joe Goode, who, like Bell and Bengston, attended Warhol's opening at the Ferus Gallery, as well as Wayne Thiebaud, these figures formed a scene that would become known as West Coast Pop Art (although Bell, in truth, would be more associated with Minimalism). 'It was a very strong movement,' says Blake, who hung out with many of its protagonists while he was in LA. 'Billy Al was interested in racing motorbikes, and he painted very specifically about that. Larry Bell was doing pictures with mirrors. Bruce Conner was making strange collages using human hair and

stuff like that. I have always been very supportive of West Coast Pop Art, because they were given a rough time.'

One of the criticisms occasionally levelled at West Coast Pop is that, unlike Pop Art from New York, it was too regional, too parochial, and overly concerned with local subcultures and fads. While this may be true for some of its practitioners, it is emphatically not the case for the most famous artist associated with West Coast Pop: Ed Ruscha. Like his contemporaries, Ruscha went along to the opening of Warhol's exhibition in the days when he still looked like a Hollywood matinee idol – as recorded in a famous black-and-white photograph of him in front of a neon sign taken by his friend Dennis Hopper in 1964. By then, Ruscha was beginning to acquire his reputation as the dominant American chronicler of the unique urban landscape of LA: some people even see in the bright, hazy colours of his paintings a vision of the city's smog. Like Warhol, who was thrilled by the Pop appearance of the highways in America's West, and Blake, who drew the Big Do-Nut Drive-In while sitting in a Stingray, Ruscha became obsessed with the signs, storefronts and strange structures cluttering LA's streets that he saw from a moving car. By recording these phenomena, Ruscha made an extraordinary contribution to the invention of Pop Art.

★

These days, Ruscha's studio is a low-slung, hangar-like space in Culver City in western Los Angeles County, a few miles south of his home in Coldwater Canyon. Even now, aged seventy-seven, despite receding grey hair and a slight stoop, Ruscha is good-looking, with bright, ice-blue eyes, like a husky's. He is also blessed with great reserves of laid-back charm. Actually, 'laidback' sounds too frenetic to describe his easy-going demeanour, which is evident in his choice of comfortable clothes: a loose, open-necked grey shirt, roomy stonewashed jeans and New

Balance trainers. At points in our conversation he speaks slowly, like someone who has just popped a couple of the diazepam pills that occasionally appear in his paintings. Every now and then he reveals a hint of defensive shyness – crossed arms, a wrinkled brow, the odd verbal stumble, throat clearing, or 'um' and 'uh' – but generally he emanates a low-key, off-duty charisma, like a tanned former star of the black-and-white movies he loves so much, relaxing in retirement. That said, Ruscha, as we shall see, is still very much making art: 'I've got this urge, this habit, and, um, I can't seem to put my tools down,' he says.

To begin with, he claims that he cannot recall the early Sixties in any detail: 'You know, it's way in the distance, and I'm having trouble remembering what I was up to.' He smiles, as if to say: but so what? Relax. After all, this is Los Angeles – the city of pleasure-seekers, not strivers, which he has documented so extensively over his long career. Besides, Ruscha says, 'After you've been doing something for sixty years, well, you say: "What got me into that?" And then you understand less about it than most people who see it.' With that, he laughs – tickled by the absurdity of attempting to understand what happened more than half a century ago. As with Rosenquist, absurdity, you see, is one of the big themes of his art.

For the past four years, this nondescript building in Culver City, beside a freeway that is softly audible beyond the glass doors of the kitchen, has been Ruscha's open-plan studio. The structure was built in the Fifties by the American business tycoon, aviator and maverick film-maker Howard Hughes as a warehouse for movie props – imitation bronze Buddhas, marble statues and sarcophagi, that sort of thing – before it became an aviation factory churning out propellers and the like. At the rear of the property, beside a small orange grove, Ruscha houses a couple of vintage automobiles, including a glossy black Ford pickup truck. His main, 'completely messy' studio is also somewhere round the back. Upon

my arrival, he emerges from this private space flanked by his Border collie rescue dog Lola, a sweet-spirited, formerly abused creature that still flinches upon encountering strangers. The British fashion designer Stella McCartney, a friend who happens to be visiting, also accompanies him: like her former Beatle father, Paul, she collects Ruscha's work. Having said goodbye to McCartney, Ruscha ushers me into a large workshop where, he says, he keeps 'some older works I've made'. It is filled with rows of art books on functional metal shelves as well as lots of artworks crated up in thick cardboard cases. The various packages and boxes are labelled with gnomic descriptions applied in marker pen: 'Rome', 'Road Tested', 'Birds Fish & Offspring', 'Basel Apartments', 'Psycho Spaghetti Westerns'. On one wall, two paintings hang side by side. To the left is a canvas by Ruscha featuring a Rothko-like background of bands of blue and orange behind a cross of metal scaffolding poles pushing at the edges of the canvas, and seemingly causing them to bow outwards. 'I call it my *Charles Atlas Landscape*,' Ruscha says, referring to the Brooklyn bodybuilder who fronted a memorable ad campaign promising scrawny weaklings that they could become attractive musclemen like him. The other painting is by a younger American artist called Dana Schutz. In it, a flock of swords, daggers, cutlasses and rapiers appears to fly as if by magic through an empty room with bare floorboards.

The most immediately eye-catching object, though, suspended from the wood-slatted ceiling at the other end of the room, is an imposing surfboard. (We are in California, after all.) Presented on its side like a lozenge or a speech bubble from a comic strip, so that the fin sticks out at a perpendicular angle like a shelf, the board is decorated with two large words in Gothic script – 'The End' – presented against a hazy greyscale ground that has been mocked up to look like scratched antique celluloid. This belongs to an extensive series of works that Ruscha began in the early Nineties,

all featuring the same phrase floating against monochrome backgrounds resembling degraded film stock, with tiny scratches, blemishes and scrapes. Many art critics have understood these works, which seem so self-evidently about finality and decline, as comments upon the slow fade of the so-called 'American Century'. On another, more personal level, they could also be read as heartfelt elegies for a glorious era of Hollywood that has long since disappeared. Ruscha has worked in the shadow of Hollywood throughout his adult life – and, as it was for Warhol, so for Ruscha Hollywood has been one of his most enduring and alluring themes. He has made frequent reference in his art to the movie industry generally as well as, specifically, to the famous sign with its blocky, capitalized white letters overlooking LA from its perch on the Santa Monica Mountains. 'This place is a storehouse, really,' says Ruscha, gesturing around him, 'for stuff that I can look back on.' And, as we talk, surrounded by so many artefacts and artworks from his past, it transpires that Ruscha can remember what he was up to in the distant Sixties after all.

Los Angeles has been fundamental in shaping Ruscha's artistic vision, but he didn't grow up in the city. He was born in 1937 in Omaha, Nebraska, where his father, who spent twenty-five years as an insurance auditor, had settled following a tough upbringing as the eldest of twelve children born to working-class parents who ran a grocery store and were strict Catholics. (Ruscha's great-grandfather changed the family name from the Bohemian-German 'Rusiska' to 'Ruscha', pronounced 'Rew-SHAY' to rhyme with the town Chickasha in Oklahoma.) 'My father had his own type of rough childhood,' Ruscha once said. 'He had to constantly be scrubbing cabbage.' Ruscha's childhood, by contrast, was not impoverished but middle class. When he was four, the Hartford Insurance Company offered his father a position in Oklahoma City, so the family moved there and bought a

house, which his mother decorated with a bust of Shakespeare placed upon the mantelpiece. Ruscha was sent to a convent school, where he spent an unhappy year being bullied by a malicious nun who used to beat his fingers with a pencil. This memory makes me think of his 1965 canvas *Give Him Anything and He'll Sign It*, which features a large, realistically painted bird with black-and-white feathers, evoking the colour scheme of a nun's habit. In a bizarre twist, consciously imitating the warped, dreamlike imagery of Magritte and Man Ray, both of whom Ruscha would later acknowledge as important influences, the bird's beak and tail have been replaced by the graphite tip and rubber end of a yellow 2H pencil. The bird lowers its head as though preparing to tap the pencil's sharpened point on to a piece of unsuspecting prey. It is an absurd, whimsical, deliberately nonsensical image – but also, perhaps, one freighted with personal significance and menace for Ruscha. Pencils crop up frequently in his paintings. Sometimes they appear snapped in two. Ouch.

As a boy, Ruscha did not encounter much art aside from the kitsch religious icons that used to hang at home. This fact is significant, because religious art is an important but under-acknowledged source for Pop: Warhol's weekly encounters as a child with the screen of religious icons of saints against a golden background in the Byzantine Catholic church a three-mile walk away from his home in Pittsburgh were an important influence upon him as a Pop artist. His portraits of the superstars Marilyn Monroe and Elizabeth Taylor, in particular, glittering against bright, monochrome backgrounds, can be understood as secular versions of religious icons.

Ruscha was not taken to any museums, and at school his education in art history consisted of little more than being shown world-famous works of art such as Rodin's sculpture *The Thinker* or Leonardo's *Mona Lisa*, which Warhol replicated in his

1963 silk-screen *Thirty Are Better Than One*. (Curiously, in Rus-
cha's studio, I spy a children's toy block, each face decorated with
a reproduction of the *Mona Lisa*, alongside some leather-bound
books that look like family heirlooms inside a glass-fronted
wooden cabinet.) Occasionally he would flick through a book
about Rembrandt that his parents owned, but otherwise it was
commercial art that caught his eye – especially the cover illustra-
tions by Norman Rockwell that adorned his father's favourite
magazine, the weekly *Saturday Evening Post*. Indeed, Ruscha would
later say that he exhibited no interest in art until he was ten or
twelve years old, when he began to admire the drawings of a friend
of his called Bob Bonaparte, who lived a couple of doors away and
sketched cartoon characters such as Dick Tracy. (This, of course,
was one of the comic-book characters painted by Warhol in his
earliest Pop pictures of 1960–61.) '[Bob] introduced me to the first
factor in my life [to do] with art,' Ruscha later said, 'which was
India ink: Higgins India ink. I remember seeing Higgins spill out
on a piece of paper, and you could watch it dry up and crack. I had
a real tactile sensation for that ink; it's one of the strongest things
that has affected me as far as my interest in art.' With this in mind,
it is striking that so many of Ruscha's later paintings of solitary
words such as 'Annie', 'Lisp' and 'Steel' would look as if the letters
had been formed by chance from splashes and blobs of various
types of liquid, including water and maple syrup, momentarily
coagulating on flat, monochrome surfaces.

At the time, though, as a boy experimenting with Indian ink,
Ruscha still had little interest in painting. His mother encouraged
him to attend an art class run by a traditional painter with a studio
in Oklahoma City, but he lasted for only three months. Ruscha
was asked to look out of the window and draw the houses on the
other side of the street – but his mind would always drift away
from the task in hand and on to comic books. 'That was where the

real vitality was,' he later recalled. 'I was constantly drawing cartoons.' His favourite comics were *Dick Tracy*, *Blondie* and *Felix the Cat*. A decade or so later, in 1960, the same year that Warhol and Lichtenstein first started considering cartoon characters as subjects for pictures, Ruscha stuck a Photostat of Felix the Cat on to a chequerboard painting with panes of abstract colour in which the brushstrokes were freely visible. This was an important, transitional, Janus-like work of art – with one eye on the recent dominance of abstraction and the other on the fledgling, as-yet-unnamed Pop mode. In this respect, it was an in-between picture, a little like Warhol's initial Pop forays such as *Batman*, *Superman* and *Dick Tracy*, or his first paintings of Coca-Cola bottles, in all of which traces of his hand remain prominent. *Felix* also presaged Ruscha's continued interest in comics as a Pop artist – an interest that manifested itself in a way distinct from the approach of, say, Lichtenstein. In *Annie Times Six* (1961) and the single-word *Annie* (1962), for instance, Ruscha evoked the Little Orphan Annie daily comic strip by painting only her name using its instantly recognizable typeface. The former work, with its grid repeating the word 'Annie' over and over, was painted a good year before Warhol's famous interest in serial imagery announced itself in paintings such as *Campbell's Soup Cans*, *192 One Dollar Bills*, *Marilyn Diptych* and *Red Elvis*. Comics appear in other early Pop paintings by Ruscha as well. In *Flash, L.A. Times* (1963), for example, an upside-down front page of the paper's 'funnies' section, with a few panels visible from that day's edition of *Dick Tracy*, appears against a depthless green background beneath the word 'FLASH', which has been painted in enormous yellow letters above. In another painting from 1963, Ruscha faithfully reproduced the front cover of the October edition of a *Popular Western* comic book, complete with tagline ('quick-trigger stories') and price (10 cents). He would repeat the device using the same front cover in yet another

painting the following year, though this time the cheap *Western* comic book, partially torn in half, floated incongruously in a blue sky above a gas station.

As well as reading comics as a teenager, Ruscha also began to execute his own cartoons, which he submitted to the student newspaper while he was still at high school in Oklahoma City. Knocking about the school library one day, he chanced upon a book about the aggressively avant-garde Modernist art movement known as Dada, which first emerged in the second decade of the twentieth century and prized combative stunts and shock tactics as a way of registering the revulsion its founders in Zurich felt about the First World War. The provocative anti-art gestures later undertaken in New York by Duchamp were also considered classic Dada. These included the infamous incident when Duchamp submitted an upturned porcelain urinal, entitled *Fountain* and signed 'R. Mutt', as a ready-made work of art to the first annual exhibition of the Society of Independent Artists at New York's Grand Central Palace in April 1917. The urinal was rejected – but it has since been credited as the first work of Conceptual Art. When Ruscha read about this and other aspects of Dada, he felt 'awakened'. Along with his love of drawing cartoons, and a burgeoning sense of horror at the prospect of spending the rest of his life in the claustrophobic, conformist Bible Belt of America's Midwest ('An artist would starve to death there,' he once said), this persuaded him by the time he had turned eighteen that he needed to get away from Oklahoma and escape to art school. He briefly considered applying to Cooper Union in New York – which incubated other artists later associated with Pop, including Oldenburg and Wesselmann – but then he heard about the Chouinard Art Institute in California, which was supported by Walt Disney, who regularly employed animators who had trained there. This fact appealed both to Ruscha's own interest in cartoons and to concerns about his

career prospects on the part of his father, who admired Disney as a 'great American', in the mould of Norman Rockwell. Moreover, Ruscha was left cold at the idea of spending any extended period of time amid the 'oppressive concrete' of New York, whereas he had always enjoyed visiting California on summer family holidays. He was also becoming increasingly fascinated by the state's hot-rod subculture. 'LA sounded better to me,' Ruscha tells me. 'Um, just had more flavour to it. More swank or something that I may have been missing at the time.' So in 1956, when he was still eighteen, Ruscha packed his belongings into his 1950 Ford (the same model that Rosenquist would later paint), which he had lowered and customized with smitty mufflers, and set off for Los Angeles along Route 66. Ruscha left Oklahoma City as a good Catholic boy with hopes of making it as a commercial artist. Yet, after arriving in LA and enrolling at Chouinard, which he soon discovered was a bohemian place where the students wore long hair, beards, sandals and jeans, and where fine art was accorded much greater prestige than commercial work, he stopped going to church and his ambitions and worldview changed.

<p style="text-align:center">*</p>

For a young artist like Ruscha arriving in the city for the first time, Los Angeles must have seemed like a blank canvas. While hard-boiled screenwriters and novelists such as Raymond Chandler had already dramatized the city as a subject, visual artists had yet to make it their own. This is something that was recognized by the British painter David Hockney, who was born in the same year as Ruscha, and also gravitated towards LA. Like Blake, Hockney arrived there in 1963, the year after he was awarded the gold medal for his class at the Royal College of Art in London. Unlike Blake, who soon returned to London, Hockney would call the city his home for the next five years. In Los Angeles, he felt free to paint

the specifics of the place he was encountering: the palm trees, the
low Modernist architecture with sliding glass doors, the mani-
cured housewives and works of art displayed like trophies – and, of
course, the nude, tanned, gay young men, lounging listlessly on
lilos or emerging from the sparkling surfaces of swimming pools
like male versions of the alluring nymphs that populate Old Master
paintings. 'Swinging London,' Hockney later remarked, 'was too
straight for me. It wasn't really gay at all, was it? I suppose that's the
truth, that's why I didn't like it.' In these well-known paintings,
Hockney was inventing the visual form of the city, creating a
snappy, recognizable vision of it that could be bequeathed to pos-
terity. 'In London, I think I was put off by the ghost of [Walter]
Sickert, and I couldn't see it properly,' he once said. 'In Los Angeles,
there were no ghosts . . . I remember seeing, within the first week,
the ramp of a freeway going into the air and I suddenly thought:
"My God, this place needs its Piranesi; Los Angeles could have a
Piranesi, so here I am."' In other words, for both Hockney and
Ruscha, Los Angeles was virgin, uncharted territory that as artists
they could colonize. 'It almost takes somebody from a foreign
country to come to America to really see America,' Ruscha says,
referring to Hockney. 'Most views of America are not captured by
Americans – they're captured by people from other countries. Like
the photographer Robert Frank [whose influential book *The
Americans* was published in 1958] – he's from Switzerland.' Perhaps
by virtue of pitching up in the big city from faraway Oklahoma,
Ruscha also had something of the outsider's fresh, askance perspec-
tive on LA. As he put it to me: 'I went from a small town to a big
town. So I was more or less wowed by this: all these millions of
nerve endings that this city was made up of. In almost every city of
America, there's an urgency, a kind of speed and spirit that you can
use to propel yourself in the making of art. Sometimes just the
noise of living in a metropolitan city like this is enough to keep

some kind of hard-edged spirit alive.' Incidentally, following on from Hockney's remarks about LA's soaring freeway ramps, it is tempting to speculate on the source of the many strong diagonals that dominate the compositions of some of Ruscha's most famous paintings, such as *Large Trademark with Eight Spotlights* (1962) and *Standard Station, Amarillo, Texas* (1963). As Ruscha said in 2008: 'I have a weakness for diagonals in my paintings and I like things that shoot up in the air.' Could it be that, like Hockney, Ruscha was unconsciously inspired by the airborne architecture of LA's freeway ramps? Certainly, much of his art adopts the tarmac-bound perspective of a car speeding along the road.

Ruscha was at art school for four years, between 1956 and 1960. Influenced by some of his teachers, such as the American painter and sculptor Robert Irwin, as well as by the attitudes of the Beat Generation epitomized by the writing of Jack Kerouac, he slowly became more and more interested in becoming a fine artist. 'It was nothing planned,' he later recalled. 'I just gradually began to lean over to the hot side of life, the stuff that really was happening, like the fine arts and the painters, being aware of galleries and the sort of things that were happening in galleries.' One day, he spotted reproductions in an art magazine of a *Target* painting by Johns and Rauschenberg's freestanding *Combine* painting *Odalisk* (1955–8), which was surmounted by a stuffed rooster, and got very excited. (At the time, Johns and Rauschenberg were routinely described as 'Neo-Dadaists' – so, given Ruscha's interest in Dada, which had been sparked in Oklahoma, his enthusiasm for their work was understandable.) 'I knew from then on that I was going to be an artist, a fine artist,' Ruscha recalled in 1980. Up to that point, he had been taught about Abstract Expressionism. 'Inspired by Jackson Pollock,' he says, 'I'd paint a canvas on the floor. It felt okay, but it was being done so well by so many artists that I thought, well, we're almost to the point of exhaustion on this. And I began

to see other things [such as the art of Johns and Rauschenberg] and I began to see popular culture and the figurative idea intruding into art and sort of pushing out the abstract.'

At the same time, he was fostering an interest in book design. In order to help pay his tuition fees he got a part-time job for six months at a small fine-arts press called the Plantin Press, where he worked as a 'printer's devil', or apprentice, and learned how to set type by hand. This interest in books and typography would have important repercussions upon the sort of art he would eventually make: gradually Ruscha began to consider books as tactile objects in their own right and his own paintings as imaginary book covers. In other words, getting to grips with graphic design was crucially important for Ruscha, just as it was for Blake. Moreover, during the Sixties, while pursuing a career as a fine artist, Ruscha continued to undertake commercial work. This included designing layouts for the magazine *Artforum* under the pseudonym 'Eddie Russia'. As we have seen, lots of Pop artists took on commercial work: Johns and Rauschenberg did so, under the alias 'Matson Jones', and so did Lichtenstein, Rosenquist, Thiebaud and, of course, Warhol.

Mixing with classmates such as his old friend from high school Joe Goode – whose deadpan series of large-scale, monochrome milk-bottle paintings of the early Sixties would blend abstraction with the new Pop sensibility – and inspired by the 'aura' of Billy Al Bengston, who taught the occasional session at Chouinard, Ruscha must have felt that his old life in Oklahoma City was very distant. Bengston, in particular, was an ostentatious character, an erstwhile professional motorcyclist who had five one-man exhibitions at the Ferus Gallery between 1958 and 1963, and also supplemented his income around 1960 by working as a stuntman in the film business, earning $500 every time he fell out of a building while producing stock footage for the studios. Compelled by

Johns's memorable *Targets*, Bengston decided to find a distinctive 'icon' of his own. He started experimenting with the V-shaped chevrons of a sergeant's stripes, which he eventually placed within geometric shapes rendered in dazzling, psychedelic and metallic colours in paintings with lacquered surfaces that could be polished up to gleam like a motorcycle's bodywork. 'My earlier work took off from things I saw in the street,' Bengston once said. 'And Los Angeles, of course, was and is a car culture . . . So I used car- and sign-painting materials and colours the way an artist would any other kind of colour.' Bengston's impersonal paintings have terse, macho names like *Big Duke*, *Clint* and *Buster*, often referring to male movie stars – appropriately enough, given the artist's dealings on the fringes of Hollywood.

Bengston and his art must have seemed exotic and even mind-blowing to slightly younger artists such as Ruscha. Yet it was returning home to visit his family several times each year that eventually inspired Ruscha to produce one of his most memorable early Pop works. He undertook the journey in various ways – hitchhiking, driving or sometimes hopping on a bus, but always passing through the states of California, Arizona, New Mexico, Texas, and into Oklahoma along Route 66. Inspired by the black-and-white photography of Walker Evans and Robert Frank, both of whom had offered distinctive, and far from celebratory, visions of contemporary American life (documenting, in Frank's case, his own road trip across the United States in 1955), Ruscha started taking pictures of the various gas stations that he stopped at or passed during his journeys. Eventually he had amassed a group of around fifty images of gas stations, mostly taken in 1962. When I visited Ruscha's studio in Culver City, prints of them all had been laid out in geographical sequence from east to west, starting in Oklahoma and ending in LA – documents of a road trip that was once a regular occurrence in the artist's life. 'I always

liked the architecture of them,' he says, 'and, uh, the fact that everybody needs them, if they're going to travel. Somehow the whole culture of gas stations had a sort of zoom factor.'

The style of the photographs is immediately striking. It is often described as 'deadpan', which reflects their flat, matter-of-fact, seemingly artless character, apparently drained of emotion. In most cases Ruscha photographed the gas stations from the vantage point of a passing car window: sometimes, blurry elements of the vehicle in which he was travelling are visible in the foreground. We see lots of tarmac – often with horizontal road markings that appear to swoosh past, conjuring the sensation of driving at speed – and, of course, the squat, blocky forms of the gas stations themselves: usually white and brightly lit by stark sunshine, like specimens in a surreal scientific study. (One or two were shot at night – and a couple of these nocturnal scenes, illuminated with copious neon, are unusually blurry.) Maybe, though, the stations are more like Duchamp's ready-mades plucked from reality: after all, if a mass-produced urinal could be a valid work of art, why not an actual gas station, or at least a photograph of one? 'They are ready-mades, you know,' Ruscha agrees. 'And I happened to have this camera that I wanted to record them with. In a sense I was glorifying each one of these things, calling attention to something that most people might say doesn't need calling attention to.'

In the photographs there are very few people, something that adds to the generally clinical air, as if we are looking at typographical illustrations in a specialist textbook or manual, or perhaps an imaginary catalogue offering different brands of gas station for curious shoppers interested in that sort of thing – underscoring the photographs, after all, is a note of brittle, possibly ironic humour. Occasionally we see the long shadow of Ruscha himself, caught at the moment of taking the picture, reminding us of the autobiographical context of the series: 'There is a certain

amount of me in there,' he concedes. But, rather than human interest, the primary focus is often the large lettering of signs and corporate logos, such as the words 'SEASIDE' and 'BOB'S SERVICE' that adorn a station in LA. Or an establishment called 'RIMMY JIM'S' in Arizona, where as well as gas, passers-by could pick up 'NAVAJO RUGS' or 'BEER & LIQUORS'. (Did Ruscha pop in to Rimmy Jim's for a quick drink? 'I sure did.') The enormous word 'STANDARD' floating like a banner raised aloft above a forecourt in Amarillo, Texas. And – appropriately enough for the final image in the sequence – a billboard bearing the brand name 'FINA'.

★

Inspired by his time working for the Plantin Press, Ruscha decided to reproduce some of these photographs in a small book. 'I loved the idea of making a book,' he says. 'I came to that because I worked for a book printer and I learned how to set type in the ancient method. And somehow I knew that the book was almost a non-existent art form. It was not really looked upon as being an art form.' The possibility of changing that was something that appealed to Ruscha as a young artist – making a book felt like territory that he could own, just as LA itself as a subject had yet to be fully exploited.

In the end, he selected around half of the photographs and arranged them in order, beginning with Bob's Service in California – near the 'seaside', of course, evoked by the sign. The sequence finished at a busy forecourt in Oklahoma City, before the self-aware postscript of a Fina oil company station that Ruscha had photographed in Groom, Texas. Each spread consisted of nothing but photographs of one or two gas stations accompanied by terse labels in small capitals providing their names and locations. In total, twenty-six gasoline stations were featured – selected,

Ruscha says, more or less spontaneously. 'It wasn't like, "Well, I've got twenty-six to come up with. Where do I start?" And it wasn't like I picked the best twenty-six. I didn't want to belabour it with any kind of deep intelligence. It was just one played off another, off another, off another – a free-and-easy way of describing the subject without belabouring it.'

Ruscha called the book *Twentysix Gasoline Stations* – another deadpan gesture perfunctorily describing the book's contents. He designed a simple cover, with the words of the title in red arranged in three lines against a white background, and spent $400 of his own money – around $3,000 today – to produce an initial run of 400 copies. Forty-eight pages long, and measuring just 5in. × 7in., the finished book was published in 1963.

To begin with, Ruscha gave away many copies – and the range of reactions he received intrigued him. 'Occasionally I would give one to somebody who worked in a gas station,' he says, 'and they would immediately say, "Oh, how great. I used to work in one like this and all." But if I gave a copy to an intellectual person, there would be doubts – sometimes, grave doubts. They would wonder about my sanity or think that I was having somebody on with this project of mine.' And was he? 'It didn't matter. It's just that I liked the end result – and, in this case, the means to the end. So doing it was just as much fun as having it finished.'

The question of whether Ruscha was being sincere or ironic in offering up photographs of gasoline stations is the crux that arguably animates all of his art – as we shall see. For now, though, suffice to say that the 'grave doubts' about the book voiced by some people at the time provide a reminder of how baffling, alien and even incendiary early Pop Art could appear, by concentrating on elements of everyday culture such as gas stations seemingly without commenting on them. We find a similarly flat, banal and apparently unadulterated presentation of popular culture in, say,

the American flags of Johns, Warhol's early paintings of soup cans, Coke bottles and dollar bills, or Lichtenstein's black-and-white canvases of isolated and enlarged commonplace objects, such as a radio, a ring, a golf ball and a ball of twine. Today, though, most 'intellectuals' with an interest in post-war American art consider *Twentysix Gasoline Stations* a milestone in the tradition of the artist's book – a good copy from that initial print run can fetch many thousands of pounds. (Another 500 copies were printed in 1967, before a third printing of 3,000 copies appeared in 1969.) As a work of art, it is both satisfying and odd – and one of the strangest things about it is the puzzling specificity of its title. Why 26 gasoline stations and not 24, 37, 49 – or just, say, 8? Ruscha looks momentarily perplexed. 'I battled in my mind about what to call it,' he says. 'And, uh, somehow I arrived at that by no particular means. No agenda, no significance. Except I did look back at my history and when I was about fourteen I hitchhiked from Oklahoma to Florida. And I recall it took twenty-six rides to get down there and twenty-six rides to get back. Whether that connects up or means anything is unimportant. The point was that I had blind faith in this number. And the blind faith led me to make the next step and make a book out of this.'

It is interesting that Ruscha alighted upon his supposedly random, impersonal title by mulling on a memory of personal significance. Moreover, 'blind faith' is a revealing phrase – an unconscious hangover, perhaps, of his Catholic upbringing. (At another point, he suggests that his memories of looking at pictures of the Stations of the Cross may have indirectly informed the appearance of his own art. Our conversation takes place in front of his *Charles Atlas Landscape*, which resembles a crucifix.) He uses the phrase 'blind faith' again later in our conversation, to describe how he comes up with the odd words and phrases that appear centre-stage in his drawings, prints and paintings, such as 'BOSS',

'HONK', 'ACE', 'OOF', 'BELLADONNA', 'GUACAMOLE AIRLINES', 'DIRTY BABY' and 'TULSA SLUT'. 'They come to me in various ways,' he says, handling a recent drawing of the words 'NAZI MILK MAIDS', which was inspired by a picture he had chanced upon while flicking through a book about the life and art of the Hollywood photographer William Mortensen, who specialized in erotic and occult subjects. The photograph, of busty young women wearing what could be German national dress, has nothing explicitly evocative of the Nazi Party about it – though it does have a certain wholesome Hitler Youth atmosphere that could trigger such an association. 'I could be accused of being a linguistic kleptomaniac,' Ruscha continues. 'I let things come to me. They happen while I'm listening to the radio or when I hear people talking in everyday life. Sometimes I have no idea where a word comes from – I just like its sound.' People often ask him if he ever runs out of words. The answer is that he hasn't so far, but it's never as simple as flicking through a dictionary until a word jumps out at him. Indeed, for some reason, riffling through dictionaries doesn't work so well. 'I can't make a work out of just anything,' he says. 'I feel like I have to keep the blind faith and use whatever I feel is tough at the time.'

In the case of *Twentysix Gasoline Stations*, Ruscha's faith was rewarded. He was so pleased with the result that he went on to produce many more books – seventeen of them in total in the decade and a half between 1963 and 1978. Most exhibit Ruscha's trademark dispassionate style. We might even call it a 'non-style', given its drab, workaday aesthetic that rejects anything traditionally considered as artistic, such as concerns about lighting or composition. Over the years, he has compiled records of unremarkable Los Angeles apartments and photographed palm trees, cacti, and nine rather uninviting-looking swimming pools surrounded by concrete and shot in colour. (He called the last book, published in 1968, *Nine*

Swimming Pools.) In *Thirtyfour Parking Lots* (1967), documented by an aerial photographer whom Ruscha had commissioned, the lines, chevrons and other markings denoting parking spaces painted on the asphalt take on an almost abstract aspect – like real-life instances of the severe *Black Paintings* that brought fame to the American artist Frank Stella in the late Fifties. These were large, aggressive canvases covered with wide stripes of black enamel paint separated by ghostly pinstripes of unpainted canvas, creating symmetrical patterns. Ruscha's parking lots could also be a contemporary, urban version of immense ancient geometrical designs such as the Nazca Lines in Peru. At the time, the Nazca Lines and other, comparable phenomena were of interest to many of Ruscha's contemporaries, as the so-called Land Art movement gained traction in America: artists such as Robert Smithson and Michael Heizer were travelling to remote locations in deserts, prairies and mountains in order to make vast interventions-cum-artworks in the natural landscape. In other words, as well as behaving like a landscape artist or a topographer mapping and classifying the urban world around him, Ruscha was also engaging in a sophisticated dialogue with other art – building upon an interest in serial imagery that had been a hallmark of modern art ever since Monet had started painting sequences of haystacks, poplar trees and the façade of Rouen Cathedral in varying conditions of weather, light and atmosphere during the 1890s.

Today, Ruscha counts his books among his most successful and satisfying works of art: 'I almost felt like they were kissed by angels, if you know what I mean.' But arguably his finest artist's book – and the one that functions best as a kind of template of Pop Art's wider concerns – is *Every Building on the Sunset Strip* of 1966. Compressed within its cover are two continuous, black-and-white photographic friezes documenting the unremarkable, low-rise architecture on both the north and south sides of the street along a

two-mile stretch in the middle of LA's long Sunset Boulevard. Printed upon a single, enormous sheet of paper, the book concertinas outwards for an extraordinary 25ft – a coup of design that imitates the diffuse, horizontal geography of the city (which provides such a contrast to the verticality of New York, with its hundreds of skyscrapers). And, appropriately enough, given the Strip's associations with Hollywood, the finished product looks a little like a filmstrip – yet one, irrationally, without any semblance of a story at all.

Shot in early-morning sunlight using a motorized Nikon camera mounted on a pickup truck, the bleached-out, street-level, overlapping images in this deliberately mechanical survey convey nothing of the lurid seediness of this famous stretch of road. Instead, as with *Twentysix Gasoline Stations*, there's barely a soul in sight – a fact that only adds to the generally impersonal, emotion-free effect, as the bland, box-like buildings blur into one another. Los Angeles, Ruscha once said, is 'the ultimate cardboard-cut-out town', full of storefront façades that are little more than 'boxes with words on them'. *Every Building on the Sunset Strip* pinpoints this hollow, wafer-thin aspect of the city with cold-eyed precision. A little like Rosenquist's Zen-inspired paintings, it expresses the emptiness of the world it depicts. Ruscha, then, was mapping not only a specific boulevard in LA, but also the thematic heartland of Pop Art in general: its obsession with surfaces. As Warhol once said: 'If you want to know all about Andy Warhol, just look at the surface: of my paintings and films and me, and there I am. There's nothing behind it.'

<div align="center">★</div>

Many of the concerns of Ruscha's early photographic books also animate the paintings that he was making in parallel with them during the Sixties and Seventies. Indeed, one of the images in

Twentysix Gasoline Stations led directly to arguably Ruscha's most recognizable series of paintings. Of the fifty or so gas stations that he photographed in 1962, all run by different oil companies (Mobil, Phillips 66, Shell, Texaco, Union, and so on), it was the image of the Standard station he had seen beyond his rolled-down car window in the Texan city of Amarillo that he couldn't shake from his mind. 'It had some mysterious element that spoke to me,' Ruscha says. 'I thought this here was a departure point, that I should pay attention to this building. It had some source of, uh, [the] future to me.' As he compiled *Twentysix Gasoline Stations*, he began planning a painting of this photograph in particular. In order to understand how he arrived at this masterpiece, though, we need to learn a little more about Ruscha's Pop paintings that preceded it.

By this point, Ruscha had already produced several Pop pictures featuring short, snappy, sometimes onomatopoeic words such as 'HONK', 'BOSS', 'ACE', 'JOE', 'OOF' and 'GAS'. In *Boss* (1961), *Joe* (1961) and *Honk (Cracker Jack)* (1962) – the last including a representation of a floating packet of the molasses-coated Cracker Jack snack against a brown impasto background – the brushstrokes are still very much in evidence, recalling the work of Johns, who also incorporated words into his encaustic paintings. The brushstrokes had disappeared, however, by the time that Ruscha painted *Oof* (1962–3), in which three enormous yellow letters spelling out the word 'OOF' appear against a flat indigo background. In fact, the letters in this painting, which is now in the collection of the Museum of Modern Art, are so enormous and so flawless that they somehow shake off their identity as elements of typography and start to look like simple shapes evoking other forms: an owl's eyes visible at night, perhaps, or breasts with dark blue nipples. The effect is ludicrous yet compelling, like nonsense verse.

Ruscha opted for a similar approach in his brilliant painting

Actual Size, also from 1962, which belongs to the Los Angeles County Museum of Art. Here, the canvas is divided into two. In the top half, the name of the common canned-meat product Spam appears in imitation of the brand's logo in yellow lettering against navy. In the bottom half, specks and splashes of navy paint, which have seemingly dripped down from the block of blue above, spatter a primed canvas. In the middle of this section, a tiny rectangle faithfully replicating the label on a tin of Spam painted at 'actual size', as the title suggests, veers off at a diagonal angle towards the right-hand edge. Six years earlier, Richard Hamilton had included canned ham in his collage *Just what is it that makes today's homes so different, so appealing?* In Ruscha's vision, though, the tin of Spam appears to be powered by a plume of yellow paint that looks like roaring exhaust emitted by souped-up turbo-thrusters. Rocket-propelled Spam: it's ridiculous, right? Well, it would be hard to disagree: there is something wilfully silly and comical about this image. But Ruscha also manages to serve up a decent helping of meaning too. The context for the painting was the Space Race of the Cold War, when it became common to refer to astronauts as 'spam in a can'. In this light, the yellow letters of the word 'SPAM' suddenly take on connotations of the Sun or a constellation of stars illuminating the inky void of deep space, while the drips underneath could be a meteor shower that the poor little space probe of the tin, filled with intrepid human cargo, is forced to negotiate. The scope of the painting is thus on the one hand funny and banal – referencing a cheap, everyday product found on the supermarket shelf, like Warhol's *Campbell's Soup Cans* – and, on the other hand, epic, encompassing the human exploration of space. The Space Race offered a glamorous subject that fascinated several Pop artists, including the Britons Derek Boshier, Hamilton and Gerald Laing, who all depicted rockets and astronauts. In his memoir *POPism*, Warhol explained why, after the Factory had

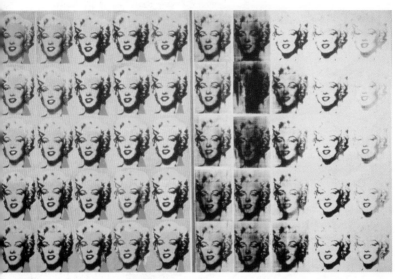

Andy Warhol, *Marilyn Diptych*, 1962

Roy Lichtenstein, *Drowning Girl*, 1963

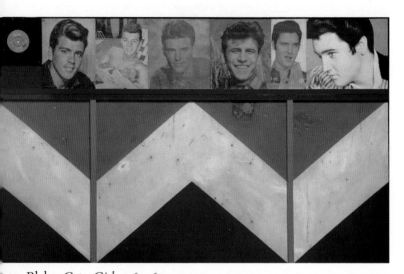

Peter Blake, *Got a Girl*, 1960–61

James Rosenquist, *President Elect*, 1960–61/64

Ed Ruscha, *Actual Size*, 1962

(© Ed Ruscha. Courtesy of the artist and Gagosian Gallery)

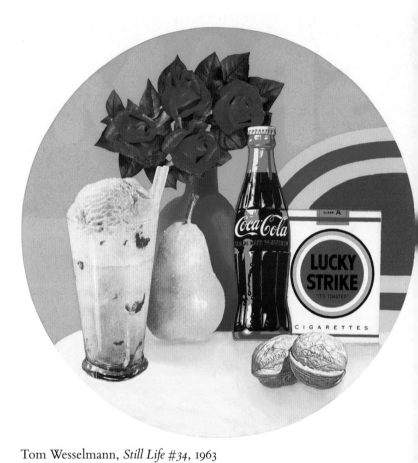

Tom Wesselmann, *Still Life #34*, 1963

(© Estate of Tom Wesselmann /DACS, London/VAGA, NY, 2015. Mugrabi Collection)

Rosalyn Drexler, *The Dream*, 1963

Evelyne Axell, *Ice Cream*, 1964

(© ADAGP, Paris and DACS, London 2015. Image courtesy of Philippe Axell)

moved to the loft of a building on East 47th Street, his friend and major-domo Billy Linich, who would become known as Billy Name, decorated it with aluminium and tinfoil and silver paint: 'Silver was the future, it was spacy [*sic*] – the astronauts wore silver suits – Shepard, Grissom, and Glenn had already been up in them, and their equipment was silver, too.' (For Warhol, of course, silver had more nostalgic associations as well: 'And silver was also the past – the Silver Screen – Hollywood actresses photographed in silver sets.')

In addition to this, *Actual Size* articulates the tussle between the new Pop style and the older mode of abstraction that had dominated the previous decade. All those drips of navy put one in mind of the work of Pollock and his contemporaries. In this reading, that tiny Spam spacecraft, with its figurative painting of the can's contents visible on the label, represents Ruscha and his Pop pioneers voyaging through a hostile environment, powered by the incandescent energy of youth, talent and a fresh vision, but also buffeted by antipathy and criticism. If only they can keep going, they have a chance of reconnecting with the Pop mother ship hovering above – the everyday world of commercial products, signage and advertising that will provide them with the 'nourishment' (Spam is edible, after all) of sustained inspiration. During my conversation with Ruscha, he compared Rauschenberg to 'Christopher Columbus – I mean, he was really discovering things.' *Actual Size* casts Ruscha himself in a similar role of the heroic explorer – yet in his case hurtling across an intergalactic stage.

That same year, 1962, Ruscha produced *Large Trademark with Eight Spotlights*, which left behind any vestige of Abstract Expressionism altogether. Now, on a vast, panoramic canvas, aping the widescreen of cinema, Ruscha painted the corporate emblem of the major film studio 20th Century Fox in huge, overblown, red letters against a dark night sky. This was illuminated, in the upper

left corner, by eight yellow elongated triangular shapes representing the searching beams of spotlights. Arresting lines connected to the logo's numerals and lettering swoop downwards to the bottom-right corner. Resembling preparatory marks to ensure accurate perspective in a technical illustration, they provide a powerful compositional effect, bisecting the canvas by carving it up along a pronounced diagonal. 'Diagonals are an action symbol in our lives, I think,' Ruscha once said. 'Anything that's horizontal or vertical tends to be settled. But the diagonal is something in action, on the move.' Overall the inflated effect is so jazz-hands and showy – after all, these bloated letters are given massive prominence, like the gargantuan presidential faces carved into the granite slab of Mount Rushmore – that one can only conclude the painting is meant to be ironic. Whether or not that's the case, *Large Trademark* does exhibit many of the hallmarks of Ruscha's distinctive Pop style: allusions to Hollywood; an obsession with words, typography and design; the blank, deadpan presentation of signs, logos and emblems commonly encountered in everyday culture; and a pervasive sense of a society characterized by cardboard-cut-out flatness. We find similar concerns, albeit expressed in a different fashion, in the Pop paintings of Ruscha's West Coast contemporary Bengston.

Large Trademark, which is now in the Whitney Museum of American Art in New York, was the warm-up act for the *Standard* paintings that followed. In *Standard Station, Amarillo, Texas*, Ruscha took the photograph that was included in *Twentysix Gasoline Stations* but reimagined it along the lines of the *Large Trademark* painting, with its striking diagonal composition. Now it is night rather than day, the station has been swivelled round so it is seen from the right, not the left; and the vantage point is down low on the tarmac, and not from the level of a passing car window. Three yellow spotlight beams in the background function like the visual

equivalents of fanfares or trumpet blasts. We have left behind the documentary reality of the original photograph and entered a strange, surreal new realm where an ordinary gas station is glorified like a dramatically lit hero in the movies moving quickly towards us. Just as *Large Trademark* tapped into a world of fantasy, by evoking the movie-making industry that was responsible for so much of America's popular mythology, so *Standard Station* alludes to another essential strand in the country's self-identity: the notion of the highway, the free-spirited poetry of the open road, the mobile, fleet world of Steinbeck and Kerouac, the romance of Route 66. The station is presented as an American icon, a thing of crisp, no-nonsense, even severe beauty. In 1964, Ruscha followed this with another, similar Standard station, seen in daylight with a cheap Western comic book torn in half above it in the sky; and then a third major painting of a Standard station, this time on fire, created between 1965 and 1968. The latter work is related to other Sixties paintings of buildings on fire, including one of a diner from the Norms chain of restaurants on La Cienega Boulevard in LA, and *Los Angeles County Museum on Fire* (1965–8), in which the institution is seen from the air like an architectural model ablaze.

One of the most significant aspects of the *Standard* paintings is the prominent use of that particular company name. Ruscha could have painted 'Shell' or 'Mobil', he could even have painted 'Rimmy Jim's Chevron', but he didn't: he opted for 'Standard', the emblem of the Standard Oil Company. Why? 'Somehow it made it easier to make this picture because it was called Standard instead of, uh, Joe's Gasoline,' Ruscha tells me. He claims that at the time he was drawn to the Standard brand quite unconsciously. Still, it is noticeable that by also painting a 'Norms' diner, he seemed to be making a statement about something specific: he was mining the culture around him for standards and norms, for stereotypes, for

clichés. In a sense, his gas station is the 'standard' for all gas stations – it is the idea of a gas station, its distillation, its quintessence. In other words, Ruscha was formulating a sort of shorthand – a recognizable visual code for gas stations – just as his *Large Trademark* had been a painting of the idea of the movies generally, rather than of a particular film. This is a constant theme throughout Ruscha's work. His photographic books present undifferentiated, generic phenomena: the individual elements of each species his camera focuses on – palm trees, cacti, LA apartments or swimming pools – all essentially look the same. Much later, in the Nineties, when he started painting majestic mountains covered in snow juxtaposed with words and phrases such as 'SCREAMING IN SPANISH' or 'ACE' (a reference to his early painting of the same word against a black background from 1962), he wasn't depicting individual Himalayan peaks but amalgamations of various images that he had culled from books and magazines. 'They're generic mountains,' Ruscha says. 'They're based on real mountains but they're also jacked with and altered to my eye and to my whim. They're the idea of a mountain.' In other words, they offer the mountain as a ready-made. As a result, these mountains appear as flimsy and flat as the picture-perfect, 2D images on which they were based – as fake, in fact, as Ruscha's vision of the façade-like buildings of LA, that 'ultimate cardboard-cut-out town'. As I suggested above, Ruscha's obsession with the pancake-flatness of popular culture is typical of a lot of Pop Art – just look at the early Pop work of Lichtenstein, who painted ordinary items, including a tyre, a desk calendar and composition books that were so generic they were free even of brand names.

The question then becomes – what is the attitude of Ruscha and Pop Art in general towards all these cultural standards and norms? Do they stimulate his approbation or contempt? To what extent,

even, is Ruscha a satirist, exposing the fathomless void behind the shiny surface of corporate American capitalism? People often complain today about the depressing homogeneity of the Western high street, following the success and ubiquity of certain global brands such as Starbucks or McDonald's. Did Pop Art predict this phenomenon, pinpointing the banality that is a by-product of the standardization of popular culture? Certainly some of Ruscha's paintings seem to be motivated by satirical intent: the image of the LA County Museum on fire, for instance, is a broadside against the establishment, an imagined apocalypse in which the values of wealthy, corporate America are put to the torch. Indeed, all those infernos that Ruscha painted – surely they are metaphorical instances of a contemporary bonfire of the vanities? 'I guess you could say that,' Ruscha tells me, pulling my line of questioning up short. 'Anybody's free to interpret my paintings any way they wish. That's what Duchamp said to begin with. You know: making the art is one thing, but it takes a viewer to add to it and interpret it. Viewers always add to every product in the world.' For a moment I think of Truman Capote, who once dismissed Warhol as 'a sphinx without a secret'. The trouble is, Ruscha's art endures in part because it is so perplexing and ambiguous, and cannot easily be 'solved'. As we have seen, the great debate about Pop Art is whether it endorses or undermines the popular culture it depicts – and Ruscha has conceded that political anger sometimes motivated his paintings. In 2008, for instance, when asked if he was cynical about the world, he replied: 'Yeah, I can be. And I find it coming out in my work.' His picture of the LA County Museum on fire was, he says, 'a little revolt against an authority figure'. Some critics have even suggested that this canvas, which took Ruscha several years to paint, emerged from the context of news footage of buildings burning in the Watts neighbourhood of Los Angeles during the race riots of 1965. 'I grew up in a period

of racial injustice in the West and in the South,' Ruscha tells me. 'I grew up in that and I watched a lot of that. That affected me. And all these things were like little building blocks, you know, [explaining] why you might even want to be an artist. God knows where all these little silver threads to your past connect up. But I guess they do connect some way, electronically connect.' In this respect, Ruscha's *Los Angeles County Museum on Fire* belongs to the same strand of hard-hitting, politicized Pop as Rosenquist's *F-111* or Warhol's *Race Riot* paintings, which responded to the brutal police suppression, using fire hoses and attack dogs, of black civil rights campaigners in Birmingham, Alabama, in 1963.

At the same time, during our meeting Ruscha also uses a very unexpected word: patriotism. 'You know, I feel like the glory of America is somehow hinted at in some of these works – in a lot of my work – be that what it is,' he says. 'I don't intentionally want to insert my patriotism into anything, but sometimes it just happens.' (In a similar fashion, as I noted in the introduction, Warhol's friend Emile de Antonio felt that the artist's crisp early black-and-white painting of a bottle of Coke was a remarkable symbol of contemporary American society, 'absolutely beautiful and naked'.) I am surprised to hear Ruscha talk about patriotism. 'I don't think I've ever used that word,' he says, before describing a trip he took to Europe in 1961, after graduating from art school, but before he embarked upon his most iconic Pop works. Over ten months, he visited many European countries, including Italy, Greece, Yugoslavia and Austria, sometimes accompanied by his brother or his mother, but mostly by himself. Two early word paintings based on distinctive street signs – *Metropolitain* and *Boulangerie* (both 1961) – record his time in France, where he loved the chic lifestyle of Paris. (England, by contrast, was a let-down. 'It was such a cold place,' he recalled in 1980. 'I was disappointed because it was not

like Charles Dickens.') During his long stay in Europe, Ruscha learned a lot about his own attitudes to art and to America. He discovered that he felt indifferent looking at Renaissance art in grand museums, but excited whenever he encountered something that felt contemporary, such as an exhibition of Rauschenberg's *Combines* that he caught in Paris. Travelling made him feel 'less connected to the Old World than the New World', he tells me. 'And so I just felt like I wanted to get back to America.' For this young artist in his early twenties, it was an epiphany of sorts. 'America feels like where I belong,' Ruscha says. 'And the elements that are somehow going to be in my work are going to come from that place, America.' This typifies the approach of many American Pop artists, who wanted to make work that felt liberated from a European sensibility.

Perhaps, then, the documentary impulse behind *Twentysix Gasoline Stations* is the key that unlocks much of Ruscha's work – as well as Pop Art more widely. At times Ruscha is amused by the absurdities of post-war America, at other times frustrated by its injustices and contradictions, but the one constant to his work is the bedrock of love and admiration for his homeland that inspires him to chronicle the culture he sees around him. Perhaps this even explains the blankness of his signature style: he is serving up America without embellishment or editorializing, in the most pared-down form imaginable, so that each of his images can stand in for the whole. I think of his paintings almost as epitaphs – after all, if it weren't for their surreal qualities, his word pictures could be taken for inscriptions on gravestones. They provide the essence of the object under consideration in a concise, if offbeat, fashion. 'There's no political thing here, no satire,' Ruscha says. 'It's a very sort of hard-edged position of taking a subject and working it to a finality. You know, like *Twentysix Gasoline Stations*. It's making something final, almost like carving it in stone so that it's official.'

He pauses. 'Somehow I feel that there needs to be some kind of capturing of this phenomenon. But it's not grandiose. I'm not urging society to wake up to the phenomenon of, say, gas stations.' This is true: Ruscha's art never tips over into pomposity. His sense of 'black humour', as he puts it – a fine-tuned sensitivity for absurdity and irony – is usually on hand. 'Absurdity really has a place in the world,' he told me in 2008. 'But not too many people are willing to touch it. It's like cold water: you want to put your toe in first and check it out. It's got much to say for it. Sometimes truly the only way to break through is to do something absurd.' This, it seems, is a big theme of Pop Art – reflecting on the absurdity, the comical precariousness, of our modern human world, with all its blaring, glaring salesmanship and hype. It's one way that the Pop artists built upon the legacy of Surrealism. Later, as I leave, I notice an unusual, misshapen lemon sitting prominently on a kitchen worktop. With a grotesque bottom half resembling a many-footed starfish, grasping claw-like at the main body of the fruit above, it is a 'Surrealist Object' in its own right. This, I imagine, is exactly the sort of oddity that Ruscha finds amusing. Above it, perched on top of a cabinet, sits a kitsch plastic garden ornament in the form of an owl. I know it is whimsical, but, looking into its yellow eyes, I can't help but think of the big yellow letters of Ruscha's painting *Oof* – an absurd connection of my own devising.

*

The sun is still high in the sky above Culver City, but Ruscha and I have been talking for a couple of hours, and poor, faithful Lola, who has settled herself on a nearby daybed covered with a thick blanket woven with a bright pattern of orange leaves, is starting to look hungry. I could be wrong, but I also sense that Ruscha himself is beginning to tire of so much talk about art. One last time, I

invite him to explain why his work has this bedevilling, impenetrable deadpan quality. Why the pervasive blankness? 'Um, it's a kind of severity that you're looking for in your work,' he says, speaking slowly again. 'It's just a kind of thing you're looking for. But I guess that's just me. Some people are looking for beauty, which is another difficult word to describe.' Another pause. 'You're trying to make sense of everything, and you get these little taps on the shoulder that come from the way you're brought up. It's true that some of those attitudes from my puritanical upbringing could have followed me throughout my life. And yet I'm not consciously referring to my history. I just feel it's really hard to describe where these feelings come from. It's a mystery.' He laughs. 'I mean, maybe my work's not warm and fuzzy. But there are so many ways to look at the world, and mine is only one sliver of that. Besides, I want to think less about things behind me, which we've been talking about, and more about what's out there in the darkness of the future. That's something that is very intriguing to me. I mean, where I'm going to go from here, without falling on my face.' Another laugh. Still, I tell him, if after all this it remains a mystery why he makes art that feels so characteristically blank, severe, deadpan, or whatever you want to call it, perhaps I've failed as an interviewer. 'No, I wouldn't say that,' he replies. 'No, I think you've said something here. But finally art is a non-verbal medium to me, you know. What can you say about it? It's meant to be looked at and talked about less. It's always fun to talk about art, sure, but, still, you have to pull yourself back and say: "Just look at the thing." And give it what you have – or give it nothing if you choose.' How ironic that this painter of words, who some people have described as a poet first and an artist second, ends by extolling art's silent, inexpressible quality.

Rosalyn Drexler, *Is It True What They Say About Dixie?*, 1966

The Great Forgotten Pop Artists

Women played a conspicuous role in the imagery of Pop Art from the beginning. There were the superstars like Marilyn Monroe, Elizabeth Taylor and Brigitte Bardot – figureheads of popular culture whom the Pop artists painted time and again. Then there were the pin-ups, glamour girls, B-movie starlets and comic-book heroines who also appeared so often in their work. More than this, though, in order to define itself in opposition to the machismo of Abstract Expressionism, Pop Art – in New York at least, if not LA – deliberately set out to represent a world of domesticity and, by association, femininity. Warhol wasn't the only artist inspired, in his case by memories of his mother, to depict everyday objects that we encounter in the kitchen as well as elsewhere in the home. When Lichtenstein was embarking on his Pop career, he painted objects culled from newspaper and magazine advertisements aimed squarely at female consumers. In *Washing Machine* (1961), a manicured woman's hand sprinkles yellow detergent from a packet into the drum of an open appliance. The following year, Lichtenstein presented more disembodied hands, this time with polished red fingernails. One sprays an aerosol can. Another wipes a surface with a sponge. Both are engaged in that bog-standard domestic chore: cleaning.

In his early diptych *Step-on Can with Leg* (1961), the artist shows us the calf and foot of a housewife wearing shiny high heels decorated with a bow, operating a simple pedal bin embellished with a floral design. Ruscha once remarked that seeing a reproduction of Johns's

Target with Four Faces in the late Fifties was the 'atomic bomb' of his art education; Lichtenstein's *Step-on Can with Leg* had a similarly explosive effect upon the British Pop artist Allen Jones, who was astonished when he first saw it. 'It just knocked me out,' he recalls. 'It took the brakes off. Suddenly you realized one should not have any kind of brake on one's imagination or enquiry.' Lichtenstein's painting became a 'talisman' for Jones, encouraging him to be 'fearless' in his own art. Arguably it is the template for the many seductive women's legs, also wearing stockings and high heels, which Jones would go on to paint himself.

In time, Jones would also be responsible for some of Pop's most controversial (and 'fearless') sculptures: *Hatstand*, *Table* and *Chair* (all 1969). In these infamous artworks, half-naked, heavily made-up fibreglass mannequins, dressed in kinky leather lace-up boots and other skimpy accoutrements from the boudoir, simultaneously function as provocative items of furniture. A woman on all fours with her breasts hanging free stares down at a handheld mirror placed on a shaggy cream rug beneath her while supporting a plane of glass on her back: she's the table. Another woman lies on her back, pulling her knees up to her naked bosom, enabling a black leather cushion to rest on the underside of her thighs: here is Jones's *Chair*. *Hatstand* is the least obviously practical piece of furniture of the three: a woman wearing thigh-high mauve leather boots, laced right up to her crotch, as well as a diaphanous garment covering her breasts and arms that affords a glimpse of her bulbous, erect nipples underneath, stands upright on a sheepskin, facing the viewer, while holding out her hands on either side. It is on her upward-facing palms that, invited by the title, we are supposed to place our hats.

At the time, Jones's fetish-furniture proved inflammatory. Created as the feminist movement was hitting its stride, the sculptures were accused of treating women as sex objects. They still are:

when Jones's retrospective at the Royal Academy of Arts in London opened at the end of 2014, more ink was spilt attacking *Hatstand* and her sisters in print. For some, they remain emblems of Pop Art's apparently sexist nature. When I met Jones in his studio in the aftermath of the retrospective, I suggested that the obvious defence for these works of art is that they do not unwittingly objectify women so much as present a fantastical stereotype of women as sex objects dreamed up by a patriarchal culture. In other words, the artist is not culpable – he's simply pointing his finger at society. Jones looks momentarily pained and baffled. 'Well, that sounds like a feminist tone to me,' he says. 'It sounds like a political manifesto – and that's fine – but the language is too studied for me, and it isn't anything that was in my view [in 1969]. Plainly, I wanted to celebrate the figure. I did not wish to illustrate an individual. I wanted to make an archetypal figure. I also wanted to make something that would arrest people if they came into the room. At that moment in time, if you walked into a room and saw a sculpture of a figure by [Jacob] Epstein, you'd go, "Oh, it's art." Primarily you'd see bronze or stone, and so you'd see art. I wanted to make a figure that when someone came into the room they wouldn't see these signals that would make it okay. Therefore I didn't want to model it myself.' Accordingly, to execute the artworks, Jones commissioned a sculptor who worked for the Madame Tussauds waxworks museum. 'As it happens, it was an incredible thing to do. Now, in the era of Jeff Koons, it is seen as legitimate for artists to order in. But in those days, even if you didn't make your own prints, people had a question about it.'

Certainly, when they were first exhibited, *Hatstand*, *Chair* and *Table* elicited a shocked, scratching-one's-head, 'Is this art?' sort of response. Formally, compared with the venerable sculptures of art history, they appeared wild. And the sexiness of their subject matter was obviously outrageous too. Perhaps this is why, not

long after they were created, Jones received a telephone call from the film director Stanley Kubrick, who had seen the sculptures in an exhibition and wanted him to design the sets for his new film adaptation of Anthony Burgess's dystopian novel, *A Clockwork Orange*. In the end, Jones – who was offered a credit but no fee – declined, though he did tell Kubrick that if he liked the ideas embodied in the sculptures, he should feel free to use them – which, ultimately, the director did. It was a wonderfully circular moment: having fed upon popular culture, Pop Art had become its fodder. Moreover, in an important sense, it is instructive that the look of Kubrick's disturbing film about the ultra-violent escapades of an uninhibited sociopath and his gang of juvenile delinquents was inspired by Jones's sculptures. The innocence and optimism at the outset of the Sixties had given way by the end of the decade to a more pessimistic, jaded and cynical mood. As Warhol put it in *POPism*: 'In '68 Martin Luther King, Jr and Robert Kennedy both got assassinated, the students at Columbia took over the whole campus and fought with the police, kids jammed Chicago for the Democratic National Convention, and I got shot. Altogether, it was a pretty violent year.' If art functions as a barometer of the preoccupations of society, then *Hatstand*, *Chair* and *Table* are startling and creepy avatars – manifestations of a new, darker spirit of the age. By 1969, Pop Art had moved from the kitchen in Lichtenstein's *Step-on Can* to the S & M dungeon of Jones's imagination. Yet, crucially, it was still drawn to women – and domesticity. After all, Jones's sculptures were designed as furniture, to be viewed at home.

Rosenquist, too, was compelled by domesticity, and not only in his well-known paintings of gloppy spaghetti. In *Dishes* (1964), he offered a close-up of colourful teacups, glasses and plates dripdrying in a red rack. This wasn't the first time that washing-up had provided him with a subject. In one of his most haunting early

Pop works, *Flower Garden*, of 1961, he juxtaposed the drooping arm, torso and left leg of an exhausted long-distance runner – the athlete Roger Bannister, sagging unconscious after running the first sub-four-minute mile in 1954, as he appeared in an image from a photo-essay in *Life* – alongside three slender women's hands, reaching upwards, and seen on a much bigger scale. The source for these hands was an advertisement printed elsewhere in the same issue of *Life*. (It took Rosenquist's eye to link the two images, since the ad did not actually appear alongside the piece about Bannister's 'triumph'.) Promoting Playtex Gloves, the ad promised housewives that they could 'restore the natural smoothness' of their hands in only nine days, by protecting them from the drying properties of soaps and detergents: 'The very first manicure you save pays for the gloves.' It also contained the supposedly beguiling (and oxymoronic) phrase 'glamorous housework', though it is hard to imagine that anyone, even in the Fifties, ever felt 'glamorous' while washing dishes. Rosenquist's monumental, grisaille painting, nearly 6ft high and 8ft wide, is memorable because – like a lot of good Pop Art – it transforms mundane material into something resonant and universal. According to one art historian, the slumping athlete has the pathos of a Renaissance deposition. Moreover, his downward trajectory provides a contrast with the upward thrust of the women's hands. Above the 'stems' of their wrists, their delicately coloured fingernails flutter and bob like the flowers of the title gently rustling in a breeze. Subtly, the painting evokes the same post-coital subtext as Botticelli's *Venus and Mars* in London's National Gallery, in which the god of war swoons back, apparently sated after sex, while his lover looks on, alert and perhaps a little disappointed by his performance. In a similar fashion, the man in *Flower Garden* is spent, while the softly insatiable female principle is still active, grasping for more. The predominantly grey colour scheme and

black background create a nocturnal mood – suitable for making alfresco, twilit love in the flower garden of the title – while the latex glove that sheathes the middle hand may evoke the use of a condom during sex. I am not sure whether the reverie of house-work presented in this painting is 'glamorous', but, like the original advertisement from *Life*, it is structured around a seduc-tive – and domestic – fantasy all the same.

Different Pop artists had different reasons for depicting imagery like this. All of them, though, were responding in some fashion to the stifling expectations that post-war mass culture imposed upon women in the West. According to one estimate, by the end of the Sixties, the average television viewer in America was exposed to 40,000 commercials every year. Consciously or not, many of these promulgated a particular vision of society that was remarkably conservative and conformist, and centred upon the family. In American popular culture in the Fifties and early Sixties, women were seen to be fulfilling their destiny only when they adhered to prescribed roles as pretty housewives. (Unsurprisingly, both the ungloved left hands in the Playtex advertisement that inspired Rosenquist's *Flower Garden* sport rings on their fourth fingers.) The era of the servile, submissive Stepford Wife had dawned – and it provided rich pickings for Pop artists of a satirical persuasion. This, surely, is part of the point of Lichtenstein's early Pop paint-ings: he was simultaneously amused and unsettled by advertising's unthinking diktats, which decreed that women should behave in a certain way. It wasn't enough simply to be a housewife. Stay-at-home mothers had to be 'glamorous' too – emptying refuse into bins while wearing designer shoes with dinky bows. The title of a 1963 painting by Lichtenstein, in which a blue-eyed, blonde comic-book heroine lies on a bed while quietly crying by herself, sums up the odds at the time of reforming prevailing gender ste-reotypes: *Hopeless*. The new rebellious spirit of the Sixties, which

Pop foresaw and arguably helped to engender, would soon do away with many of these fusty patriarchal values, culminating by the end of the decade in feminism.

*

Somewhat depressingly, though, the art world in America and Britain in the Fifties and Sixties was just as hidebound, in terms of its old-fashioned attitudes towards women, as other, more traditional parts of society. This is what the sculptor Marisol lampooned when, in 1961, she participated in a panel discussion at The Club, a weekly gathering of artists associated chiefly with Abstract Expressionism that had been founded on East 8th Street in 1949, and soon established itself as New York's leading avant-garde forum. Alongside three male artists, Marisol sat on stage in silence while wearing a white mask. Sensing that her reticence was meant as a protest against the sexist values of many of The Club's members, who were not prepared to listen to women when it came to the 'serious' business of talking about art, the predominantly male audience became livid, chanting that she should remove the mask. 'When the noise got deafening,' the American artist Al Hansen later recalled, 'Marisol undid the strings. The mask slipped off to reveal her face, made up exactly like it. What a stunt! It's something only she would think of and it brought down the house.'

Marisol wasn't the only female artist associated with Pop who encountered sexism and resistance within the boys' club of the art world on both sides of the Atlantic. During the Fifties, a young British painter called Rose Wylie, who would find success and recognition much later in life when she hit her seventies, enrolled at Folkestone and Dover School of Art in Kent. 'My painting tutor said to me, "You know, there's not much point in talking to you because you will get married, run a house and have

children," ' she recalls. 'I grew up in a very male-dominated art world.' Although Wylie was not involved with the Pop movement during the Sixties, when she put her ambitions as a painter on hold to concentrate on bringing up her children, she did eventually prove her tutor wrong and return to art. After graduating from the Royal College of Art in 1981, she fashioned a distinctive, self-consciously untutored style, presenting elements from popular culture, such as fashion photography, newspaper shots of famous footballers and scenes from her favourite films, in an unforgettable, expressionistic, madcap manner that is at once coarse and jubilant. Although her large paintings are not 'Pop' in the strict, historical sense, they are animated by much of the freshness and irreverence that Pop Art unleashed. 'Pop opened a door to ordinary, bright objects – bright paint, cars, shine, shaving, advertisement,' she says. 'All that kind of bright, moving, real world, which Corot wouldn't have used, which the Impressionists didn't use. I find it very exciting. It's alive and not fuddy-duddy – and not precious. It appeals to the man in the street. It's shared.' Pop prized the lingua franca of popular culture over the rarefied language of modern art, which had distanced itself from ordinary people.

Wylie's testimony about the mid-century chauvinism of British art schools is corroborated by the recollections of another female artist – who was, emphatically, an important figure in Swinging London's Pop scene. In the early Sixties, Jann Haworth, who had been brought up in California, arrived in London, where she would meet her future husband Peter Blake, and enrolled at the Slade School of Fine Art. She recalls: 'I said to one of the tutors, "Do you need to see a portfolio of my work?" And he said, "Well, no, we don't really need to see portfolios of the women students. We just need to see their photographs because they're here to keep the boys happy." I promise you – not a word of a lie. At the Slade,

for sure, there was this kind of separation, that somehow the male students knew about paint. They [the tutors] would say, "Men just know about paint, and women don't."'

This sexist attitude inspired Haworth to devise her chief contribution to Pop Art: the invention of so-called 'soft sculpture', which she developed around the same time as other artists such as Claes Oldenburg and Yayoi Kusama. Infuriated by her tutors' dismissive attitudes towards young female artists, Haworth became determined to find a medium that stereotypically 'belonged' to women. She turned to sewing. Here, she felt, was a field in which she could outdo her male peers: 'It was something I really understood – and I knew the male students didn't.'

One of her most quintessentially Pop works in this new idiom was the early still-life sculpture *Donuts, Coffee Cups and Comics* (1962), in which the objects of the title, fashioned out of sewn and stuffed cloth, sit upon a tabletop. Here is a triumvirate of archetypal Pop imagery: a platter of colourful iced doughnuts (created a year before the newlywed Blake, accompanied by his bride Haworth, sketched the Big Do-Nut Drive-In sign in LA), a pair of coffee cups (stitched together barely a year after Lichtenstein had painted his steaming *Cup of Coffee* in 1961) and the 'funnies' section of a newspaper – specifically the *Dick Tracy* comic strip that also inspired Warhol and Ruscha. This subject matter was natural for a child of California such as Haworth – and she went on to make more soft sculptures of American stereotypes, including a cheerleader and a kapok-stuffed cowboy in unbleached calico. At the same time, Haworth was always conscious of the culture surrounding her in London. She imbued *Donuts, Coffee Cups and Comics* with a witty British twist, by decorating her crockery with a china-like blue-and-white pattern – turning it into a surreal tableau of an English tea party overrun by vulgar Americans. That same year, Haworth also sewed a bunch of

flowers out of wool and yarn and attached them to a wire frame, and produced the first of her two *Old Lady* sculptures. This life-sized, patchwork figure represents a grandmother wearing wire-rimmed spectacles and lace-up leather boots, sitting upon a chair. With great economy, Haworth used the structure of the furniture to define the granny's body, simply by draping clothes, including a red-and-brown woollen shawl, over it. 'The idea was that older people are trapped in a chair or immobile,' she explains. To ensure that the mood of the sculpture didn't become excessively melancholic or maudlin, though, Haworth created the lady's expression by stitching together thick ridges of bright fabric, which swarmed across her face like colourful caterpillars. 'I was trying to make the idea of wrinkles be not an awful thing but something that was full of colour and liveliness and memory,' she says. The result is a tender and sympathetic study of old age. If you look closely, you can see Haworth's *Old Lady* sitting to the right of the swirling, collage-like composition that she co-designed with Blake for the cover artwork of The Beatles' *Sgt Pepper*.

Haworth felt excited by her discovery of soft sculpture, in part because her tutors didn't understand it. One of them was Paolozzi, whose involvement with the Independent Group had done so much to prepare the ground for Pop in Britain. 'When I showed Paolozzi [an example of sewn work],' Haworth recalls, 'he said, "You should cast it in bronze." And I had the presence of mind to say to him, "I have cast it – in cloth." ' Bronze was redolent of the traditional – and patriarchal – aesthetic values from which Haworth wished to liberate herself. And, during the Sixties, her fresh approach won her fame. After spotting her soft sculpture in the exhibition *Four Young Artists* at the ICA in 1963, the hedonistic and well-connected art dealer Robert Fraser (who can be seen shielding his face while handcuffed to Mick Jagger in Richard

Hamilton's series *Swingeing London* of 1968–9) offered to represent her. Eventually, Haworth had a solo exhibition at Fraser's gallery in 1966. This was noteworthy: the only other female artist officially on Fraser's books during the Sixties was Bridget Riley. Before long, pictures of Haworth beside her distinctive sewn figures were commonplace in the press. In time, though, the reputation of her husband began to overshadow her. As recently as 2005, her entry in the index of a textbook about Pop Art read as follows: 'Haworth, Jann, *see* Blake, Peter'. Moreover, her contribution to soft sculpture – which would influence British artists such as Tracey Emin and Sarah Lucas, working several decades later – was gradually forgotten. Instead, the absurdly enlarged soft sculptures of Oldenburg, including gigantic squidgy hamburgers, light switches, toothpaste tubes, electric fans, telephones and toilets, were accorded pride of place in the history books.

In 1968, Haworth and Blake received a Grammy Award for their *Sgt Pepper* album cover. Forty-five years later, I visited Haworth in her large log cabin in the Utah ski resort of Sundance, where she showed it to me. Years ago, she had given it to her children to play with in their Wendy house at the bottom of the garden, where it had suffered a great deal of wear and tear. The gilded gramophone horn had snapped off and become tarnished, while the family dog had chewed the wooden base, scoring it with teeth marks. Somehow, I couldn't help remarking, this sorry-looking trophy was like a symbol of Haworth's faded reputation. She smiled ruefully. 'I felt I could do it all,' she told me. 'I felt I could be an artist, take care of my daughter, and do all the cooking and shopping and cleaning – all of that stuff. And I was willing to take that position at that time. Now I think I was exceptionally stupid in that regard – and made an exceptionally good decision in terms of my children. You know, the making of

a mind surpasses the making of an art object. People are more important than art.'

<center>★</center>

Haworth is one of many female Pop artists ill served by art history. In 1991, the Royal Academy of Arts in London mounted a large exhibition of Pop Art. With more than sixty artists from all over the world, it was an important, scholarly show, rehabilitating the movement's reputation following the nadir of the late Seventies and early Eighties, when Pop was still perceived to be glib and superficial, and languished at the bottom of the contemporary-art caste system. Still, of the 258 artworks in the exhibition, only one was by a woman: the self-taught French artist and associate of the Nouveaux réalistes, Niki de Saint Phalle. The work, *St Sebastian or the Portrait of My Lover* (1960), included a dartboard positioned as the 'head' of the artist's lover, above a shirt and tie splattered with bursting skeins of Pollock-like paint. The early Christian martyr Saint Sebastian was a staple of art history, often depicted tethered to a post or tree and shot with arrows.

Yet, thanks to the research of a new generation of art historians, the paucity of women artists in the orthodox narrative of Pop Art now seems like a horrible oversight that is finally being corrected. Women not only provided Pop with manifold subjects – film stars, pin-ups, comic-book girls and commonplace goods bought by housewives – but they were also its authors. A slew of recent exhibitions and publications have championed female Pop artists such as the American painter Idelle Weber, whose elegant Sixties images of silhouetted office workers look uncannily like the dapper protagonist of the title sequence of the American period-drama television series *Mad Men*.

Another female American artist recently brought back from the brink of obscurity is Marjorie Strider, who during the Sixties

produced paintings of anodyne pin-ups and sunbathers, with bikini-clad breasts and bottoms jutting out from supporting panels in specially sculpted reliefs. Strider called these reliefs 'build-outs'. One of her best-known pictures, *Girl with Radish* (1963), is a close-up of the face of a gorgeous seductress with raven hair. Fluttering her eyelashes, she parts her scarlet lips to reveal a row of pristine white teeth biting down gently upon the suggestive red bulge of a radish. Flat and cartoon-like, she has all of the personality of a sex doll: she is a synthetic simulacrum of a woman, rather than a portrait of someone real. 'I was making a satire of men's magazines,' Strider once said about her paintings, which adopt the sly humour of parody.

Like Strider, several other important female Pop artists made art engaging explicitly with sexuality. One of the most memorable artworks in this vein is Marisol's sculpture *Love* (1962), which was given to the Museum of Modern Art in New York by Wesselmann. In this pithy piece, an upturned bottle of Coke, still full of brown soda visible through the curvaceous, aquamarine glass, emerges from the mouth of a plaster cast of the lower part of Marisol's face, which functions like a plinth. It's a bold, simple and aggressive work of art that has been likened to an act of oral rape. Certainly, it appears that this eyeless woman, whose sliced-up face has been placed horizontally so that she occupies a submissive position, is being force-fed a phallic bottle. As a result, the title is acerbic: Marisol's *Love* is a bleak parable about the ferocity of male desire and the inequality of the battle of the sexes. It is a punchier, more headstrong version of the idea expressed the following year by Strider in *Girl with Radish*. Where Strider flirted with male fantasies about fellatio, as expressed in the hackneyed visual culture of the mass media, in order to send them up, Marisol confronted them directly, with clear-eyed brutality. Of course, *Love* could be understood in another way too. It also comments upon the

violation of our personal space by capitalism, which, via endless
print adverts and commercials, continually shoves products that
we neither want nor need down all our throats. Still, the subtext
of sexuality – signalled by the title – is what gives the sculpture its
protesting, proto-feminist power.

Sexuality was a principal theme for the glamorous Belgian Pop
artist Evelyne Axell, who gave up a New Wave film and theatre
acting career in order to become a full-time artist at the start of
the Sixties, and convinced René Magritte, a family friend, to
tutor her at his home in Brussels once a month for an entire
year. Often, Axell's work, which has also been described as
'proto-feminist', has a strong strain of empowerment, wresting
back control of female sexuality from the male-centric bias of art
history. Unlike the beautiful nude women in countless traditional
paintings and sculptures, offering titillation for a heterosexual
male audience, the seductive amazons in Axell's images are
self-aware and in control: conscious of their physical desires, and
capable of getting exactly what they want. One of Axell's most
famous oil paintings, *Ice Cream* (1964), is typically provocative. In
it, a young woman whose face has been rendered naturalistically,
and therefore sympathetically, using a range of subtle greys, licks
a brightly coloured – and highly suggestive – ice-cream cone held
firmly in her left fist. Her mascara-laden eyes are closed, appar-
ently in rapture, while her hair is a dramatic and intense red,
offsetting the ripples of green, yellow and blue emanating from
her like pulses of desire. At first, one might think that this work
ostensibly kowtows to a selfish view of heterosexuality, which
considers a man's sexual pleasure more important than that of his
female partner. Linger a little longer, though, and the picture
begins to tell a different story. This woman has none of the anti-
septic blankness of the blow-up doll in *Girl with Radish* : she looks
like an actual person, not a masturbatory aid – and one, moreover,

who is clearly deriving sensual pleasure from her 'ice cream'. In other words, this painting places female, and not male, sexual desire centre-stage. Moreover, the 'phallus', here, isn't rigid or intimidating, like the bottle of Coke in *Love*, but soft and rapidly melting (look at the drips of green and pink as the scoops of ice cream start running down the yellow cone). Its distinctly droopy state is hardly designed to flatter the male ego.

In order to understand the full implications of Axell's *Ice Cream*, it is illuminating to contrast it with Wesselmann's *Great American Nudes*, which drew flak from feminists for supposedly objectifying attractive women, draped languorously across furniture like come-hither odalisques. In *Great American Nude No. 27*, for instance, a flatly painted, eyeless and naked woman lies with legs parted against what appears to be a blue bedspread, above a row of sweet drinks and desserts in the foreground. The implication seems to be that this woman is as delicious as a milkshake or an ice-cream sundae. From a feminist perspective, of course, it is demeaning to present a woman in such a fashion, as though her only *raison d'être* was to be embellished with whipped cream and a maraschino cherry in order to provide pleasure for a man. Whatever the rights and wrongs of this argument in the case of Wesselmann, suffice to say here that we find something like the reverse of *Great American Nude No. 27* in Axell's *Ice Cream*. In the latter painting, it is the man, and not the woman, who is imagined passively as a sweet snack, consumed with relish by the picture's active heroine.

<div align="center">★</div>

Ice Cream is a brazenly erotic, practically explicit work of art – one wonders why Axell didn't go the whole hog and simply call it 'Blow Job'. This was Warhol's on-the-nose title for a silent, black-and-white film shot at the end of 1963 or in early 1964, in

which his camera lingered on a man's face as a sexual partner, or string of partners, performed fellatio on him off-screen. (In *POPism*, Warhol revealed that he lined up five boys who were ready and willing to take turns servicing the star of the film during the shoot.) Warhol's *Blow Job* belonged to a series of minimalist, voyeuristic and unedited Pop 'anti-films' of people engaged in simple, everyday acts such as eating, dancing or having a haircut. He made these films using a fixed second-hand 16mm Bolex camera, which he bought in 1963. The first film in the series was *Sleep*, which Warhol shot one sweltering, mosquito-ridden weekend in the summer resort and artists' colony of Old Lyme in Connecticut. It presented several hours of looped footage of the artist's lover at the time, the stockbroker-turned-poet John Giorno, asleep. That weekend, Warhol was also accompanied by his good friend Marisol, who, like him, had a solo exhibition at Eleanor Ward's Stable Gallery in New York in 1962. Warhol called Marisol 'the first girl artist with glamour', and in 1963 he invited her to star in one of his movies, *Kiss*. (The following year, she also participated in his film *Thirteen Most Beautiful Women*.) In *Kiss*, Marisol can be seen kissing the (homosexual) Pop artist Robert Indiana, who was also with the Stable Gallery at the time. Like Marisol, Indiana, who was born Robert Clark but took the name of his native state after moving to New York in 1954, made a work of art called *LOVE* – although, unlike Marisol's sculpture, his version would become one of the most recognizable icons of Pop Art, synonymous with the so-called 'Summer of Love'. Originally designed as a Christmas card in 1964, but subsequently realized in various media, including painting and sculpture (it was even reproduced on a US postage stamp), Indiana's composition presents the four letters of the word 'LOVE', in red capitals against a background of green and blue. Bumping up against the edges of the composition, as though expanding with irrepressible,

heart-bursting *joie de vivre*, the letters are arranged in two rows: 'LO' above 'VE'. The 'O' is tilted sideways, so that it encircles a diagonally slanting wedge of green, which animates the whole by providing an unexpectedly insouciant accent. Like a lot of American Pop Art – and unlike, say, British Pop, which is often said to be more narrative and analytical in comparison – Indiana's *LOVE* has an all-out, upfront quality: visually, it is bold, simple, unequivocal and frank. It looks like a fine-art logo for a brand without a corporation, created by someone who always called himself a 'sign painter', on account of his obsession with the use of words in everyday signs, but who was equally influenced by the hard-edge paintings of his friends Ellsworth Kelly and Jack Youngerman, whom he knew from Coenties Slip.

Sometimes, the interconnectedness of the New York avant-garde during the Fifties and Sixties can seem remarkable, and even dizzyingly complex – especially when compared with the proliferating variety of contemporary art around the world today. This close-knit quality offers a reminder that, although categorization can be useful – Indiana and Rosenquist are always considered as 'Pop' artists, while Kelly is a proponent of 'hard-edge' abstraction, and so on – actually there was much more cross-pollination than perhaps at first we realized. *LOVE*, for instance, shares many characteristics with Kelly's signature paintings. In the context of this chapter, though, the sobering point is that here were three young and successful artists – Indiana, Marisol and Warhol, hanging out together a lot in the early Sixties, and attending as many parties and art openings as they could – and yet today only two of them remain well known. The other one – inevitably, the woman – has been all but forgotten, beyond a small audience informed about mid-century modern art. What makes this feel especially unjust is that, in those early days, Marisol wasn't a third wheel so much as the leader of the pack. On one occasion, Warhol

later recalled, Marisol invited him and Indiana to a party thrown by an Abstract Expressionist painter called Yvonne Thomas. Warhol walked in, scanned the room and saw at once that it was 'chock full of anguished, heavy intellects'. 'Suddenly the noise level dropped and everyone turned to look at us,' he wrote in *POPism*. '(It was like the moment when the little girl in *The Exorcist* walks into her mother's party and pees on the rug.) I saw Mark Rothko take the hostess aside and I heard him accuse her of treachery: "How could you let *them* in?" She apologized. "But what can I *do*?" she told Rothko. "They came with Marisol." Between 1962 and 1963, as a sign of the affection between them, Marisol sculpted a wooden portrait of Warhol wearing a white shirt while sitting cross-legged upon a period chair. At the bottom, Marisol incorporated an actual pair of Warhol's beaten-up, black leather shoes – not quite the 'old socks' that Lichtenstein's colleague at Rutgers University, Allan Kaprow, had suggested should be used to make art in the future in his essay 'The Legacy of Jackson Pollock', but not far off.

In some ways, Marisol, with her ice-queen persona, was atypical of female Pop artists in general. Marisol's silent inscrutability – her face was so mask-like, as her stunt at The Club had suggested, that she once supposedly remarked, 'I can't find out what I look like' – was of a piece with Warhol's deadpan veneer. Indeed, as I mentioned in the introduction, Warhol may have partly modelled his manner upon Marisol, who moved to New York a year after he did, but established herself as a fine artist more rapidly – notching up her first solo exhibition, at the Leo Castelli Gallery, as early as 1958. At that point, in the late Fifties, Marisol was still making fetish-like sculptures influenced by Pre-Columbian artefacts, using wood, terracotta and alabaster. In truth, the only thing about her that heralded the coming Pop revolution was her sang-froid disposition. But 'coolness' would

become one of Pop's defining traits. Warhol is the classic example. So much of his work has a particular quality. Call it what you will – cool, deadpan or neutral; detached, mechanical, impersonal – the processes he used ensured that this effect would be the outcome. Silk-screen printing, for example, involves several stages that 'distance' the finished work of art from its original subject. Even his films, which purport to present unedited reality, anticipating by decades the mania for reality television that characterizes our own time, have a remote quality. His 485-minute-long, black-and-white film, *Empire* (1964), for instance, in which night descends upon New York's Empire State Building, which had recently been illuminated with floodlights for the first time, was shot at 24 frames per second. Yet Warhol specified that it should be projected at 16 frames per second, thus deliberately slowing it down. The footage's already daunting length of six and a half hours was extended to a potentially mind-obliterating eight hours and five minutes. *Empire* does present an unadulterated view of the skyscraper, as it appeared in reality during the first half of a July night in 1964. Yet, as is so often the case with Warhol, it also injects that same reality with a metaphorical shot of Novocain – numbing it, chilling it, placing it on ice. This is a quintessential strategy of Pop Art: just look at Lichtenstein's well-known comic-book paintings, in which 'hot' subject matter – such as the chaos of modern, jet-fuelled aerial warfare – is executed in a 'cool' manner, painstakingly imitating the visual effects of mechanical reproduction. The impassioned gestural spontaneity of Abstract Expressionism had been deep-frozen. This context helps to explain why certain female artists, who were important at the time, were frozen out of art history themselves, because their work didn't 'fit' the classic narrative of Pop.

★

A good example of this phenomenon is the British artist Pauline Boty. During her lifetime, Boty enjoyed fame as a painter, actress and free-spirited advocate of women's independence. Born in suburban south London in 1938, she grew into a charismatic and attractive young woman whose nickname at the Wimbledon School of Art during the Fifties was the 'Wimbledon Bardot'. After graduating from the Royal College of Art, where she studied stained glass and overlapped with wunderkinds of British Pop, including Hockney and Jones, she shared a ramshackle house in Notting Hill Gate with the textile designer Celia Birtwell. After a ten-day romance in the summer of 1963, she married the literary agent Clive Goodwin.

Over a glittering career in which she became a bona-fide 'personality', she hung out with Bob Dylan, appeared in a David Bailey photo shoot in the pages of *Vogue*, and designed posters and programmes for stage productions in which she also performed at the Royal Court Theatre. Her final painting was a risqué image of a bottom commissioned for Kenneth Tynan's avant-garde revue *Oh! Calcutta!* In hindsight, Boty seems like the incarnation of the Swinging Sixties. 'I had simply never come across anyone like her and she shook up my view of things,' Tynan's wife, Kathleen, once wrote.

Yet, following her death from cancer, aged just twenty-eight, in 1966, her starlet persona began to count against her. Her reputation as a 'dolly-bird' and heartbreaker endured – it was said in the Nineties that grown men with grey hair in Notting Hill still cried at the sound of her name. But her achievements as an artist tumbled into obscurity, even though she was profiled, alongside Blake, in Ken Russell's BBC television documentary *Pop Goes the Easel* (1962). The film, which is available online, includes a memorable sequence in which Boty dances the twist while wearing a feather boa.

For almost three decades, from her death until 1993, not a single one of her paintings was exhibited in the UK. Even today, the Tate owns only one artwork by Boty: an oil painting called *The Only Blonde in the World* (1963), which it acquired as late as 1999. It is a hybrid work, combining abstract motifs with a sliver of figurative painting, in which Marilyn Monroe, with a joyful expression on her face, totters along rapidly on high heels. Abstract, curling red marks on either side of her, painted against a flat green background, appear to buzz and vibrate. Their meaning is ambiguous – but perhaps they are Boty's shorthand for the shock waves of this vivacious film star's charisma. Just as Blake made Pop artworks that may be understood cumulatively as fan mail to popular culture, so Boty – who sometimes paid homage to Blake by including in her paintings chevrons and fairground lettering – was turned on by the brave and intoxicating new worlds of cinema and rock and roll. At the same time, like Blake, she was not afraid to draw upon her sophisticated training as an artist. That she studied stained glass is significant when we consider *The Only Blonde in the World*, because it suggests that Boty may have thought about the picture in terms of religious art. The abstract parts of the canvas function like the painted doors of an elaborate altarpiece, semi-opened to reveal a pulse-quickening glimpse of this secular saint within.

Like Axell, Boty brought something distinctive to Pop: a confident and sympathetic representation of female sexuality. Take *With Love to Jean-Paul Belmondo* (1962), in which a monochrome publicity portrait of the French New Wave heartthrob becomes a target for female desire, represented by an enormous red rose with many petals. This suggestive plump flower, which Boty often used as an emblem of female sensuality, dominates the top half of the painting, squashing Belmondo's white straw hat. With its raucous orange background, the painting is a racy celebration of

sex – from a woman's point of view. Much of Boty's work has a similarly joyous quality. In other words, there is nothing remote about her pictures, which also touch on contemporary events such as the Cuban Missile Crisis and the assassination of JFK: she always painted with immediacy and gusto. Ultimately, this may explain her lengthy invisibility, since she did not go in for the trendy emotionless detachment prized in public by Warhol, Lichtenstein, Rosenquist, and many other (mostly American) male Pop artists. But this is to do her a disservice. Boty may not have painted like an *American* Pop artist – yet just look at the subject matter and fresh attitude embodied in her work: she was a Pop artist all the same.

<div align="center">*</div>

A similar fade-out from art history was also the fate reserved for the American artist Rosalyn Drexler. Like Boty, Drexler remains relatively unknown today – even though, now eighty-eight, she has a painting in the collection of the Whitney Museum of American Art in New York. Her anonymity is often explained by referring to her Sixties paintings as 'hot', and pointing out that the prevailing Pop fashion when they were made preferred 'cool'. Yet, while it is true that her art has a strong painterly component – i.e., it never looks 'mechanical', like that of, say, Lichtenstein or Warhol – it is also the case that her Sixties work, in particular, contained great originality of vision. Moreover, Drexler's approach, in her paintings, was startlingly prescient of later developments in contemporary art, while during the Fifties and Sixties she was embedded within the nexus of the avant-garde.

Born to a middle-class family in the Bronx in New York in 1926, she grew up in that northern borough of the city as well as in the neighbourhood of East Harlem in Manhattan, where her grandparents had a second-hand store. In 1946, having attended

the public university of Hunter College on Manhattan's Upper East Side for a single semester, she married the figurative painter Sherman Drexler, with whom she had two children. A few years later, while feeling stifled by the drudgery of looking after a baby, an unexpected opportunity arose that would have a lasting impact upon her life. At the time, Drexler practised judo at Bothner's Gymnasium, on West 42nd Street in Hell's Kitchen, which was frequented by 'carny folk' – people who performed in circuses and funfairs. Whenever she turned up, Drexler would encounter dwarfs tumbling and honing showbiz tricks on mats in front of the big window. 'There was also a man on a unicycle who rode around the gym while supporting his wife upside down on his head,' she recalls. 'He wore a special doughnut on his head and her head fitted into it upside down.' Drexler, who would later become a successful novelist, Off-Broadway playwright and Emmy Award-winning screenwriter, enjoyed observing the exotic performers in the gym. Similarly, around the same time on the other side of the Atlantic, Blake was visiting the circus and sensing that, as well as providing entertainment, it could be a source for art.

During her sessions at Bothner's, Drexler befriended a girl who also worked out there in order to keep fit for her career as a wrestler. Intrigued by how she earned a living, Drexler asked this friend to set up a meeting with her manager, Billy Wolfe, a professional wrestling promoter who ran a travelling troupe of around thirty women wrestlers. The encounter took place in a room in the nearby Dixie Hotel on 43rd Street, and soon turned into an audition. 'I put on a bathing suit, and walked back and forth a couple of times,' Drexler recalls. '[Billy] said, "Good, expect a call from us soon from Florida and we'll see what's happening."' Soon afterwards, Drexler, who was still only twenty-four, did receive a call, inviting her not quite to run away with the circus but to leave

behind her husband and four-year-old daughter and become a wrestler. She set off for Florida. 'I wanted to see what it was like, and I wanted to leave [home] for a short time and earn some money,' she explains. 'My whole idea was, I've got to get away from this family thing for a while. It was too much for me.'

After arriving in the Sunshine State, Drexler went to meet Wolfe's wrestlers, who had congregated in another room of the hotel. She opened the door to discover the aftermath of an accident: a woman was bent over a mirror with a pair of tweezers, pulling out fragments of bone from her gums. Meanwhile, on the bed, another wrestler was grooming a third member of the troupe, by removing blackheads from her legs. 'It was a lot like Monkeyville,' Drexler says. 'I mean, a whole lot of ridiculous stuff. It was a world apart from anything I'd ever known.' Her training took place quickly, in her hotel room: 'Somebody else held a pillow at chest height, and I would hit it. The idea was to make the most noise but the least damage.' All she needed now was a persona, so Wolfe opened up a phone book in the hotel room and jabbed his finger inside at random. It alighted upon the name 'Rosa Carlo', to which Wolfe decided to add the moniker 'the Mexican Spitfire'. Drexler was becoming a real-life version of the outlandish fighters that would later populate the paintings of Blake.

For the next three months, Drexler toured the American South, performing as her alter ego. 'I hated it,' she says. 'Nothing about it was empowering: it was dirty, tiring and boring. And there was nobody [in the troupe] I could relate to. A bunch of former waitresses – not that I wasn't ever a waitress, but . . .' She pauses. 'I don't know why I did it.' In a photograph of her preparing to perform as Rosa Carlo, in which she laces up one of her wrestling boots while wearing a kind of shiny, reinforced bathing suit, Drexler sports a curious expression of both trepidation and determination. In 1962, Warhol used another photograph of

Drexler – this time crouching, match-ready, as Rosa Carlo – for his silk-screen *Album of a Mat Queen*.

While she was on the road, Drexler kept notes recording her experiences, which she drew upon later in her novels *To Smithereens* (1972), in which a street-girl takes to the ring as Rosa Carlo, the Mexican Spitfire, and *Submissions of a Lady Wrestler* (1976). These tales earned Drexler a small following as a pioneer of a niche genre known, in the words of one fan, as the 'spandexual romp'. *To Smithereens* was even reviewed in the *New York Review of Books*, where it received a rave: 'There's hope for literature yet.'

Just as Rosenquist's beatnik adventures as an itinerant sign painter a year or two later would help to shape his perspective as an artist, so Drexler's stint as a wrestler in 1951 informed her outlook. Part of the reason why she hated touring so much was because, in the Deep South, she encountered prevalent and explicit racism – and that dismayed her. The wrestling troupe was 'big news in small towns', she says, and the boards advertising that night's entertainment specified separate seating areas in the audience for 'colored folk'. 'And then the water fountains were white-only,' Drexler recalls. 'The toilets: white-only. I wasn't aware of this prejudice before. I said, "Why is this happening? I don't want to be here." It was a monstrous world and I was very upset by it. So I left.'

<p style="text-align:center">*</p>

A few years after returning to her family, Drexler followed her husband in the mid Fifties to Berkeley, California, where Sherman was finishing his art degree, having dropped out in 1945 to become a painter. Money was short. 'We'd have to put the stove on to heat the place,' Drexler once recalled. 'The cockroaches would come out.' Around this time, as well as posing frequently for her husband, Drexler also started to make visual art herself. To

begin with, she was a sculptor, not a painter, inspired by the revolutionary assemblage style then being honed by Rauschenberg and others. Eventually, in 1960, she showed her abstract sculptures – agglomerations of plaster and poured lead attached to found scrap metal – at the experimental Reuben Gallery on Fourth Avenue in New York. To make them, Drexler melted the lead herself. 'I used to order bars of lead,' she once said. 'Metal was melted in pots right on my kitchen stove. Stunk up the house but I got some weird shapes. I'd pour the hot lead into plates of Plasticine clay and it was really abstract stuff. I could have died from the fumes.'

That Drexler exhibited at the Reuben Gallery is significant. During the two years of its existence, from the summer of 1959 to May 1961, the gallery was a cynosure of New York's downtown art scene. This was the place where, in the autumn of 1959, Kaprow presented his unprecedented performance piece *18 Happenings in 6 Parts*. In this ground-breaking event, which inaugurated the Happening movement, the 32-year-old Kaprow – who, like Rauschenberg, was an acolyte of John Cage – instructed his participants to undertake simple, everyday actions, such as squeezing an orange, sweeping the floor or climbing a ladder. Everything took place within a grid-like wooden set redolent of New York's architecture, which Kaprow had also designed. Since each Happening was unique, never to be performed again, defining them in general is tough: it has been said that documenting the movement is 'like trying to catch the wind in a butterfly net'. Broadly, though, like *18 Happenings in 6 Parts*, the Happenings were forerunners of performance art, involving a series of usually plotless actions that had the semblance of spontaneity even when they were tightly structured. The result was a spellbinding synthesis of art and theatre.

It is worth dwelling briefly on the Happenings because they

remain an under-acknowledged influence on Pop Art. Several art-
ists who would be prominently associated with Pop, including
Dine and Oldenburg, who at that time was still working part
time in the library of Cooper Union, started out as instigators of
the Happenings. In 1959, for instance, in a small room in the
Judson Memorial Church on Thompson Street in Greenwich
Village, which was another important centre for the Happen-
ing movement, Oldenburg constructed a gritty installation called
The Street. Filled with a cornucopia of trash, including old rope
and rags, as well as objects and figures crudely fashioned from
cardboard, newspaper and burlap that looked as if they'd been
chewed by rats, this apocalyptic urban panorama was later used by
Oldenburg as the setting for a Happening of his own called *Snap-
shots from the City*. A couple of months after that, in May 1960,
Oldenburg re-created *The Street* in the Reuben Gallery. Its
punk-like spirit and over-the-top, cartoonish aesthetic, as well
as its interest in quotidian ephemera that anyone could chance
upon while walking through the city, were all aspects of *The Street*
that would later become hallmarks of Pop Art. Like many
avant-garde artists working in New York in 1960, Oldenburg was
trying to reconnect art with reality, by drawing upon the ener-
getic, anything-goes attitude that he encountered every day on
the city's streets.

To understand how interwoven the various strands of
avant-garde creativity swirling around New York were at the
beginning of the Sixties, consider the 'environment' that Kaprow
presented in the courtyard-cum-sculpture garden behind the
uptown Martha Jackson Gallery in the early summer of 1961. For
this artwork, entitled *YARD*, Kaprow filled the open-air space –
which already contained five sculptures, including works by Max
Ernst, Alberto Giacometti and Barbara Hepworth, which were
first wrapped in protective tarpaper – with scores of old car tyres

arranged in random mounds. '*YARD* thus looks neither exactly like a junk pile nor any of the usual arts, nor even a funhouse,' Kaprow wrote in the accompanying catalogue. 'Yet *YARD* could relate to any or all of them.' As June hit, and the temperature rose, the tyres started to stink. A rubbery stench wafted inside the gallery – ensuring that they could not be ignored.

It would be possible to write a PhD thesis on the role played by humdrum tyres in avant-garde American art of the Fifties and Sixties. In 1953, Rauschenberg collaborated with Cage to produce *Automobile Tire Print*. To make the work, Rauschenberg instructed Cage to drive his Model A Ford in a straight line over twenty sheets of paper that Rauschenberg had already glued together and placed outside his studio on Fulton Street. Before reaching the paper, the rear tyre of Cage's car passed through an artfully positioned pool of paint, so that it then deposited a diminishing black tread mark along the full length of the sheets. A few years later, in *Monogram*, one of his most notorious *Combines* that was first shown at Castelli's in 1959, Rauschenberg arranged a tyre around the midriff of a stuffed Angora goat that had caught his eye in a second-hand office-furniture store on Seventh Avenue in New York. Then, in 1961, came Kaprow's *YARD* – a kind of proto-Pop, rubberized riposte to Pollock's all-over painterly tangles. *YARD* must have influenced Kaprow's friend Lichtenstein, who, in 1962, painted his own mammoth *Tire*, which belongs to his austere early Pop series of solitary commercial objects presented in stark black and white against blank backgrounds. Like the related canvas *Golf Ball*, which parodies a well-known series of oval pictures by Mondrian full of clusters of vertical and horizontal black lines, like swarming plus and minus symbols, *Tire* functions in part as a burlesque of abstract painting, thanks to the hard-edged, graphic, zigzagging design of its crunchy tread. There are also lots of tyres attached to the mangled vehicles in Warhol's *Death and Disaster*

series. The most prominent one, though, is the specimen seen in close-up in *Foot and Tire* (1963), which replicates four times in black and white the sole of a man's boot trapped beneath the twin rubber behemoths of a juggernaut's rear wheels – functioning, in Warhol's vision, like a metaphor for the crushing and ultimately catastrophic forces of fate. Of course, we should not forget the whopping Firestone tyre, like Lichtenstein's but flipped on its side and with the brand name visible, which is such an eye-catching element within Rosenquist's *F-111*.

But we should also pay attention to a little-known painting called *Automobile Tires* (1958–62) by the Greek-born American artist Chryssa. In this oil-on-paper work, which was begun before any of the artists mentioned above, with the exception of Rauschenberg, had decided to incorporate tyres into their art, Chryssa painted a grid of ordinary tyres seen, like Lichtenstein's *Tire*, in three-quarter view. Chryssa not only sensed the power of a car tyre as an icon of everyday urban life ahead of her Pop contemporaries; she also, by repeating the same image sixteen times across her composition, anticipated the classic Pop trope of serial imagery, which is now seen as quintessentially Warholian. Here, then, is yet another instance of a female Pop artist not receiving her dues.

<p style="text-align:center">*</p>

As we have seen, at the turn of the Sixties, Drexler was very much ensconced within the avant-garde scene downtown. In 1960, the same year as her debut solo exhibition at the Reuben Gallery, she performed alongside Dine and Oldenburg, as well as the artist Lucas Samaras and Oldenburg's wife Patty, in a Happening called *E.G. (An Opera)*, written by the American artist Robert Whitman. Photographs survive that document this Happening, which also took place at the Reuben. In one of them, Patty

Oldenburg and Drexler can both be seen wearing ballooning, brightly painted costumes stuffed full of scrunched-up newspaper: Oldenburg's is yellow, while Drexler's is ultramarine. Eventually these were ripped open by Dine, who was in character as 'the Ball Man', wearing a costume covered with multicoloured spheres.

The reception for Drexler's Reuben show was positive. In particular, she recalls, the American Abstract Expressionist sculptor David Smith was encouraging: 'Keep doing this, he said, because women start and then they stop and you don't hear about them again. Keep going.' Drexler's work also won the attention of another Abstract Expressionist star, whom she met in the Cedar Tavern. 'Franz Kline saw a piece that I happened to have brought with me one day, and he said, "I'd like to exchange with you,"' Drexler once recalled. 'So I said, "Okay", and we did. I got one of his ink washes on a ripped-out telephone-book page. A few years later, when we were broke, I foolishly sold it for about $500, which paid for an almost entire vacation in Provincetown [in New England] with the entire family.'

When the Reuben Gallery closed the following year, however, Drexler was not picked up by another dealer – even though her work was already known by the right people (she had been introduced to the gallery by Ivan Karp, who later 'discovered' Lichtenstein), and despite the fact that other artists on Anita Reuben's books quickly found representation elsewhere. Her response to this rejection was to change tack from sculpture to painting – which was what she had always wanted to do anyway. 'When the Reuben Gallery closed, everybody else was asked to be in other galleries, but I wasn't,' Drexler recalls. 'And I thought, well, they don't want a sculptor, they must want a painter. So I'll be a painter. I was so naive!'

Although as a painter she was self-taught, it didn't take Drexler

long to establish her sophisticated Pop style. 'I never learned to draw or paint or any of that stuff, but I found a way,' she says. 'I had to find a way to do what I wanted to do – and that's why I turned to the media. Even though I felt it was cheating.' At the very moment when Warhol and Lichtenstein were looking to popular culture for inspiration, so was Drexler. Most of her paintings of the early to mid Sixties were inspired by B-movies, films noirs, pulp fiction and sensational tabloid stories. 'I work from camera images,' she once said. 'I look through newspapers and magazines for photographs, and when one hits me, I can visualize the painting immediately, even to size and colour. I blow up the photographs and paint right over them. It's a way of using found objects.'

Against flat backgrounds of (mostly bright) monochrome colour, she painted figures, including gun-toting gangsters and slain mafia kingpins, along with their broads and molls. She also depicted macho men and femmes fatales embroiled in violent, sometimes life-threatening arguments. These latter pictures are often grouped together as a dark and ambiguous series known as Drexler's *Love and Violence* paintings. Their principal theme is the threat of physical violence against women. In *The Bite* (1963), a vampiric man appears to chew at the naked shoulder of a blonde victim in his arms. *Self-Defense* (1963) features another blonde, this time with one of her breasts exposed, wielding a small pistol while clawing at the face of a male assailant, presumably a would-be rapist. Perhaps it was partially inspired by Drexler's experiences on the road as a wrestler. 'Once a bunch of guys followed us in a car across an open field,' she tells me. 'But we had this pearl-handled revolver in the glove compartment. Even so, it was hard to get away from that chase. I don't know what brought it on. Something in a coffee shop.' Drexler's worldview is 'a cross between daytime serials and Samuel Beckett', according to Arne Glimcher,

the American art dealer who showcased her work, including a picture called *Ice Cream Cone* ('God knows where that stuff is today,' she says), alongside paintings by Lichtenstein, Warhol and Wesselmann, as well as Marjorie Strider, in the *First International Girlie Exhibit* at the Pace Gallery in New York in 1964.

As well as actual and blown-up reproductions of newspaper and magazine photographs, Drexler collaged into her compositions cascading text culled from film posters, before painting over them. 'Like a tomb,' she explains. 'You're burying the image – and yet it lives, like the un-dead. My work is like the un-dead: buried under all these colours and paints, pretending a kind of life. But underneath is just paper and ink.' Although this strategy caused her some concern at the time – 'I was very guilty about it – achieving something not out of your head,' she once said – it was, in a sense, a natural progression from making sculptures using everyday detritus: the only difference now was that she wasn't working with any old junk but specifically with throwaway images from the media. Even though de Kooning had done something similar a decade earlier by using photographs of the mouths of models in advertisements in his *Women* series, Drexler was one of the first artists to cut out photographs and put them on the canvas so prominently. In doing so, she anticipated the trend during the late Seventies and Eighties for Postmodern appropriation art among the so-called Pictures Generation, which included Barbara Kruger, Richard Prince and Cindy Sherman.

Despite their bright colours, Drexler's best images have a palpable darkness. In *The Defenders* (1963), against a searing yellow background, men in black suits brandishing pistols, like characters from Quentin Tarantino's film *Reservoir Dogs*, stand beside a colleague who has apparently been shot dead. Meanwhile, in the lower left corner, a grey-faced, ghoulish gangster, wearing a baggy raincoat, blasts a tommy gun straight at the viewer. It's a tense, edgy scene

of chaos and confusion – compounded by the word 'ERROR' that is visible in the middle of a tranche of text running across the painting's background, like jam filling a slice of sponge cake. If these suited men are federal agents defending America from organized crime, as the badge-like, official-looking star painted behind one of them seems to suggest, they aren't doing a very effective job. *The Dream* (1963) is a startling scene of sexual menace, painted over a poster for a 1961 B-movie rip-off of *King Kong* called *Konga*, set in London. ('Not since "King Kong" has the screen exploded with such mighty fury and spectacle!' its poster promised.) In the top third of Drexler's painting, a ferocious, colossal gorilla bares his fangs against an orange background, while a terrified and defenceless victim, her clothes rumpled to reveal lots of purple flesh around her left thigh and bosom, lies along the bottom edge of the composition, against a rich royal blue. A torrential alphabet soup of indecipherable text, chopped up from the original poster, tumbles from the gorilla's fist down towards the woman's head – so that the painting looks like a Pop rendition of Goya's famous etching *The Sleep of Reason Produces Monsters*, in which a shadowy host of furry and feathered monsters swoops behind a slumped figure in the foreground. The mouth of the woman in Drexler's painting – red, raw, glistening and open to reveal a flash of teeth – is especially potent, echoing the gorilla's maw above. Incidentally, it is fascinating to note how frequently women's mouths provide the focus of compositions by important Pop artists, from Warhol to Wesselmann. Even Hamilton represented women's faces with nothing but floating pairs of lips in his paintings *Hers is a Lush Situation* (1958) and *$he* (1958–61). Perhaps this general tendency has something to do with Pop Art's twin obsessions with consumption and desire.

A woman's mouth is also the fulcrum around which another of Drexler's paintings pivots. *Marilyn Pursued by Death* (1963) presents

the film star, primly dressed in a white blouse and dark pencil skirt as well as sunglasses, running away from a black void. Following her is a crouching, creepy-looking bald man in sneakers, also wearing sunglasses, half running, half skulking in her wake. Everything in the painting is black, white or grey, aside from an incandescent, flickering double outline in orange and red that surrounds the figures like the incipient flames of hell's inferno. As for the figures themselves, they have been thickly painted with various greys so that, like Drexler's gangsters, they have a cadaverous skin tone. The only unpainted section is Monroe's mouth, where the original source for the painting, a blown-up newspaper photograph complete with half-tone dots, is still visible. 'This is something that happened on Arthur Miller's property,' Drexler explains. 'There was an accident and somebody got really hurt, and Marilyn [who divorced her playwright husband Miller after less than five years of marriage] panicked and started to run. Actually, this man must have been someone trying to protect her, chasing after her. But, in my mind, he represents Marilyn's inner fear of death. She had obsessive-compulsive disorder and was always afraid of death, so this is a psychological portrait of Marilyn Monroe. The painting was once called *Death is a Man in Sneakers*, but I thought that was unkind. It took me so long to paint it – longer than anything else. I don't know why.'

Monroe wasn't the only contemporary pop-culture icon painted by Drexler. The following year, like Blake, she worked on a painting of The Beatles. In her version, unlike Blake's, the members of the band appear faceless – as though their features have been erased by time. They almost look like silhouettes, yet they remain recognizable thanks to their distinctive mop-top haircuts and black Mod collarless suits. In evoking a sense of oblivion lurking beneath the glittering façade of popular culture, Drexler was

articulating something similar to other Pop artists such as Rosen-
quist, who also painted quartets of faceless men, as in *4 Young
Revolutionaries* (1962) and *4-1949 Guys* (1962).

Indeed, in keeping with the tradition of some of the strongest
Pop Art, such as Warhol's *Death and Disaster* series, Drexler was
never afraid of intelligent – and occasionally scathing – social cri-
tique, as another painting by her featuring men in suits reveals. *Is
It True What They Say about Dixie?* (1966) is a large canvas, 5ft wide,
inspired by a newspaper photograph in which a mob of grim-faced
men wearing dark suits and ties marches purposefully towards the
viewer. Clearly, they have a job to do – and it's going to be ugly.
Their ringleader is the stocky man marked out by his hat and col-
ourful red tie, decorated with a floral pattern. This is Eugene
'Bull' Connor, who had administrative responsibility for the fire
and police departments of Birmingham, Alabama, during the
civil rights campaign of 1963, when, in a virulent display of
racism, the authorities turned fire hoses and attack dogs upon
non-violent black activists. Warhol immediately recorded this
brutality in his *Race Riot* series, which he produced the same year.
'Bull Connor had a very bad reputation,' Drexler says. 'He was a
hateful human being. Along with his henchmen, he stopped the
freedom marchers with all kinds of terrible things. He was respon-
sible for a lot of deaths and attacks on black people.'

Drexler's painting is effective in part because, in the manner of
Greek tragedy, where violence happens off-stage, the attacks
themselves are not depicted. (In this, she differed from Warhol,
who screen-printed shocking pictures from the news directly on
to canvas.) 'Instead, you just see the evil intent of these marching
men who hated other people who wanted freedom,' Drexler says.
'All you need to see is the ominous intent and that's strong enough.'
Drexler augmented the inescapable sense of menace by deploying
a simple device: blending the men's black suits together, so that the

mob is presented as a many-headed monster, emphasizing the enhanced, collective power of the group over the individual. 'It's very intimidating,' she says. Moreover, by restricting the colour scheme to (mostly) black and white, she alluded to the simplistic politics and polarities of race then evident in Alabama. The ironic title of the painting refers to a song written in 1936 about the apparent paradise of 'Dixie' – a nickname for the Southern United States: 'Is it true what they say about Dixie?/Does the sun really shine all the time?/Do the sweet magnolias blossom at everybody's door?/Do the folks keep eating possum till they can't eat no more?' 'It's a song about how wonderful it is in the South,' Drexler says. 'And then you have this hateful group of men out to kill and destroy the freedom marchers.' Thanks to her time as a wrestler travelling across Dixie, when she encountered racism in the South at first-hand, Drexler was well placed to answer the question posed by the title of her painting: yes, it is true what they say – that Bull Connor is a murderous racist.

Three years earlier, Drexler had already treated violence against black men as a theme in a much smaller painting called *Death of Benny 'Kid' Paret* (1963), which records the final moments of an infamous boxing match that took place in Madison Square Garden in 1962. In the twelfth round of this title fight, the welterweight boxer Emile Griffith backed his Cuban opponent, Benny 'the Kid' Paret, into a corner and subjected him to twenty-nine consecutive punches, including eighteen thrown in just six seconds. Controversially, although Paret slumped through the ropes surrounding the ring, the referee did not stop Griffith's onslaught. Eventually, Paret collapsed, fell into a coma and died in hospital ten days later. In the aftermath, there were angry suggestions that the referee should have intervened much earlier.

Drexler's painting is a neglected masterpiece of Pop Art. Against a black background, she divides the crucial final seconds

of this fatal bout into a grid of six lozenges, each of which has the distinctive square shape, with curved corners, of a television screen on a typical mid-century cathode-ray-tube set. Numbered from one to six, these squares switch between mid-shots and close-ups as the action unfolds – presenting distinct moments from the fight like sequential panels in a real-life comic strip. In the first square we see Griffith backing Paret, wearing shiny white shorts, into the corner of the orange ring, up against the ropes. Then the savage pummelling commences, in a frenzy of quick paint like a passage from a work by Bacon, while in the background a white shirt is visible, as the referee looks on. In the fourth panel, Paret appears to swoon, isolated from his tormentor, before falling backwards in the fifth, towards a spectral figure in a green jacket. In the final square, we see Paret from the sweaty perspective of a ringside seat. By now, he is nothing but a raw, fleshy ragdoll, about to be engulfed by the black void that surrounds him. It is a moment of great, heartfelt pathos. Moreover, the cruciform shapes created by the black ropes in some of the panels suggest that Drexler deliberately set out to offer a secular version of the Stations of the Cross: here, it seems, we are witnessing Paret's 'crucifixion'. This potentially portentous theme, which in other hands could have become overly hectoring and solemn, remains fleet because Drexler refuses to mask the source of the painting: watching a big fight on the box. Part of the point of *Death of Benny 'Kid' Paret* is to articulate something about the relatively new pastime of watching television – on a flickering, glowing set, within a darkened room (hence the painting's black background). Thus, in Drexler's vision, a mundane experience – a sports fan turning on the telly and sitting back down on the couch – offers the revelation of something much more profound, even spiritual and universal: a compressed tragedy resulting in the death of a heroic scapegoat. Like the best Pop Art, this painting offers a disquieting truth about the nature

of the media, which provides spectacle for millions of passive, safe consumers at home, at the expense of sacrificing its 'stars'. Finally, it is worth pointing out that, while the brushwork in this picture may be relatively loose, gestural and expressionistic – and so out of step with the cool, mechanical effect of a lot of Pop Art produced in 1963 – other qualities of the painting, including its use of serial imagery derived from popular culture, couldn't be more 'Pop' if they tried. *Death of Benny 'Kid' Paret* belongs to the same tradition of so-called 'Dark Pop' as Warhol's *Death and Disaster* series. It may even be the first painting devoted to the act of watching TV.

★

The year after she painted *Death of Benny 'Kid' Paret*, Drexler made a disturbing self-portrait in which she appears, with odious blue skin, in high heels, black stockings and a garter belt, resting upon her arms and shoulders while performing a sort of contorted bicycle kick in mid-air. The whole thing – right down to her skin tone, which deliberately evokes the colour of blue movies – smacks of parody, burlesquing the centrefold in a girlie magazine. This, surely, is a jibe at how society perceived women in those days. Sexy and superficial: fine. But being a serious artist: for the most part, that was a no-no.

Did it feel tough in 1964 to be an artist and a woman? I am standing with Drexler in front of her *Self-Portrait* in a gallery in New York. For a moment, she looks cross. 'It's hard enough just to be a human being,' she replies. 'A woman and an artist are not separate things. And I was kind of protected. My husband was a painter, and all our friends were artists, and I was in this community, which is a lovely thing to be. Unfortunately I didn't notice that my career was slipping away because I was a woman. That's what they say.' And looking back now, does she think that they

were right? 'It's partly true, of course. I know Castelli came to a lot of my shows and did nothing. Everybody knew about my work. I was in museums early on. And then . . .' What went wrong? 'I don't know. I guess they were full up.' Does she feel angry or has she made her peace with how things turned out? 'Of course I'm at peace with it,' Drexler says. 'I'm still working. I have opportunities now. If I'm lucky, I'll live for a year or two more.' She pauses. 'Look, you want me to say, "Hey, I was just as good as the rest of the guys" – but I was just as good as I was. I did what I could. Anyone else can judge it if they want to, but it's too late now. I can't go back and say, "Put me in the hierarchy." I have to accept what life gives me. Everybody knows what happened. It could have been worse. So I wrote books. I had plays produced. I even worked in TV and got an Emmy. Too much good was happening for me to sit down and say, "Oh dear, you know, they've done me wrong." But history knows what happened.' Drexler looks around her at the paintings that she made many years ago, which are visible on the gallery's walls, and smiles: tight-lipped, unamused and defiant. 'The main thing is I kept working. That's where I live: the ideas. I'm not happy when I'm not working. I love the work.'

Afterword: The Power of Pop

Like many summer days in New York City, the third of June 1968 was a scorcher. Around 4.15 that afternoon, Andy Warhol pulled up in a cab outside the Factory, which had moved earlier in the year to a new address at 33 Union Square West. As he paid the fare, Warhol spotted Jed Johnson, the interior decorator who was his lover for twelve years, walking down the street, carrying a bag of fluorescent lights from a hardware store. A moment later, he also noticed a feminist scriptwriter called Valerie Solanas, whom he vaguely knew, heading towards the Factory. Solanas, who had founded a radical organization that she called SCUM. (Society for Cutting Up Men), which boasted a membership of one, had in the past asked Warhol to read one of her scripts called 'Up Your Ass'. Warhol loved the title, but was put off by the story, which was so filthy that he worried Solanas was an undercover cop trying to get him into trouble. Unfortunately, after flicking through the script, Warhol mislaid it. So when Solanas started asking for it back, he was unable to return it. Increasingly, her calls to the Factory became hostile and erratic. Before long, she was demanding money in compensation to help pay her rent at the Chelsea Hotel. Peeved by her demands for what he perceived as a 'handout', Warhol invited her instead to earn $25 by performing a bit part in his new erotic movie, *I, a Man*, which he was shooting over the autumn of 1967. Solanas turned up that September, did a funny turn in a short scene on a staircase and left. After that, Warhol didn't hear much more from her – until he saw her, suddenly, walking along Union Square nine months later.

The curious thing, as Warhol remembered thinking while he waited with his two companions for the elevator up to the Factory, was that, despite the breezeless summer heat, Solanas was wearing a fleece-lined winter coat. She was also holding a paper bag. 'Then I saw that there was something even more odd about her that day,' he later wrote. 'When you looked close, she'd put on eye make-up and lipstick.' After arriving on the sixth floor, Warhol drifted off into the studio, before taking a phone call from one of his superstars, the talkative actress Viva. As he was putting the phone down, he heard an explosion, and whirled around: 'I saw Valerie pointing a gun at me and I realized she'd just fired it.'

Her first shot missed Warhol, who dropped to the floor and tried to crawl under a desk. But then she moved in closer and fired again, twice more – and Warhol 'felt horrible, horrible pain, like a cherry bomb exploding inside me'. Two bullets from her .32-calibre pistol ripped through his body, causing catastrophic damage to his stomach, liver, spleen, oesophagus and lungs. Crumpled on the floor, and finding it difficult to breathe, Warhol had to wait half an hour for the ambulance summoned by his business manager, Fred Hughes, who was informed that it would cost $15 extra to sound the siren. Solanas, meanwhile, wandered around the Factory for a few more minutes, terrorizing the artist's associates, and shooting one of them in the hip. Then she trained her gun on Hughes, who implored her: 'Please! Don't shoot me! Just leave!' Looking confused, she went to call the elevator, before turning back towards him. According to Warhol, when the lift doors opened, Hughes had the presence of mind to say, 'There's the elevator! Just take it!' And she did – before later giving herself up to the police.

Warhol was whisked away several blocks to Columbus Hospital, where doctors performed life-saving surgery upon him for five hours. During the course of the operation, there was a

moment – as he discovered afterwards – when he was lying on the table, clinically dead. Eventually, of course, he came back round. But he was hospitalized for eight weeks, and never fully recovered from his injuries, either physically or psychologically. In the wake of the shooting, he became ever-more fearful of his own mortality. Death, which had always been one of his most important themes, asserted itself in his art with greater prominence. More than a decade later, in 1981, he created a series of *Gun* paintings, including, a large silk-screen, now in the Tate, featuring two images of a snub-nosed pistol similar to the one used by Solanas.

In addition to this, his lifestyle and philosophy began to change. He left behind the dark, drug-addled wildness of the original Silver Factory of the mid Sixties and smartened up his act. His studio took on a more conventionally corporate appearance, and he pursued business interests such as magazine publishing as well as painting. There was a risk that the shift would come at a cost: 'I was afraid that without the crazy, druggy people around jabbering away and doing their insane things, I would lose my creativity,' he once said. 'After all, they'd been my total inspiration since '64, and I didn't know if I could make it without them.' Some critics and art historians remain unconvinced that he ever did. His formulaic celebrity portraits of the Seventies, for instance, for which he charged $25,000 for every original 40in. × 40in. canvas, with discounts available if clients bought in bulk and ordered multiple copies, have frequently been offered as an example of Warhol selling out. (That said, these paintings do also have their defenders, such as the British artist Jeremy Deller, who argues that during the Seventies Warhol became a kind of court portraitist to imperial America, chronicling his jet-set age.) 'Being good in business is the most fascinating kind of art,' Warhol wrote in 1975. 'Making money is art and working is art and good business is the best art.' Was he capitulating to The Man? 'You'd be surprised how many

people want to hang an *Electric Chair* on their living-room wall,'
he once said. 'Especially if the background colour matches the
drapes.' Leaving aside the brilliantly arch nature of this remark,
who wouldn't now put up with such a disturbing image at home,
given that Warhol's *Death and Disaster* pictures attract such exorbi-
tant prices at auction? In 2013, during a sale held at Sotheby's in
New York, Warhol's *Silver Car Crash (Double Disaster)* of 1963 sold
for a record price for the Pop artist of more than $105 million. His
transformation from subversive guru of the counter-culture to
bankable asset was complete.

*

Warhol's shooting is sometimes taken as a watershed not only in
his career but also in the history of Pop Art generally. The day
after it happened, Warhol was front-page news. 'Actress Shoots
Andy Warhol' ran the headline in the tabloid *New York Daily
News* – six years to the day, as he later pointed out, after the
appearance of the '129 Die in Jet Disaster' front page that he had
decided to paint in 1962, initiating his series of *Disasters*. His time
as a national news story, though, was short-lived. Two days later,
Robert F. Kennedy was assassinated – and Warhol was yesterday's
man. And around the same time that he was jettisoned from the
front pages and replaced by Bobby Kennedy, so the number of
headlines generated by Pop Art started to diminish. Other forces
within contemporary art were becoming more dominant: Min-
imalism, Land Art, Arte Povera, Conceptual Art. Pop's once-
rampant ability to antagonize and shock was dwindling. It had
been co-opted by the same mass culture that it had originally
raided, and was regularly being ripped off by designers and
advertisers. According to Lichtenstein, Pop had once seemed
incendiary and 'despicable'. Now, though, it was mainstream – a
lifestyle choice influencing the appearance of everything from

fashion and furniture to movie posters and record covers. Towards the end of the Sixties, Allen Jones sensed that his art was reaching an ever-larger audience. 'I could see album covers which were plainly coming out of my paintings,' he says. 'And [the Japanese fashion designer] Issey Miyake went on record saying that some of his designs came out of looking at my sculptures.' In 1968, the same year that Warhol was shot, the *New York Times* declared that Pop Art was dead. Many people believed that it had already peaked several years earlier – including Peter Blake, who told me that Pop's classic years were '59 to '64. Another alternative 'ending' for Pop Art is Warhol's announcement in Paris in 1965 that he was intending to 'retire' from painting in order to concentrate exclusively on film-making.

Yet, looking back at Pop Art after more than half a century, something remarkable about it becomes apparent: its ability to survive – and thrive. Yes, the buzzing 'High Pop' of the Sixties did eventually falter, like someone coming down after a decade-long amphetamine binge. But its irrepressible spirit never faded away completely. In part, this was because Pop proved to be highly contagious, spreading quickly across the world. Its infectious quality, of course, was a direct result of its graphic legibility, which meant that, unlike other art forms, such as abstract painting, Pop Art could easily withstand reproduction in the media, since the two were so in sync. And as it travelled, it accrued distinctive, local significance in the hands of various important international artists.

An early example of this phenomenon was the so-called Capitalist Realist movement that emerged in Düsseldorf during the Sixties. Its two principal protagonists were the maverick artist Sigmar Polke, who died in 2010, and his more famous contemporary Gerhard Richter, who is now the most valuable living artist in Europe. Born in the Lower Silesian town of Oels in 1941, Polke

grew up in the Soviet Occupation Zone before his family fled to the West German city of Düsseldorf in 1953. Eight years later, he enrolled at Düsseldorf's Kunstakademie, where he met Richter as well as Konrad Lueg, who were both fellow students. Two years after that, inspired by examples of the new American Pop Art that they were encountering in shows and magazines, the three collaborated with a fourth artist, Manfred Kuttner, on an exhibition in an abandoned shop window. Richter described it at the time as the 'first exhibition of "German Pop Art"'. Little documentation of the show survives, but supposedly Lueg took a branded tub of washing powder and turned it upside down, while Polke strung together several magazines and hung them up like a mobile sculpture. Within a few months, Richter and Lueg had also staged a celebrated exhibition called *A Demonstration for Capitalist Realism* inside a furniture showroom. As well as presenting some of their own work, the pair displayed furniture on plinths and offered themselves as living art.

On the face of it, Capitalist Realism had many affinities with American Pop. Just as Lichtenstein made a series of paintings of solitary objects such as his *Cup of Coffee* and *Tire*, so Richter concentrated on banal, everyday products, including a stool and a roll of toilet paper. Like Warhol, he also drew upon the mass-produced, commercial imagery of advertising, as in his paintings *Folding Dryer* (1962) and *Ferrari* (1964). Polke did something similar: as well as early drawings in ballpoint pen of a bar of soap and folded shirts, he made paintings of socks, more folded shirts, a broken-off bar of partially unwrapped chocolate, and biscuits – all of them redolent of the visual ploys of advertising.

Comparisons between the Americans and their German contemporaries are sometimes irresistible. In 1963, for instance, Lichtenstein created a painting called *Hot Dog with Mustard*. That same year, Polke produced *The Sausage Eater*, in which an eyeless,

disembodied head in profile, with smiling red lips and a full, podgy cheek, consumes a serpentine string of brown frankfurters that snakes its way around the rest of the canvas. Around the time that Lichtenstein became interested in replicating coloured patterns of so-called 'Ben-Day dots', which allowed publishers to reproduce pictures mechanically, Polke also began to investigate commercial printing techniques. His *Rasterbilder* (*Screened Paintings*), which he began in 1963, borrowed the 'raster' dots of halftone newspaper illustrations. These would become some of his best-known images, inevitably leading to talk about his distinctive 'Polke dots'.

Yet, for all the similarities between what was happening in New York and Düsseldorf in the early Sixties, there were also some significant differences. For one thing, Polke always liked his dots to be messy, whereas Lichtenstein strove for a pristine effect. In fact, unlike American Pop, which often appears meticulous, Polke's pictures generally have a deliberately casual, even clunky quality. Part of the appeal of this approach for Polke was that it offered an antidote to the Nazi obsession with purity, clarity and 'truth'. Thus, Capitalist Realism was a reaction against the spectre of the Second World War and the toxic legacy of the National Socialist Party. Moreover, living in West Germany during this era did not offer the same experience as capitalist America. While Pop artists in New York and LA were surrounded by a glut of *things* – something that Warhol recognized when he remarked that a can of Coke was within reach for both the president and the bum on the street corner – Polke and Richter discovered that capitalism wasn't necessarily a panacea that could cure West Germany of austerity. Indeed, consumer culture, for these young German artists, was something they couldn't afford. 'When I came to the West, I saw many, many things for the first time,' Polke once recalled. 'But I also saw the prosperity of the West critically. It wasn't really

heaven.' A large strand of Capitalist Realism, then, was about interrogating the shaky state of German society – and one way that Polke did this was via humour and satire. His painting of socks, for instance, is deliberately humdrum and ironic. In *The Sausage Eater*, the endless frankfurters suggest both gluttony and coercion, as though the eyeless figure is being force-fed. (We could even consider it as a German counterpart to Marisol's sculpture *Love*.) *Sparkling Wine for Everyone* is a crude, watercolour-and-ballpoint doodle that punctures the hollow promises of prosperity uttered by West Germany's leaders. Polke's clowning was usually motivated by something deeply serious. In this respect, he was like many other important Pop artists – it's just that the sharp end of what he had to say was reserved for his own particular setting.

<p style="text-align:center">*</p>

Capitalist Realism occurred at the same time as Anglo-American Pop. So did the French movement of Nouveau réalisme, which the critic Pierre Restany defined in his manifesto of 1960. Of the signatories, all of whom were broadly concerned with making art that responded to urban life, it was perhaps the self-taught artist Martial Raysse whose work most closely resembled that of the classic Pop artists on the other side of the Atlantic. Now almost eighty, Raysse is not well known outside his native country, where he was honoured with a retrospective at the Pompidou Centre in Paris in 2014. Born in the resort of Golfe-Juan, he grew up on France's Côte d'Azur, and a sunny sense of beachside relaxation would become an essential part of his signature – and spectacular – work of the Sixties.

In the late Fifties, Raysse became obsessed with plastic. He started producing jaunty, sprightly and playful sculptural assemblages, using everyday objects, including skittles, skipping ropes

and bright pink synthetic brooms. The tone of these works is joyful and ironic, raucous and ridiculous. They look like wilfully silly versions of Rauschenberg's *Combines*. Around 1961, though, Raysse switched predominantly to painting. Many of his images from the Sixties feature photographs of glamorous and alluring women rendered in fluorescent colours against vivid and unbroken monochrome backgrounds. At this point, Raysse still found inspiration in the artificial and futuristic materials of France's modern consumer society. He was always experimenting: embellishing his canvases with plastic flowers, neon lights, even video. Often during the Sixties, Raysse painted copious green foliage, but there is nothing natural about his pastoral vision: the fantastical realm of his paintings is wholly synthetic.

It would be easy to dismiss his Sixties works as derivative of Warhol – until, that is, you look at their dates. Raysse, who participated in the *New Realists* exhibition at the Sidney Janis Gallery in New York in 1962, wasn't racing in Warhol's slipstream: rather, the two artists were neck and neck. For the *New Realists* show, Raysse considered submitting two paintings of luridly made-up women – both of which, in retrospect, anticipate Warhol's slightly later yet more famous pictures of captivating actresses. On certain occasions, even, Raysse was way ahead. For instance, *Raysse Beach*, his festive environmental installation of 1962, with its pictures of frolicking swimwear models surrounding a flashing jukebox, a parasol and some inflatable pool toys upon a sandy floor, surely influenced the young American artist Jeff Koons. In my mind, there is no question that Raysse deserves a more central position within the pantheon of Pop Art.

*

These days, Koons is a bona-fide colossus of contemporary art: he currently holds the record for the world's most expensive living

artist, after his monumental stainless-steel sculpture *Balloon Dog (Orange)* sold at auction in 2013 for $58.4 million. In the late Seventies and early Eighties, when Koons was starting out in New York, Pop Art was in abeyance. The dominant trend in contemporary art at that time was Neo-Expressionism, typified by the work of painters such as Julian Schnabel and the fashionable graffiti artist Jean-Michel Basquiat, with whom Warhol collaborated in the hope that some of the younger man's stardust would help to alter the perception that his own career was on the wane. In 1986, though, following a memorable show in SoHo at the Sonnabend Gallery, which had championed Pop Art, including Warhol's *Disaster* pictures, in Paris back in the Sixties, Koons rose to prominence. He belonged to a new, Pop-influenced movement marketed as Neo-Geo (shorthand for New Geometric or Neo-Geometric Conceptualism), which also included the artists Ashley Bickerton and Peter Halley. Swiftly, though, it became apparent that Koons was not only going to be the poster boy for Neo-Geo but also would become the pre-eminent artist of the so-called Age of Money.

From the get-go, Koons operated within the long shadow of Pop Art. Almost every aspect of his output feels like a fresh iteration of ideas first explored by Pop's missionaries, from the everyday vacuum cleaners that he encased in Perspex in the early Eighties (he also made art using other ready-made domestic objects such as telephones and toasters) to his self-conscious photographic manipulations of the language of advertising, which appeared in art magazines. Even his sculptures in stainless steel, such as his blank-faced *Rabbit* (1986), by virtue of their reflective properties, relentlessly foreground an obsession with surface appearance – something Warhol, notoriously, was keen to emphasize too. Like Warhol, Koons has also moved beyond the realm of fine art – designing everything from album covers to a BMW.

While it would be straightforward enough to create an extensive list of specific Koons artworks that owe an explicit debt to Pop Art, it is arguably more instructive to consider his broader concerns within the historical context of the Sixties movement. Just as Lichtenstein once implied that he invented his cartoon style in order to create a painting so shocking that people would be reluctant to hang it on a wall, so Koons has devoted his career as an artist to pushing at the limits of acceptable taste. There is nothing chic or stylish about Koons's *Banality* series of sculptures of 1988, which presented figures recognizable from popular culture, including the silent-film comedian Buster Keaton, the pop star Michael Jackson with his chimpanzee Bubbles, a dog from the Garfield comic strip and the Pink Panther cartoon character. By any conventional standards, these polychrome wood and gilt porcelain sculptures, fabricated by Bavarian woodcarvers and Italian ceramicists, are repulsive: toe curling, cloying, excessively saccharine and irredeemably vulgar. Their closest visual relatives are the tawdry baubles and tchotchkes on a grandmother's mantelpiece, or throwaway souvenirs in a cheap gift shop. Indeed, the scandal they generated when they were first shown almost simultaneously in galleries in New York, Chicago and Cologne must have seemed mightily familiar to anyone who had witnessed the arrival of Pop almost three decades earlier. One veteran critic remarked that 'the hysterical critical reaction' was 'unlike anything I can remember since the advent of Pop Art in 1961–2'. Koons's horribly kitsch sculptures of poodles and puppies were in such bad taste that they seemed divorced from accepted canons of what constituted a work of art. To borrow Max Kozloff's words about Lichtenstein's early Pop paintings, they appeared like 'a pretty slap in the face of both philistines and cognoscenti'. Surely they were ironic or satirical?

The question of the sincerity of this former Wall Street

commodities broker is a complex issue: it is possible to construct compelling cases on either side of the argument about whether or not Koons is 'for real'. Either way, Koons – like the founding fathers of Pop who preceded him – somehow concocted a type of anti-art so 'despicable' that it made people angry. And Pop Art had shown him how to go about it: by diving downwards, without fear or compunction, to the very bottom of the sea of taste. Yet, even if we can never satisfactorily resolve it, the debate about Koons's ingenuousness is revealing, because it chimes with a bigger question that still hangs unanswered over Pop Art today. What, exactly, is Pop Art's position vis-à-vis popular culture? Is it detached and critical – like the work of the Independent Group's Hamilton, who analysed and dissected popular culture before presenting its constituent parts in paintings that look like unsolvable puzzles? Or is it more impassioned and involved – as in Blake's fan-boy art? Sometimes, perhaps, it was possible for Pop Art to be both: Warhol's *Campbell's Soup Cans*, for instance, are a nostalgic paean to his childhood but also, arguably, a swipe at mid-century American capitalism, which offered cheap food in abundance at the price of brain-numbing conformity. When I asked Blake if he believed that the best Pop Art was necessarily motivated by affection for the popular culture that provided it with inspiration, he answered simply: 'Yes.' And perhaps – against the odds – a similar sort of affection motivates Koons. Often Koons is accused of making work cynically with one eye on the market, while laughing up his sleeve at the dupes prepared to splash out on such dross. Yet, if we take what he says about art at face value, it would appear that, like Blake, he too is a sort of innocent 'fan', deriving joy and life-enriching pleasure from his subject matter. 'Jeff is never a satirist,' explains his British former dealer Anthony d'Offay. 'He is always dead-on serious.' Even when he calls one of his exhibitions

Banality? 'Yes,' d'Offay says. '*Banality* means that you don't have to go to the Courtauld [Institute of Art] and study Cézanne to love art, or let it strengthen and help you. Jeff is saying, there isn't high art and low art – one in the museum that is the real thing, and then everything else trying to get there. He means that art isn't for sophisticated people, it's for everyone.' D'Offay could be reading straight out of the Pop Art playbook penned by Kozloff ('Anything goes, just as anything goes on the street'). He pauses, before talking about Koons's *Puppy* (1992), a 40ft-tall piece of flowering topiary shaped to resemble a gigantic West Highland Terrier. 'What a wonderful thing. Once you've seen it, you never forget it. I think *Puppy* is one of the most remarkable sculptures in the history of art. Everybody loves it. It's like Michelangelo's *David*: there isn't a person who looks at it who doesn't think what a miracle this is.'

<p style="text-align:center">★</p>

Today, international contemporary art is characterized by pluralism rather than by distinct, clear-cut movements. Yet Koons is far from the only important individual now making art influenced by Pop. Like him, the British and Japanese artists – and market superstars – Damien Hirst and Takashi Murakami have both been inspired by Warhol's investigations into the overlap between business and art. There are countless other examples of artists shaped by Pop, such as the British artist Julian Opie, whose graphic, cartoon-like figures, painted within heavy black outlines and against bright colours, owe an obvious debt to Lichtenstein. Or Opie's (and Hirst's) Dublin-born former tutor at Goldsmiths College in south-east London, Michael Craig-Martin, who paints commonplace commercial products such as safety pins, USB sticks, Coke cans and takeaway polystyrene coffee cups, floating against

vast areas of flat, lurid background colour. Then there is the New York-based American painter Elizabeth Peyton, whose portraits of celebrities were first shown at the Chelsea Hotel in 1993. Inspired in part by Hockney, and working openly from photographs, Peyton paints royalty and pop stars, including Kurt Cobain, Jarvis Cocker and the Gallagher brothers from the Mancunian rock band Oasis, in a heartfelt, subjective manner – providing a delicate tribute to the popular culture of her own time.

In 2011, the Californian-born artist and composer Christian Marclay, who was raised in Switzerland, the spiritual home of the timepiece, won the prestigious Golden Lion awarded to the best artist at the Venice Biennale for his quicksilver film-montage epic, *The Clock* (2010) – a neo-Pop tour de force that is already being hailed as the first major masterpiece of the twenty-first century. Stitched together out of thousands of fragments from the movies, either featuring a timepiece or a character referring to the time, this bravura artwork has been seamlessly edited so that it corresponds precisely to the time in the real world – thus reducing the gap between art and life within which Rauschenberg had wanted to operate back in the Fifties. Accordingly, *The Clock* lasts for twenty-four hours – an endurance marathon that puts even Warhol's *Empire* in the shade – yet it rarely feels as though it is flagging. This is because Marclay has a sure-footed understanding of rhythm, so that he follows moments of tension and pathos with slapstick and broad comedy, ensuring that the viewer feels continuously involved, despite the fact that each narrative is interrupted after just a few seconds. There is something absurd about a work of art that tells the time while simultaneously unravelling it. But by cutting short each sampled film, Marclay exposes the artifice of strategies employed by film directors and editors to manipulate audiences, such as soulful music, lingering close-ups and dramatic lighting.

Aside from the obvious points of comparison, such as Marclay's interest in the lingua franca of film, or his willingness to fashion an artwork out of ready-made snippets of popular culture, *The Clock*'s keen understanding of the absurdity of aspects of the modern world is something else that its creator has inherited from Pop. Just think of the absurdity that so often animates the work of Rosenquist or Ruscha – or even Warhol, who gave Marilyn Monroe the gaudy appearance of a novice transvestite incapable of applying remotely subtle or convincing make-up. Or take Oldenburg, whom I met in 2015, while visiting his studio split across several storeys of a beautiful former propeller factory in New York. Many of Oldenburg's classic soft sculptures of grossly enlarged, squashy items of food have a deliberately comical quality, including his self-consciously ridiculous *Floor Burger* of 1962 – a gigantic, coarse approximation of a hamburger, complete with a crude gherkin placed on top of the upper part of the bun, created by stuffing acrylic-painted canvas with foam and cardboard boxes. Working in concert with his wife at the time, Patty, who was a skilled seamstress, Oldenburg also created a *Floor Cake* and a *Floor Cone*. All three sculptures look utterly absurd. 'Yes,' Oldenburg replies, his eyes twinkling with mischief, 'but don't you think that hamburgers *are* comical? I mean, I didn't do that. The guy who invented hamburgers did that.' Oldenburg, who is now eighty-six, has a distinctly quizzical attitude towards the world around him. With ironical, childlike glee, he seems to relish his sense of the unstable unreality of existence. Does he ever wake up and think that everything is absurd – as in: what are we all doing here, we strange human creatures, surrounded by so much bizarre stuff? 'Oh yes,' he says. 'Don't you feel that now and then? I think everybody feels that. And since no one can understand what it's all about anyway – since no one has the slightest idea about where they are or who they are or what the world is or anything – they

can only document it.' Perhaps here is a clue to another working definition of Pop: documenting the world from a position of wry detachment.

<center>★</center>

Five years after *The Clock*, Marclay announced his Pop credentials even more explicitly, in a solo exhibition at the White Cube gallery in south-east London. The show contained *Surround Sounds* (2014), a room-sized animation with a retro feel, in which onomatopoeic words painstakingly culled from the pages of vintage comic books cascaded across the walls with shimmering intensity. The idea was that each word would behave on screen in a manner appropriate for the sound that it evoked. Thus, 'BOOM' and 'BAM' appeared to explode outwards in chromatic detonations, while 'SHHH' was more of a grey whisper sliding down the screen like dreary rain. 'KRAK' literally cracked in half before our eyes, and 'RUMBLE' bobbled about at the bottom like an angry wasp in a bottle. Yet all the while the animation remained entirely silent. Elsewhere at White Cube, Marclay elaborated his comic-book conceit in a series of paintings which alluded to the birth of Pop Art by containing monosyllabic, punchy words such as 'SPLAT', 'SPLOOSH' and 'SMAK', screen-printed over brightly coloured backgrounds laid down with fluid, gestural brushstrokes, evoking Abstract Expressionism. By 'sampling' different styles, yet privileging none of them, Marclay was operating like a classic Postmodern artist. And arguably the most tectonic shift of all within the history of twentieth-century art – the transition from Modernism to Postmodernism, which summons art from the surfeit of images and information threatening to overwhelm us in our overly processed, mediated world – came about as a result of Pop Art.

This is why, even though it predated the advent of the Internet

by several decades, Pop Art remains relevant in the Information Age. Indeed, according to Jeremy Deller, Warhol was a 'one-man Internet before it was invented'. Deller met Warhol shortly before he died in 1987, and he has a point: Warhol's obsessions (celebrity, shopping, socializing, sex) are now the pre-eminent preoccupations of reality online. As a result, Warhol is often seen as the most important American artist of the second half of the twentieth century, because his innovative and diverse work was so farsighted. Perhaps, then, it is no surprise that Warhol's particular brand of Pop has been a fundamental influence upon the American Ryan Trecartin, the figurehead of a younger generation of so-called 'millennial' artists making work in response to the Internet and social media. Collaborating with his close friend Lizzie Fitch, Trecartin produces and stars in 'movies' (his word) that explore the impact of the revolution in digital technology upon the way we now communicate and interact. His nightmarish and anarchic videos are not for the fainthearted: bombarding us with bass-heavy sounds, neon colours and frenetic, aggressive cuts, Trecartin's films at first seem utterly formless. Gradually, though, you realize that there is a controlling intelligence at work. Trecartin is intent upon interrogating and parodying the narcissistic conventions of our mindless, online age. Reality television, video blogs, the self-regarding excesses of social media – Trecartin identifies the ephemeral tropes of each and re-presents them in great splurging skits, like deluges unleashed from the odious cistern of contemporary culture. Usually his films feature a motley crew of show-offs whose phantasmagorical qualities are enhanced by outlandish wigs and make-up. These over-the-top harlequins are strongly reminiscent of Warhol's superstars. Indeed, Trecartin's approach in general is indebted to the experimental film-making career of America's Pop artist-in-chief. You may hate what Trecartin does and refuse to call it art – but you couldn't say that it lacks

urgency or fails to skewer the short attention span of our channel-hopping world. And even if you do detest it, you'd better get used to it, because this is what art in the future will look like – and it wouldn't be here if it wasn't for Warhol.

*

Pop as a mode, then, rather than Pop Art the Sixties movement, remains one of the most powerful artistic ways of expressing what it's like to be adrift in the digitized ferment of our chaotic, 24/7 modern mass media. Consider contemporary art in China. It may sound strange, but in order to understand the mindset that produced Pop Art in mid-century America, I believe that you need to visit China today. Just as America in the Forties and Fifties was expanding rapidly and rampantly as a nation, so China over the past two decades has transformed itself with astonishing speed, having opened itself up to capitalism. Look, for instance, at the skyscraper-rich skyline of Shanghai: China's recent economic miracle has resulted in a self-confident, glittering and newly manufactured world. And just as capitalist goods like Coca-Cola began to infiltrate China in the Nineties, so Chinese artists who wanted to come to terms with this profound and irreversible shift in their society became obsessed with another product of the West: Pop Art. One of the first Chinese artists to engage with Pop was Wang Guangyi, who, in the wake of the Tiananmen Square protests of 1989, fused imagery reminiscent of commonplace propaganda posters from the era of the Cultural Revolution with the logos of Western brands such as Swatch, Porsche and Benetton, familiar from advertising. These grew into an important series of works known as his *Great Criticism* cycle. At the same time, during the Nineties, another artist called Yu Youhan, who was also participating in China's burgeoning Political Pop move-

ment, began to paint colourful pictures of Chairman Mao decorated with swathes of folksy flowers. Of course, back in 1972, Warhol had embarked upon his own Mao portraits, based on the cover photo of the publication *Quotations from Chairman Mao Tse-tung*. Warhol's painterly pictures, which defuse the menace of the leader of China's Communist Party by presenting him as though he is wearing make-up, would develop into the most extensive series of his career.

Even today, younger Chinese artists such as the Shanghai-based Xu Zhen are still referencing Pop. In 2007, Xu created an installation called *ShanghART Supermarket*. This meticulously reproduced a typical Chinese supermarket, with rows of shelves stacked full of consumer products, including packets of noodles and cans of Coke. The only difference between his installation and a real supermarket, though, was that each of the products available for sale in Xu's work was empty – light as a feather and filled only with air. This didn't prevent people from buying them all the same, in the belief that they were purchasing a clever little piece of Conceptual Art. The whole thing smacked of parody – in Xu's own words, he was using capitalism to fight capitalism. Yet it would never have been conceived without the example of Warhol, who had already created plywood boxes screen-printed with designs commonly found on packaging back in the Sixties. These were the *Boxes* – for Brillo soap pads, Heinz tomato ketchup and Kellogg's corn flakes, among other products – that Warhol first exhibited at the Stable Gallery in New York in 1964. Moreover, like Warhol, who had his own corporation – Andy Warhol Enterprises, Inc. – which looked after his various business interests, Xu established a company of his own in 2009. Called MadeIn Company, riffing on the ubiquitous product-label 'Made in China'. it describes itself as 'a contemporary art creation company, focused

on the production of creativity'. Xu is no longer a singular art-
ist – he has become a corporate brand. Good business, it seems,
continues to yield the 'best' art.

★

Riding a tsunami of prosperity, Chinese artists – like many con-
temporary artists working around the world in India and
elsewhere – could have found inspiration in various types of West-
ern art. But the one that seduced them the most was Pop. Three
decades after its creation, Pop was the go-to style for an increas-
ingly capitalistic nation on the up. Isn't that telling? Of course, it
makes a certain sense, because Pop excels at replicating the bliz-
zard of consumer products confronting us all, as well as the
relentlessness of our cyclical mass media. More generally, though,
the spirit of Pop Art endures because it is so inclusive and demo-
cratic. Originally Pop was a reaction against the restrictions of
abstraction, returning to imagery that everybody could under-
stand: it was an art of iconolatry, not iconoclasm. The shift from
Abstract Expressionism to Pop Art was one from subjectivity to
objectivity, from the archetype to the stereotype, from the exalted
to the everyday. But there was something else about Pop that
made it so attractive: it was witty, playful and irreverent – and it
was never afraid to appear seductive or glamorous. As a result,
some of the sacred, high-minded principles of modern art, which
were essential elements in the matrix of Pop's formation, could
suddenly be conveyed to the many, not the few. The curator
Henry Geldzahler was amazed when, barely a year after the
movement was first being documented in galleries and magazines,
a workman installing air-conditioning in his apartment recog-
nized a Warhol as a piece of Pop Art. Perhaps the labourer was a
modern art aficionado, who could also have picked out a Rothko,
had he seen one. But that wasn't the implication of Geldzahler's

story, which was making a point about the speed and depth of Pop Art's success and its ability to reach a wide audience. By drawing upon the shared language of the street, Pop Art was able to communicate with the man on the street too. Its wit was its weapon – capable of imparting hard-hitting messages, as well as complex and sophisticated ideas, with a lightness of touch.

One of the most intriguing moments in the history of Pop Art – emblematic, I believe, of this vital part of the movement's DNA – occurred relatively early on, in 1963. Inevitably, it involved Warhol. The setting was the Californian city of Pasadena, where Walter Hopps, one of the co-founders of LA's Ferus Gallery, had pulled off a coup by staging the first ever retrospective for Marcel Duchamp, featuring 114 artworks, including several major loans. It so happened that the reception for the retrospective coincided with Warhol's road trip to the West Coast; specifically, it took place the evening after the opening of his own exhibition of *Elvis* portraits at the Ferus Gallery. Warhol and his entourage decided to go along – although, on the night itself, one of them, Taylor Mead, almost wasn't allowed in because he hadn't dressed 'properly'. (He had borrowed a sweater that was so baggy on him it hung down past his hands and knees.) Despite Mead's sartorial outrage, Duchamp had invited the underground film actor to his table by the end of the party – and Warhol joined them.

On the face of it, it sounds like a curious encounter: shallow, lightweight Andy versus brainy, heavyweight Marcel. Moreover, we don't know what Duchamp and Warhol spoke about. 'I talked a lot to Duchamp and his wife, Teeny, who were great,' Warhol wrote, with typical, playing-it-cool understatement, in his memoir. In fact, the only thing we know for sure was that Warhol indulged in too much pink champagne, so he had to keep pulling over on the drive home. 'In California, in the cool night air, you

even felt healthy when you puked,' he said. 'It was so different from New York.'

But make no mistake: the story of that evening in Pasadena offers a sort of parable that helps to explain Pop Art's importance. As Duchamp himself once observed, Pop Art was a direct descend-ant of his cerebral, conceptual approach. Without Duchamp's discoveries – without his assertions that anything could be art, even ordinary, mass-produced and previously overlooked ready-made objects such as a urinal, a bottle rack, a snow shovel or a bicycle wheel – Pop Art wouldn't have been possible. This is why, during a BBC television interview broadcast in 1979, Lichtenstein said this, in order to explain why he had been drawn to the imagery of comic books: 'All the mechanical things – the dots, the black lines around everything, the primary colours – all of this was ready-made, to symbolize what we were getting into: a ready-made plastic era.' In other words, Lichtenstein was con-scious of his inheritance from Duchamp, who had already identified the ready-made nature of the modern world.

If you accept this proposition, you must also agree that the movement is therefore less vulgar or silly than some people still think. Pop Art didn't come out of nowhere, but drew upon the high-flown concerns of European Modernism, transforming them with everyday culture into art that was sexy, glamorous, eye-catching – and wildly popular. In doing so, it revitalized the flagging tradition of modern art. So that reception in Pasadena functioned like a sort of rite – in which the baton of modern art was passed from one generation to the next.

Moreover, once Pop's raucous spirit had been unleashed it would never be contained – so that even now, for artists in the twenty-first century, it remains as relevant as ever. As a result, it's high time that we stopped thinking about Pop Art as the brash, adolescent show-off of modern-art movements, petering out at

the end of the Sixties. Instead, it taught us a profound lesson about Western society: that there was no longer any barrier between high and low culture, the avant-garde and the masses. This was its greatest and most prophetic insight into the potent, often bewildering forces that still shape our world today. As Warhol recognized long before the rest of us, once you 'get' Pop, you will never see reality the same way again.

Author's Note

This book has been published to coincide with Tate Modern's major exhibition *The World Goes Pop*, which opened in September 2015. It could not have been written without the support of the BBC. In recent years, I have written and presented a number of BBC television documentaries about Pop Art, including single programmes devoted to Warhol (for BBC One) and Lichtenstein (BBC Four), as well as *Pop Go the Women*, a one-off 'special', focusing upon female artists, for *The Culture Show* on BBC Two. Moreover, while I was researching and writing this book, I was also making *Soup Cans & Superstars: How Pop Art Changed the World*, a ninety-minute history of Pop Art for BBC Four that took me all over the world, from Los Angeles to Shanghai, via Paris and New York as well as London, in order to meet some of the most important living artists associated with the movement. I am very grateful to the documentary's director, Jude Ho, and assistant producer, Alice Rhodes, for our ongoing conversations about Pop Art, which lasted for several months. I am also thankful that the production agreed to provide me with transcripts of all the interviews that we filmed with the artists. My book is structured primarily around encounters with four of them – Peter Blake, James Rosenquist, Ed Ruscha and Rosalyn Drexler – all of whom I interviewed on camera under the guidance of Jude, who also directed *Pop Go the Women*, and who kindly read an early draft of my manuscript. I am grateful to Mark Bell, the BBC's Commissioning Editor, Arts, for asking me to keep returning to the subject, and to Richard Bright, executive producer on *Soup Cans*

& Superstars, who was supportive of this book from the beginning.

At Penguin, I would like to thank my editor, Daniel Crewe, and copy-editor, Donna Poppy, as well as Keith Taylor, managing editor, and Poppy North, who oversaw publicity for the book. Special thanks should also go to my agent, Rosemary Scoular, who provided constant encouragement, and to my former editor, Ben Brusey, who came up with the idea for the book in the first place.

Inevitably, this book draws heavily upon the scholarship of others. In the interests of making the experience of reading it as swift and graceful as possible, I have not included footnotes. I have also refrained in general from referring to art historians by name. However, I would like to acknowledge here the work of several pioneering scholars, including David Mellor, Marina Pacini, Sid Sachs and Sue Tate, who were generous with their time, research and expertise when I was shooting *Pop Go the Women*. My fourth chapter is indebted to their ground-breaking efforts, which have ensured that many of Pop's women artists are being taken seriously again at long last. It was Tate, in particular, who tipped me off about the gender imbalance of the *Pop Art* exhibition held at the Royal Academy of Arts in 1991.

I also want to thank the many other art historians, curators, dealers and specialists who agreed to talk to me as part of my research. These include: Arne Glimcher, who founded the Pace Gallery in 1960, and his wife, Mildred, who is an expert on the Happenings; Richard Feigen and Frances Beatty, respectively chairman and president of the Richard L. Feigen & Co. gallery in New York, who introduced me to the work of Ray Johnson; Michael Findlay, a director at New York's Acquavella Galleries; Tom Wesselmann's widow, Claire, as well as their daughter Kate, and Jeffrey Sturges, studio manager of the artist's estate; Flavia Frigeri, co-curator of *The World Goes Pop* at Tate Modern; and

Garth Greenan, who kindly flew me to New York for the opening of Drexler's 2015 solo exhibition *Vulgar Lives* at his gallery – a trip that enhanced my research considerably. Thank you, too, to Johnson Chang, Ronald Feldman, John Kasmin and Anthony d'Offay, whose insights have informed and enriched my understanding of Pop Art in manifold ways.

Most of all, though, I wish to thank the many artists who agreed to share with me their memories of Pop Art, as well as their observations on the movement, both for this book and during past interviews for the *Telegraph*. I have benefited immeasurably not only from talking to the artists I have quoted directly in the text, but also from stimulating conversations with Mary Banham (the wife of Reyner Banham and the sole surviving key member of the Independent Group), Derek Boshier, Jeremy Deller, Letty Eisenhauer, Gérard Fromanger, Vitaly Komar, Jeff Koons, Nicola L, Richard Smith, Idelle Weber, Xu Zhen – and Richard Hamilton, whom I met ahead of his exhibition *Modern Moral Matters* at the Serpentine Gallery in 2010, shortly before his death the following year.

During our interview, Hamilton pithily described the difference between his own brand of British Pop and the version that the Americans were making. 'They were not selective in the sense that I was,' he said. 'I was researching everything, whereas it seemed natural to them: why not paint a hamburger or an ice-cream cone? I thought: wouldn't it be interesting to make a picture of an object that I admired, like a brown toaster? I thought: there's something "Pop" about the idea of painting a toaster because it's high design. But it's not an ice-cream cornet.' At points, Hamilton also sounded wistful, ruminative. Referring to *Hommage à Chrysler Corp.*, *Hers is a Lush Situation* and *Pin-up*, he said: 'They were the three best things I've ever done, I suppose. My mind was at the right age to be able to do that sort of thing: I was really

inventing something, and it was quite a serious business. As I get older, I think I can't do it any more. I've always had the feeling that I couldn't do as well as those earlier things.' Not, Hamilton continued, that everyone recognized the brilliance of his early paintings at the time. On one occasion, he met the critic Lawrence Alloway on the stairs of the ICA. Alloway was a good friend and a frequent guest in Hamilton's house, where he had often seen the artist's Pop paintings but never said anything about them. 'So I asked him directly: what do you think of my paintings? And he said: I think they're stupid.' So much for Alloway's reputation as the courageous champion of Pop Art who gave the movement a local habitation and a name.

Finally, as well as thanking my wife, Katharine, for her support and love, I would like to say how thrilled I was when, at the suggestion of my editor Daniel and Penguin's art director, John Hamilton, Peter Blake agreed to design the cover for this book. Irrespective of the words contained within, the publication was elevated at a stroke thanks to his satisfying and eye-catching composition.

Alastair Sooke
London
June 2015

Index